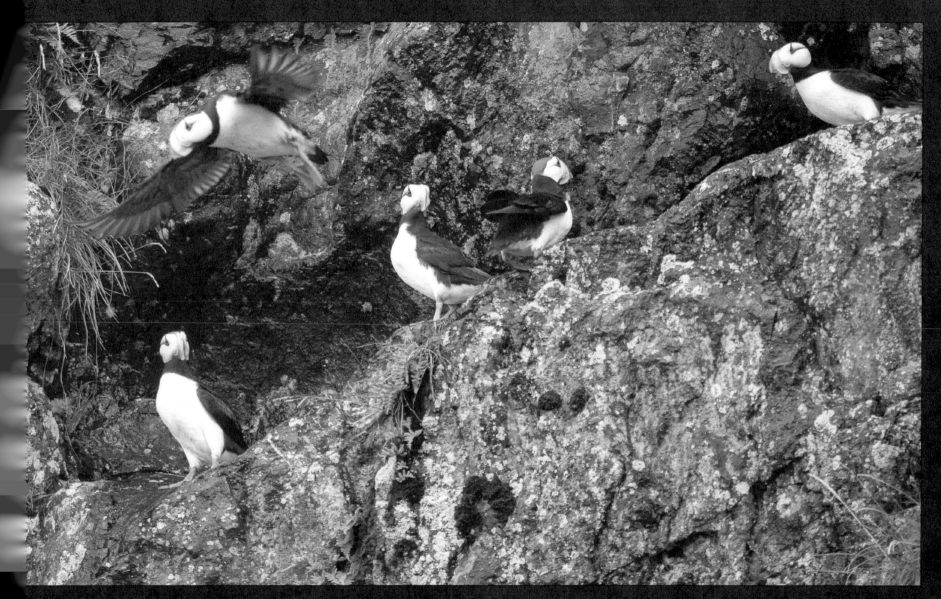

A human being is part of a whole, called by us the "Universe," a part limited in time and space. He experiences himself, his thoughts and feelings as something separated from the rest —a kind of optical delusion of his consciousness. This delusion is a kind of prison for us, restricting us to our personal desires and to affection for a few persons nearest us. Our task must be to free ourselves from this prison by widening our circles of compassion to embrace all living creatures and the whole of nature in its beauty.

—Albert Einstein

Acknowledgements

"No other person has walked the path that destiny has laid out for you, but along the path, you'll come home to a thousand different places. . . . Even on the loneliest night, when it seems there is no one else on earth willing to travel such a strange and magical road, you will find your tribe out walking among the stars."

— Martha Beck, *Steering by Starlight*

I'd like to thank kindred spirits on my path: Pope Francis, who has reverence for all earthly beings; and the fellow travelers in my tribe who sang with me, "In the jungle, the mighty jungle, the lion sleeps tonight," as we bounced through the African bush, hats flying, sunglasses and smiles plastered to our faces. I want to thank Dr. Marg Wood, Barbara Kenney, Gail Sullivan, Dr. Virginia Huang, Rev. Sherry Peterson, Jeanne Waite Follet, Laura Jane, Karen Poch, Richard Dickinson, Pat O'Rourke, Marguerita Reczycki, and Lori and Rich Rothstein. I also appreciate the help of safari guides and mentors Kyle de Nobrega, Grant Atkinson, Andy Biggs, Greg Harvey, Roy Toft, Suzy Eszterhas, Greg du Toit, Guts Swanepol, David Lloyd, and Bashi Patane. Many thanks for my bookmaking guides: publisher Jenny Pivor and editors Elise McIntosh, Susan Franco, and Sami Lawler

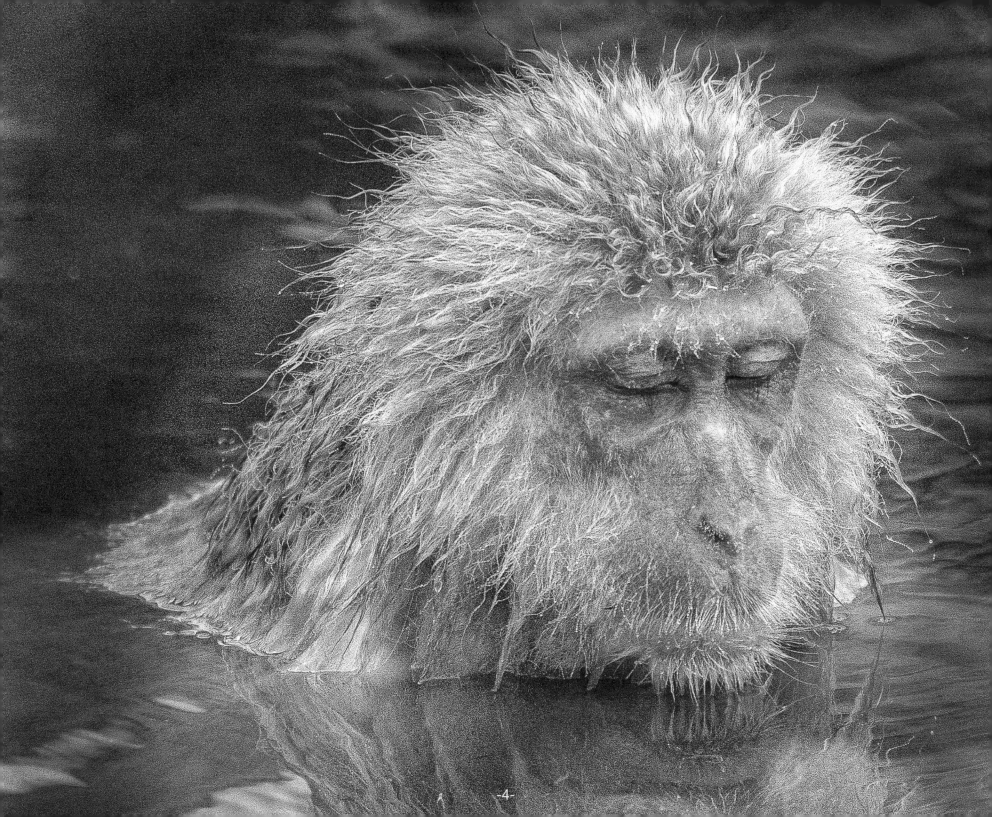

Awakening Awe:

An Illustrated Journey to Reverence

by Mary Baures

Contents

Part 4 Moments of Awe

Part 5 We Can Solve This

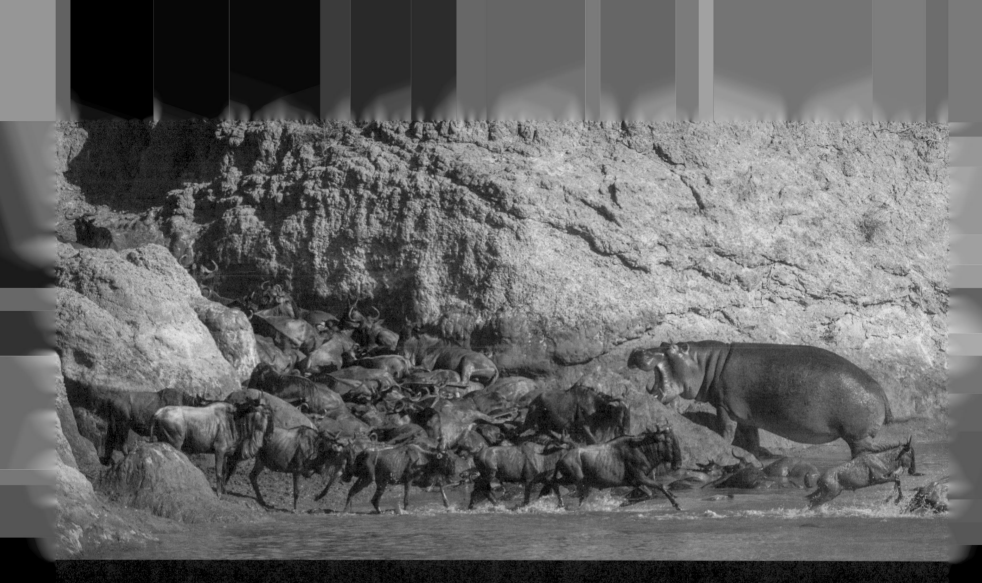

Introduction

Hundreds of wildebeest hesitate high up on a rocky outcropping over the raging Mara River in Kenya. Their bearded faces peer into a sea of comrades below, all swimming for their lives. Braying and grunting mingle with the thundering and splashing of the river. Pressure is mounting from behind. Courage or a shoulder on a rump pushes them down. In a spray of hooves and dust, they trot, slide, then slow to maintain balance. Steep pathways fuel their momentum for their leap into the river. They spread their legs, rise into a float. Their legs, weary from so much running, become wings. They billow, then disappear momentarily in a splash.

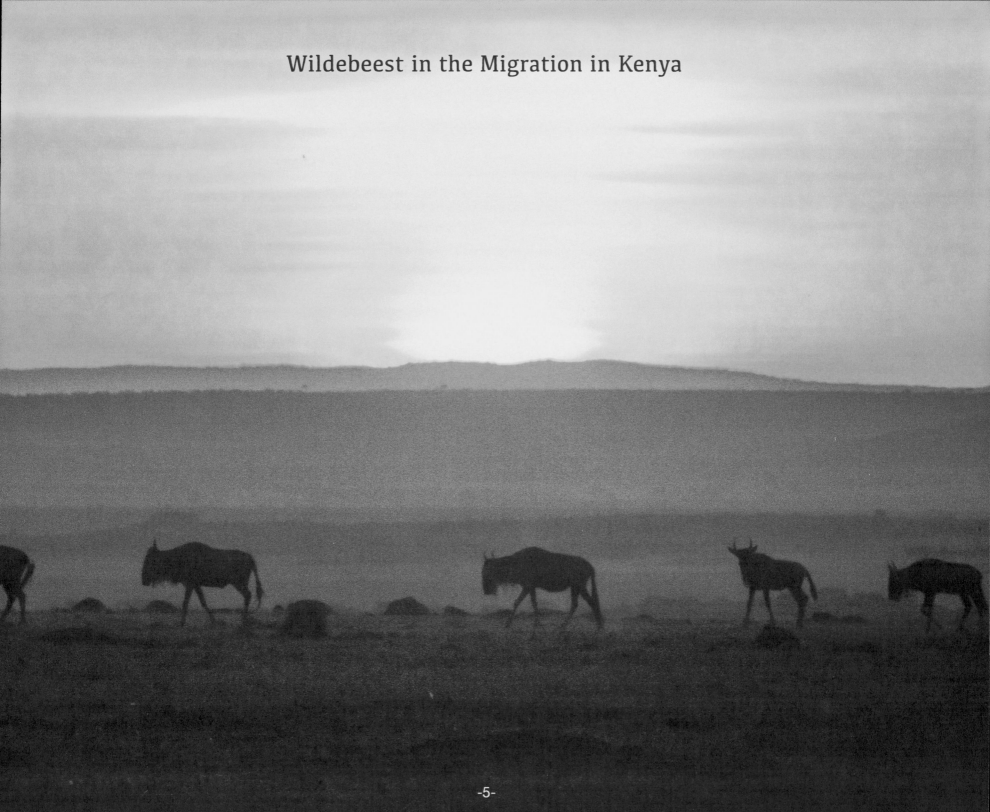

Wildebeest in the Migration in Kenya

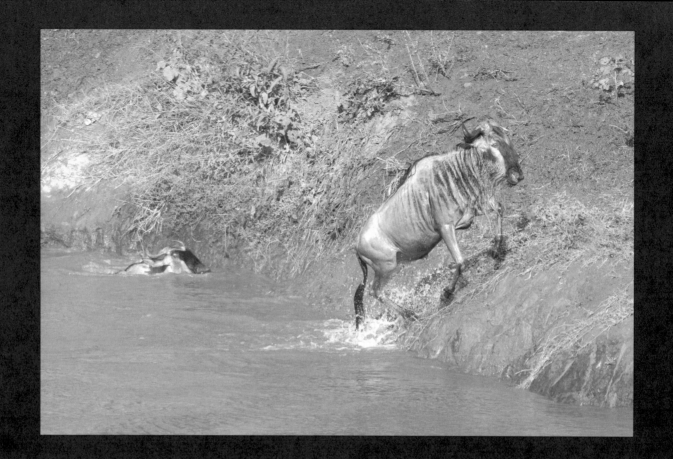

Wildebeest in the Migration in Kenya

Bouncing and paddling amid a swarm of horns and tufted chins, they arrive at the opposite shore. A newbie, just born in the annual birthing season during the rains, dances happily toward his mother whom he'd lost in the plunge into the water. There are many more herbivores than crocodiles, but some wildebeest have lost calves to toothy jaws. Many sprain ankles or break legs. As exhaustion sets in, some are trampled. Driven by hunger, thirst, and some mysterious instinct, the largest herd of animals in the world follows a dream of eating rain-ripened grass.

Their ancient clockwise migratory route has been orchestrated over centuries. Each February, all the females give birth in the south of the Serengeti when, in two weeks, half a million calves are born. They may smell rain or feel pressure in the air, but they follow cloud bursts, which create fertile terrain. Instincts vector them, but the forces that drive them are as complex and fragile as Mother Nature herself. I'm awestruck—feeling a mixture of fear, joy, and surprise—as I glimpse a hidden rhythm within the universe. A dimension vaster than thought, surged up from my depths. We live in an era of great hunger for grace. We can nourish it by slowing down and taking in the grandeur of the world.

The Circle of Life

After spending most of my life as a psychologist, I took up wildlife photography. In the jungles of Africa, Brazil, and Borneo, relationships with animals changed me in profound ways.

As I photographed animals, I tried to see through their eyes, sense when their heart quickened. I felt caution as a jaguar slid discreetly through grass toward prey, a caiman with a mouth like an alligator. I felt a mother elephant's delight when she pulled her baby close and the baby's surprise when he whacked himself with his nose.

My journeys into the wild brought me back to what I didn't know I'd lost—the magic of childhood. Wild lives guided me across the threshold of human limitation to the force that blossoms flowers—from which we came and to which we return.

Animals love life. Birds sing with all they've got. Elephants in water splash, squirt, and frolic with joy. Watching puffins soaring off cliffs in Alaska, a wolf howling at Yellowstone, and orangutans nursing babies in Borneo, I was alive in all my senses. Sitting around a nighttime campfire in Zambia, I felt embraced by other lives. My breath merged with the sounds of crickets and frogs. The eerie whoop of hyenas mixed with the deep reverberating moans of lions calling to each other. Out of the clutter and grasping of our culture, under the sliver of the moon, I connected to something elemental.

I realized that tiny magical moments, like mini-rainbows cascading in a waterfall, the clean leap of a leopard from a tree, the graceful dance of impalas, the slashing horns of a buffalo, went unnoticed while I sat in boxy rooms with ideas, disconnected from the energy flowing through living things. My generation had been part of the largest human migration in history. We moved away from sunshine and fresh air into buildings where we viewed the world on screens. I had become unmoored from my roots in nature. Wild animals spoke to the forgotten parts of me.

As I watched ducks flap out of a lake in unison, I realized how our world is a flow of relationships and exchanges. The grass becomes the antelope, then the leopard. The earth is not just under our feet. It is around and inside us as water forms into flesh, oxygen enables us to breathe, and calcium and protein fuel our actions. When we dump toxic chemicals into the earth, into water, air, and the source of life, they become us.

A vibrant web of bees, ants, bats, frogs, and birds support us, but our delusion that we are separate keeps us from even trying to coexist. We place ourselves above nature, at the apex of a hierarchical order, with little value on the species upon which we depend, but in the circle of life, no one is ahead or above. We are all equal and interdependent.

Zebras in the Great Migration in Kenya

"Wild lives guided me...to that force that blossoms flowers..."

Each rabbit, wolf, and mouse has his or her version of hope. Each knows the fear of squirming up behind a bush to make oneself small or running until his lungs give out to keep his one treasured life. They are not unlike us. Like children, they are innocent and vulnerable. Gentle giants, like elephants and gorillas, speak in body gestures that become feelings on the skin, deeper than words. They have been on earth longer than us and are wiser. They would never destroy their only home.

When bulldozers destroy forests, the lungs of the earth, for doohickeys and thingamajigs, we break the back of our own being. Deforestation enables viruses that live harmlessly in animals to spill over into humans where they are deadly.

I saw videos of Chinese wild markets where bats on a stick and pangolins were sold in squalid containers next to wolf pups, peacocks, rats, and snakes. Ducks and quails with broken wings and eyes glued shut hopped over dead birds in bins. Wild species that would not encounter each other in nature were crammed together, allowing diseases to spread. Limp, dead koalas, so fuzzy in life, were matted with blood and draped across the roof of the cage, while live ones below soaked up their feces, blood, and suffering.

Dogs, thirsty, trembling, and bloody where their front paws were chopped off, watched as their cage mates were set afire. Although their muzzles were taped shut, they still whimpered, drowning out the sound of raccoons licking blood off a garbage can inside wall.

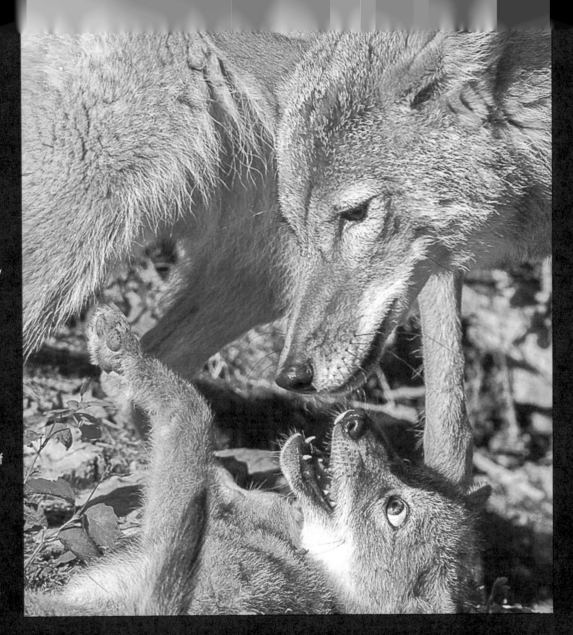

Shoppers, carrying children in their arms, tuned out their cries because their culture believes torture is supposed to make meat taste better. Merciless, they shopped as if they were buying something, not someone whose life was precious.

It wasn't bats or pangolins who started the coronavirus outbreak, but our denial of them and wolf pups, koalas, and dogs as kin. After our cruelty brought the economy to its knees, we had karmic ramifications; the death we gave bats, raccoons, dogs, and pangolins spilled over into us.

Just as the animals trapped in cages watched their cage mates die, we were trapped in our houses watching death tolls climb. Just as people gasped for air as their lungs filled with fluid, crying and collapsing glaciers were drowning from the fever we gave the earth. Forests clean our air and filter our water, but we allowed chainsaws to convert them to shopping malls because we could not imagine being unable to breathe. Not listening to our mother has consequences.

The Laws of Nature

We become toxic when we lose contact with our wiser intelligence. The coronavirus did not arise instantly like Venus on the half-shell dripping with water from our polluted oceans. We knew from SARS, Zika, West Nile, AIDS, and Ebola that deforestation and wet markets helped animal pathogens jump to humans. SARS was probably passed in a Chinese market from a bat to a civet cat, similar to a mongoose. When it mutated, it leaped to humans in 2003 and 2004, infecting 8000 people, killing 774. In July of 2020, Chinese officials in Kazakhstan said an "unknown pneumonia" deadlier than COVID-19 had killed 1,700 people so far. These outbreaks are just the beginning. They teach us the earth was designed for all life. Stealing the homes of other species and caging them in disease-ridden conditions has karmic consequences. Destroying wildlife habitats violates Mother Nature's design. Nature has sent us a warning.

Many Americas were horrified by China's treatment of animals, but our own factory farms are straight out of a horror film. Mutilations are done without painkillers. Pigs and chickens never see the sun. Employees feed them antibiotics to confine them in cramped, germ-infested stalls, opening us up to salmonella and antibiotic-resistant diseases, like MRSA. The stress of tight confinement and of watching others slaughtered weakens their immune systems, so they are prone to disease. A mutant form of Bird Flu, which could emerge from factory farming, is 90 times more deadly than COVID-19, according to Dr. Justine Butler, in *Zoonoses*: *A ticking time bomb.* Allowing pigs, goats, chickens and cows to move in healthy conditions is better for us.

The Center for Disease Control reports that each year about 2 million people get infections resistant to antibiotics. About 25,000 die from them each year. Mercy for animals is not a fringe issue.

We need to coexist with other species not destroy them. The US Department of Agriculture's Wildlife Services kills millions of foxes, mountain lions, wolves, coyotes, bears, prairie dogs, and raccoons who are viewed as pests to ranchers with cattle and chickens. In 2017, Wildlife Services killed more than 2.3 million animals by poison, aerial gunning, strangulation, and leg-hold traps. They recklessly kill off the earth's creatures, but their damage does not end with the lives sacrificed for profits. They are causing broad ecological destruction and loss of biodiversity.

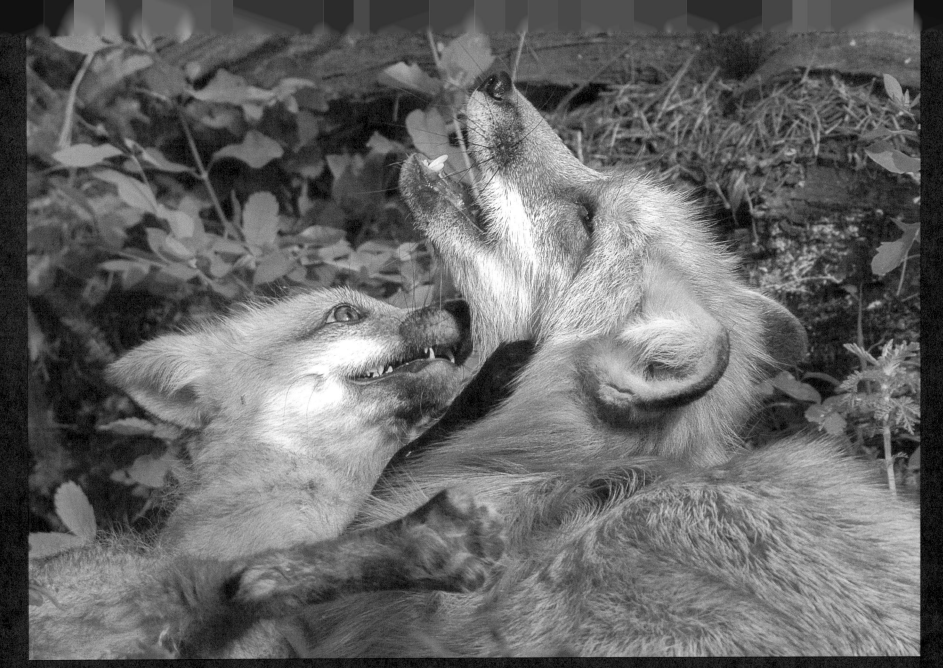

Over 50 percent of our federal spending goes for the military—tanks, submarines, bombs, fighter planes, and nuclear weapons—but our enemy is our delusion we are above and separate from nature. The exquisite armor of the pangolin was no match for our arrogance.

Rachael Carson, in her groundbreaking 1962 environmental book *Silent Spring*, said, "Man's war against nature is inevitably against himself." A marine biologist, Carson used precise and poetic descriptions to link mollusks to seabirds and fish.

The interconnection of all life is why using DDT and pesticides damages our own health. Studied by President John F. Kennedy, her work led to DDT being banned. Carson's thesis was that technological progress was at odds with natural processes and must be curtailed.

DDT was developed in 1939 to clear the South Pacific islands of malaria-causing insects for US troops, but it was later used by civilians to kill insects. We continued to be in denial about the interdependent web of life when we poured 20 million gallons of Agent Orange over Vietnam's rainforests during the war from 1961 to 1975. Our goal was to ruin crops so our enemy would not have food and to defoliate trees so Vietnamese forces would not have a canopy in which to hide, but our damage went way beyond the trees and crops.

In 1994, when I went to Vietnam with psychologist Dr. Dave Johnson of Yale University, other mental health professionals, and former soldiers trying to heal the wounds of the Vietnamese war, we visited a hospital where scientists showed us pictures of babies with facial deformities. They were birth defects caused by Agent Orange. I felt ashamed of my country's inability to grasp the big picture.

Our delusion of separation enables the misuse of rodenticides which causes collateral damage to hawks, foxes, skunks, raccoons, bears, and bobcats. Our delusion that we own the earth ruptures nature's system of checks and balances.

Coyote Pup Targeted by Wildlife Services as a Pest

When we kill wolves for ranchers, deer, and elk populations explode and destroy plants necessary to control flooding. In February 2017, Congress voted to allow the coal industry to dump toxic metals into streams with dire health consequences for people in rural areas. Repealing steam protections was good for industry but lethal to everything else.

Destroying other living beings violates laws wiser than man's law. Pope Francis says other creatures are imbued with His radiance. He said the coronavirus pandemic is nature's response to humans ignoring the current ecological crises. Our survival depends on us seeing the coronavirus

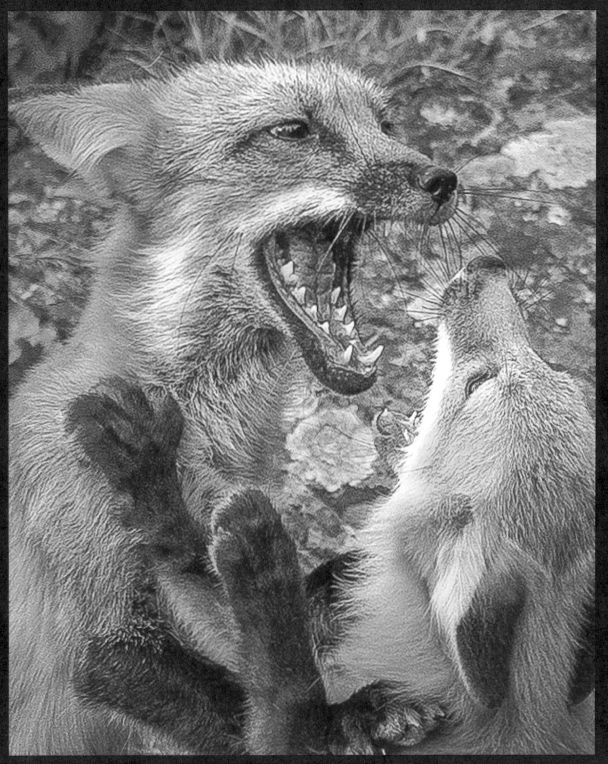

Master Lessons of Nature

Following the lessons of nature leads to more physical, spiritual, and mental health. Gary Ferguson in The Eight Master *Lessons of Nature* shows how reweaving connections to the outside world leads us home, because aspects of nature are hardwired into our DNA. Here is his summary of nature's lessons:

1. Mystery: Wisdom begins when we embrace all that we don't know.

2. Life on earth thrives thanks to a vast garden of connections.

3. The more kinds of life in the forest, the stronger that life becomes.

4. Healing the planet means recovering the feminine.

5. Our animal cousins make us happier and smarter.

6. Life doesn't waste a drop of energy.

7. After disaster and disruption, nature teaches us the art of rising again.

8. Elders can help us be better at life.

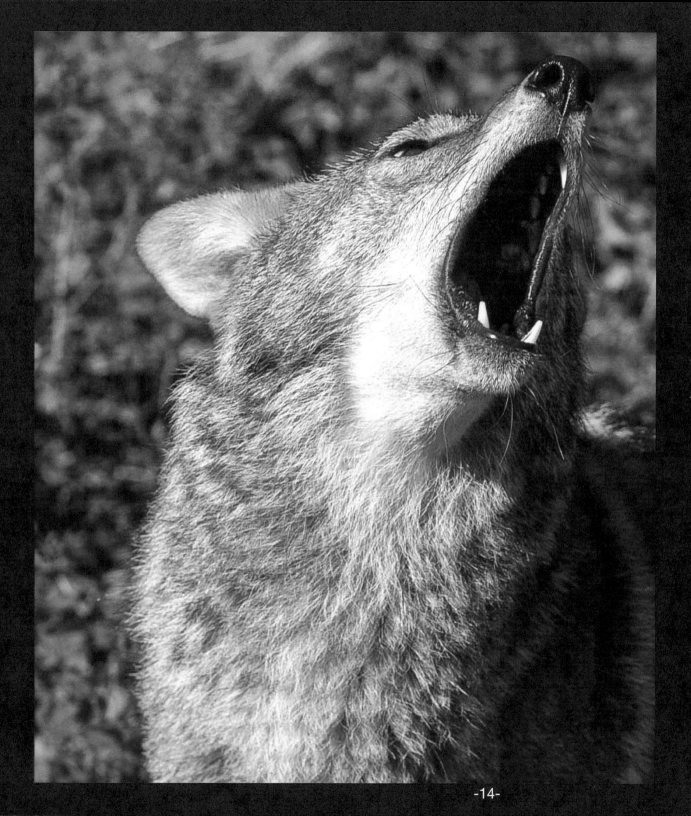

"There are no human words to adequately express the inner energy I've felt when my howls are answered by wolf howls drifting through the lodge pole pines. The connection on such a primal level far surpasses the capabilities of human conversation . . ."

— Diane Boyd-Heger
wildlife biologist, wolf
recolonization, Rocky Mountains

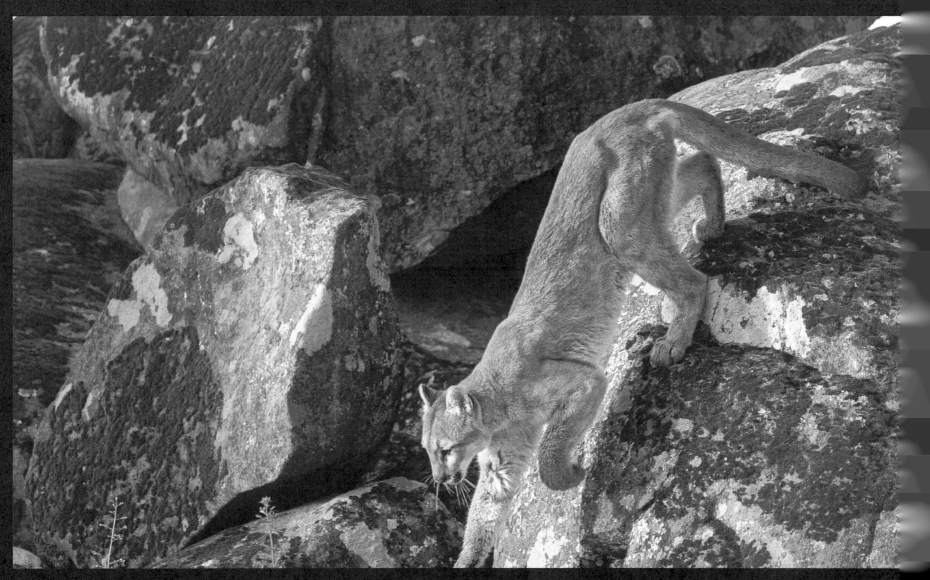

Mountain lions, gorillas, jaguars, and leopards, who share with us the breath of life, are part of intact forests and ecosystems. There's a poignancy to showing them to you because their existence is threatened by our mindset.

This book avoids much of the tragedy our economic and cultural values inflicts on them because you would turn away. Showing you their innocence and magic will help you see them as infused with awe. Then, I hope you will treat them with reverence.

I tell you my stories and show you my images so you can come along with me, see what I saw, feel what I felt. Once we develop a more porous sense of self and view ourselves as part of the circle of life, we know the wonder, sacredness, and awe in nature are in us.

Wolves Song

In Yellowstone National Park, I heard the long, wavering swell of a wolf calling. He was joined by a chorus of others echoing across the landscape. Native Americans believe that when our small mind encounters a wolf's howl, we delight in his energy. However, when our larger mind hears the deep-throated songs echoing back rhythmically, they speak to us in visions. For me, the howls offered hope for creatures full of life teaching us nature's wisdom. In the 1920s, after we gruesomely exterminated wolves in Yellowstone, elk and deer nibbled new shoots of aspen, willows, and other plants needed by rabbits, weasels, foxes, and beavers. Without wolves, the balance of nature was destroyed.

With the return of wolves in 1995, life bloomed over the terrain like a wolf's song. Trees came back. Foliage flourished with berries, bugs, and birds. Roots stabilized riverbanks and enabled beavers to find wood for lodges and thus thrive. Their dams attracted badgers, muskrats, and rabbits. With more vegetation, river channels narrowed, lowering the threat of floods. Wolves were better stewards of the landscape than people.

Disrupted ecosystems lose the largest predator first, so smaller animals with viruses multiply and carry pathogens to humans. Protecting wolves and coyotes rather than slaughtering them protects us from epidemics and fights global warming. Predators keep deer and elk from destroying oxygen-producing trees and bushes. Both in Yellowstone where wolves were returned and in Finland where Eurasian lynx were returned, the resilient ecosystem responded. Culling predators isn't as effective as ranchers hope. Researchers in Australia did a two-year study of culling dingoes and determined that lethal control disrupts social relationships that regulate reproduction, so it was better for livestock when predators were left alone.

The Wolf Lady

When Karin Vardaman of the California Wolf Center tried to find some common ground between ranchers and wolves, she developed The Working Circle to open up a dialogue. Vardaman saw how polarizing the conflict was when she presented a PowerPoint "Wolves and Livestock" at a community hall in Montague on the Oregon border.

Around her in a semicircle were men in cowboy hats and boots. They had weathered skin and calloused hands. Some held rifles. Others held handguns. Many waved anti-wolf flyers. When she spoke, one man interrupted her. His voice rose in anger. He said he did not appreciate her coming to town and telling them what they should do about wolves. The group then chanted, "Shoot, shovel, and shut up," as their solution to wolves.

A government-sponsored livestock protection program had exterminated wolves by 1924. But in 2011, a lone gray wolf on a radio collar in Oregon came to California. Some friends followed him. The agricultural community became galvanized by fears for their cattle if the predator was resurrected.

Empathizing

Learning to empathize with ranchers is how Vardaman found ways to collaborate with them. She visited cattle farms and saw how they were proud of saving animals from the horrors of factory farming. When a petite rancher in her sixties showed Vardaman around, Vardaman asked the rancher what her biggest concerns about wolves were. "Wolves are magnificent, but I love my cattle," the cattle farmer explained. "I don't want my cows to be food for a wolf. We love our animals. While they are in our care, we take responsibility for them very seriously."

Vardaman's eyes filled with tears. She could no longer view cattle farmers as villains. Through her own transformation, she got ranchers to agree on using riding "stewards" who patrolled on horseback and scared wolves away from cattle. They also herded the cattle together, which lessened the chance of a lone cow being picked off. Through Vardaman's empathy and dialogue, ranchers gave up their entrenched view that "the only good wolf was a dead one" and became open to the possibility of coexistence. When we have emotional connections with others, we view them as nuanced and complex rather than simplistic stereotypes.

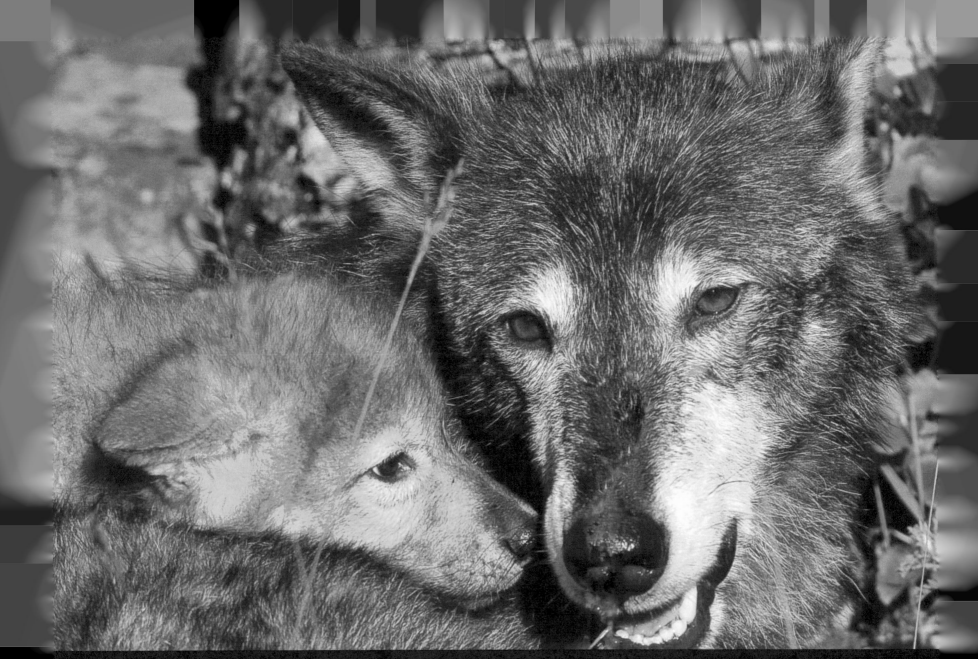

"Conservation should protect the value of all life, including human life.
Cameras will help achieve that"

What is Wealth

Looking deeply into the amber-green eyes of a jaguar, I sensed the ancient wildness of the Amazon whose ecosystem they keep in balance. In 2014, I photographed jaguars in Brazil's Pantanal, the world's largest tropical wetlands. In August 2019, when the Amazon burned, I saw photographs of blackened forests and the charred remains of jaguars. According to Dr. Esteban Payán, the 2019 Amazon fires killed over 500 adult jaguars, a key species of the rainforest. Ones not cremated by flames lost their homes in a matter of weeks. I was anguished that their guttural roars, bass notes of the forest, were silenced by the blazes.

The fires were part of Brazilian President Jair Bolsonaro's plan to turn forests into human wealth. The discovery of both diamonds and gold under the earth funded deforestation for farming. About 42 percent of Europe's beef imports come from Brazil. To assist in his goal to make Brazil more industrialized, he planned to build a hydroelectric river plant on the Trombetas River, a bridge over the Amazon River, and a highway system for vehicles.

Some of the land he wants to clear belongs to the 850,000 native people of Brazil. "Where there is indigenous land, there is wealth," Bolsonaro said. He called the tribes "prehistoric, with no access to technology and the wonders of modernity." The indigenous people think Bolsonaro is daft to destroy so much life for cooper, zinc, tin, diamonds, and gold because they have vastly different ideas of what wealth is.
Wealth to the indigenous tribes is the health of the multitude of interwoven lives they are part of—427 mammal and 1,300 bird species that include macaws, anacondas, dart frogs, bees, termites, jaguars, pink river dolphins, toucans, hoatzins, howler monkeys, otters, sloths, capybaras, anteaters, iguanas, eagles, lizards, kinkajous, and all the leaves, roots, branches, and insects that provide food and shelter to all life. The health of native people is linked to the health of the ecosystem.

In a meeting with journalists, tribal leader Ewerton Marubo, wearing a headdress of macaw feathers and ear and nose rings, said of Bolsonaro, "He sees us as animals. As if we didn't know how to think, but we are much more intelligent than him. . . . Just imagine if all this is destroyed, if the government opens up this area. In two years, it will all be gone. The wood will be gone. The fish will be gone. The rivers will be polluted. All they want is to destroy."

True to his prediction, in August 2019, much of the rain forest went up in smoke, ghostly remains of a vibrant life. The blackness of cremated jaguars, capybara, howler monkeys, sloths, and other animals darkened the skies of Sao Paulo thousands of miles away. With no concern for wildlife and their offspring, farmers announced a coordinated "day of fire" to clear land for the beef industry. Soon 87,000 fires raged in the Amazon and spread uncontrolled.

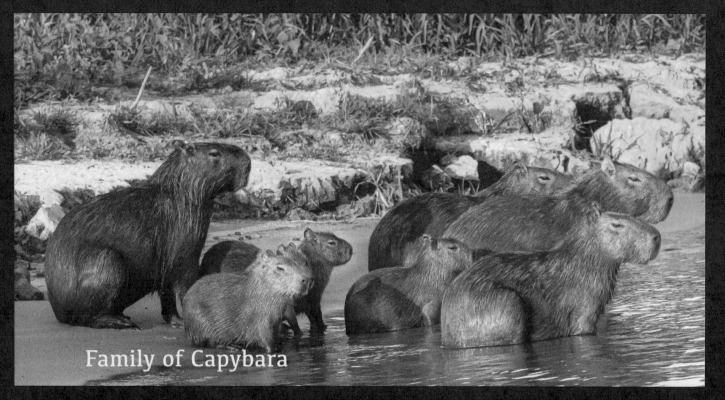
Family of Capybara

Brazil's former environmental minister, Marina Silva, said, "Resources of thousands of years cannot be sacrificed for the profits of a few decades." Silva said the crisis was an ethical issue caused by a "regressive" government. Bolsonaro and his followers lived in a parallel universe from scientists, environmental experts, and the indigenous tribes who have vastly different ideas about what is of value.

Researchers say wildfires will cause the next epidemics. In 1988, huge blazes in Indonesia created conditions for the Nipah virus, with a morbidity rate of between 40 percent and 70 percent. Scientists believe fires forced fruit bats to leave their forest homes and roost on farms and orchards. When pigs ate what the fruit bats had tasted, they became infected. Humans ate the pigs and began to die from brain hemorrhages. The Ebola outbreak came from deforestation in Central and West Africa. Only a small percentage of wildlife pathogens are known to science. They are locked in balanced ecosystems until our deforestation spills them out. Diseases from mosquitoes are also linked to forest destruction. As leaves and roots disappear, malaria-carrying mosquitoes breed in puddles. We are learning what native cultures have known all along. The forest is more valuable than the short-term profits of ranchers, loggers, and miners.

The more we psychologically develop, the more we empathize with multiple points of view. When we widen our perspective to embrace contradiction and paradox, we see that Ewerton Marubo, in a feathered headdress and nose rings, is wiser than the president of Brazil. Why do those who are "prehistoric" without the "wonders of modernity" have so much more wisdom than those committing ecological arson? Because native tribes are self-aligned with the web of life and are guardians of the natural world.

In another blow to the rain forest, Bolsonaro's government suggested a new bill that would allow sport hunters to turn jaguars into rugs and lifeless heads on a trophy wall. It would also allow hunters to kill or capture parrots, otters, and monkeys. Repealing the ban on hunting threatens biodiversity and a healthy ecosystem.

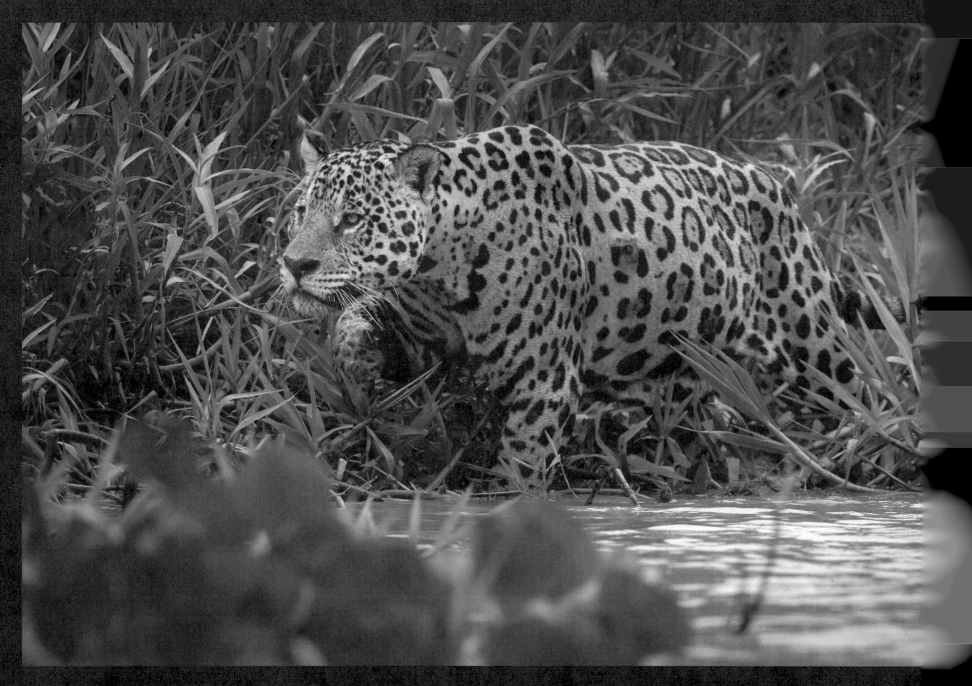

Almost every day we spent hours with Mick Jaguar, photographing him from a boat. He was habituated to us and allowed us to watch him hunting. We tried to photograph him from the left side because his right eyelid was damaged. He could see out of it, but the lid did not totally retract

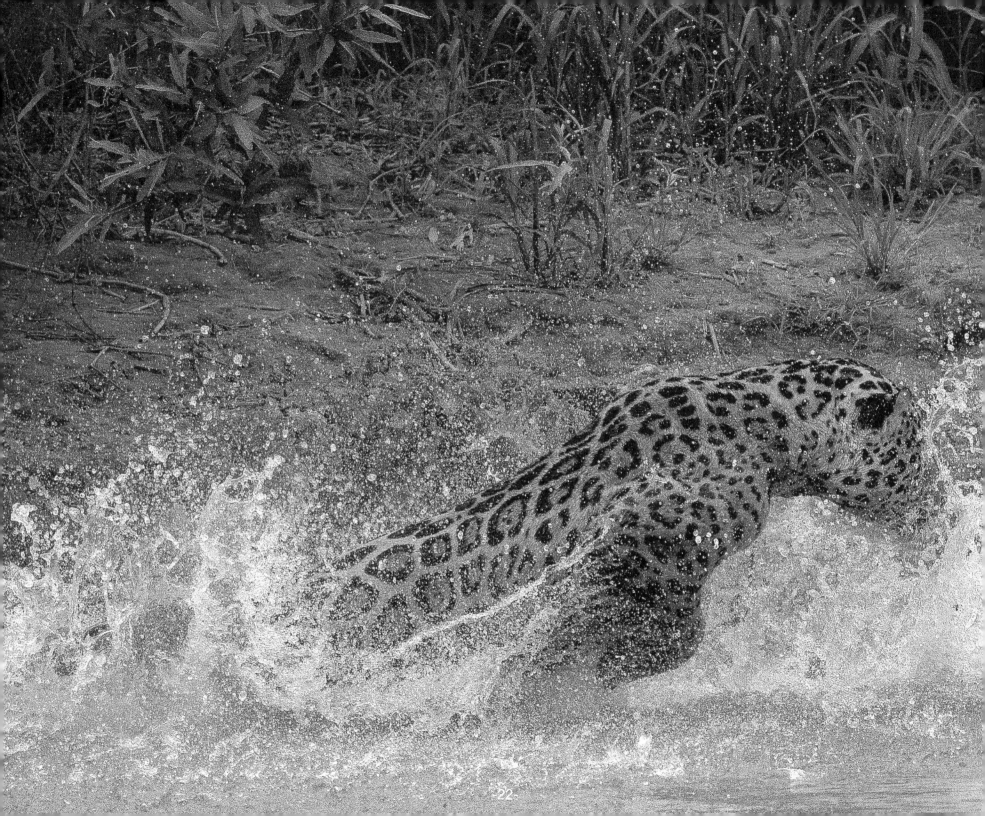

In April 2020, as the coronavirus spread through Brazil, President Jair Bolsonaro continued to ridicule scientists who created what he called an "absurd campaign of hysteria." As deaths spiraled out of control, Bolsonaro told the elderly to go back to work. "Some will die. Such is life," he said. His focus on wealth at the expense of health created a conflict with the governor of Sao Paulo, João Doria, who said a good economy required people to be alive. Doria said they had two viruses to confront: "the coronavirus and the Bolsonaro virus."

Previously, Bolsonaro gave loggers and miners implicit permission for illegal invasions of tribal lands, and tribes have been left to defend themselves. "I'm scared at times," said Paulino Guajajara, a forest warrior. "But we have to lift up our heads and act. . . . We are protecting our lands and life on it, the animals, the birds, even the Awá who are here too. There is so much destruction of nature happening, good trees with wood as hard as steel being cut down and taken away. We have to preserve this life for our children's future." In November 2019, Guajajara, who was 26 years old, was shot in the head and killed by illegal loggers.

In April 2018, indigenous tribes stained the streets red to symbolize the blood shed to protect their lands. On July 27, 2019, dozens of armed miners in army fatigues invaded an indigenous village in northern Brazil. They stabbed leader Emyra Wajapi and threw his dead body in the river. Violence in lawless, isolated areas goes unpunished.

When *National Geographic* writer Chip Bowen visited a shamanic healer in the Amazon, he learned jaguar spirits were guardians of the forest. Aztecs and Mayas worshiped jaguars as regal and ferocious gods who battled underworld forces. "You can't erase a spirit," the shaman told him. "The body may have died but the spirit is still here."

I wonder if a jaguar's spirit can help us hear the cry of the earth.

Following Mick Jaguar when he was hunting paid off. He attacked a caiman who barely got away.

Beef Industry
Burns Up Life

Fast-moving animals like jaguars and pumas had more chance of outrunning the fires, but 2.3 million other animals, such as sloths, anteaters, armadillos, ocelots, frogs and lizards went up in smoke immediately. Dr. Esteban Payán of Panthera, the Global Wildcat Conservation Organization, says, "The scale intensity and velocity of fire destruction" are alarming because there isn't "an equivalent collective response" by humanity.

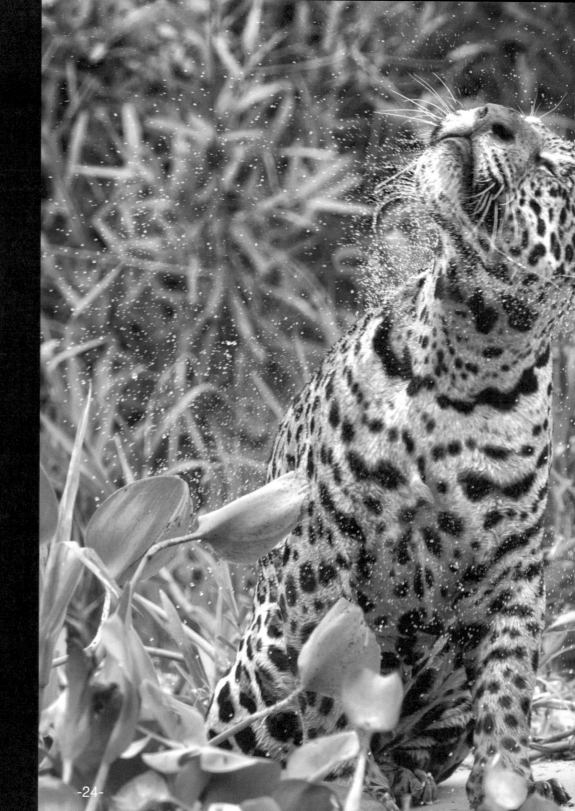

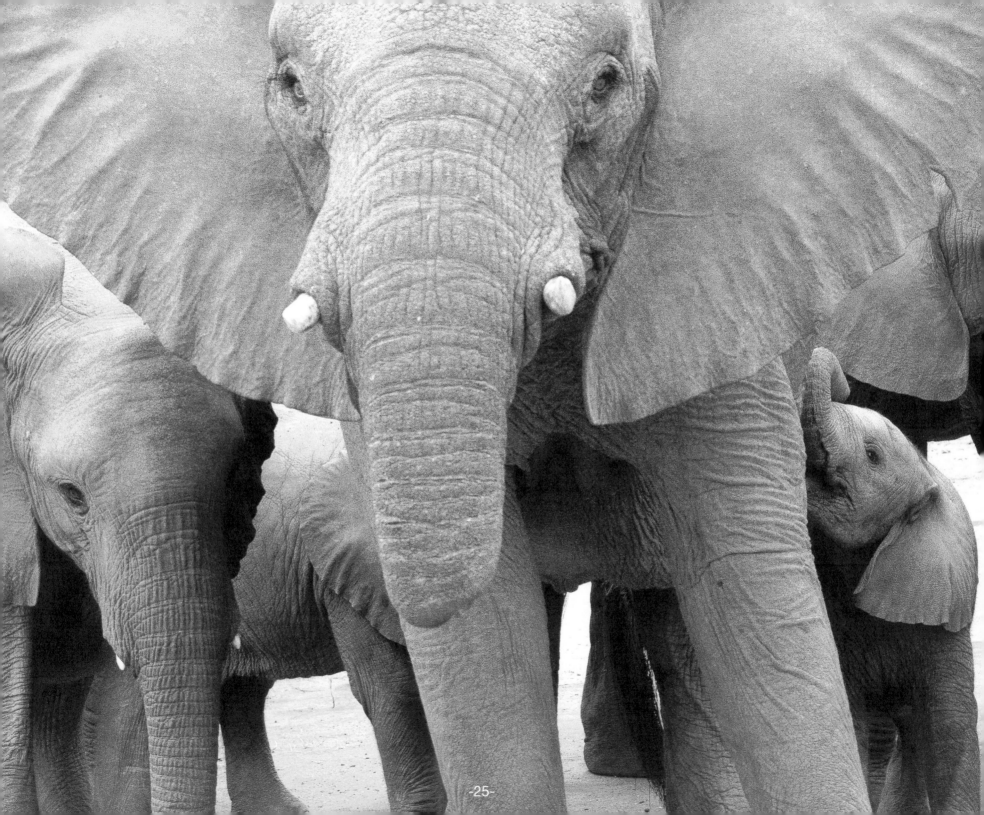

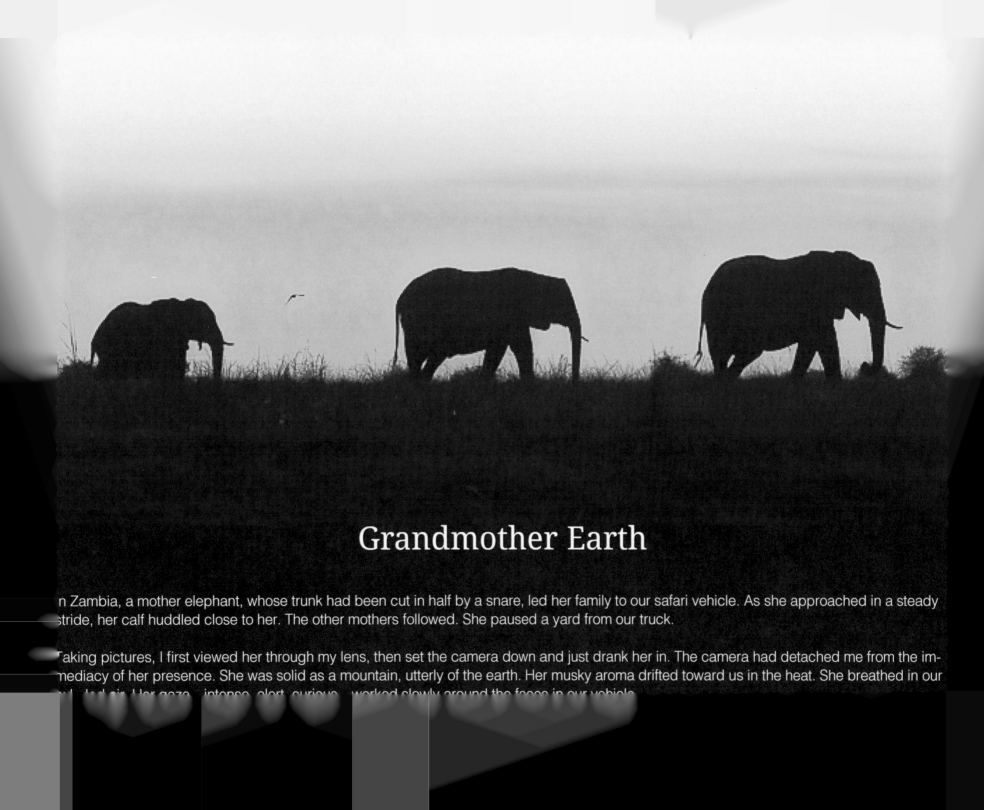

Grandmother Earth

n Zambia, a mother elephant, whose trunk had been cut in half by a snare, led her family to our safari vehicle. As she approached in a steady stride, her calf huddled close to her. The other mothers followed. She paused a yard from our truck.

Taking pictures, I first viewed her through my lens, then set the camera down and just drank her in. The camera had detached me from the immediacy of her presence. She was solid as a mountain, utterly of the earth. Her musky aroma drifted toward us in the heat. She breathed in our

What We Do to Elephants,
We Do to the Earth

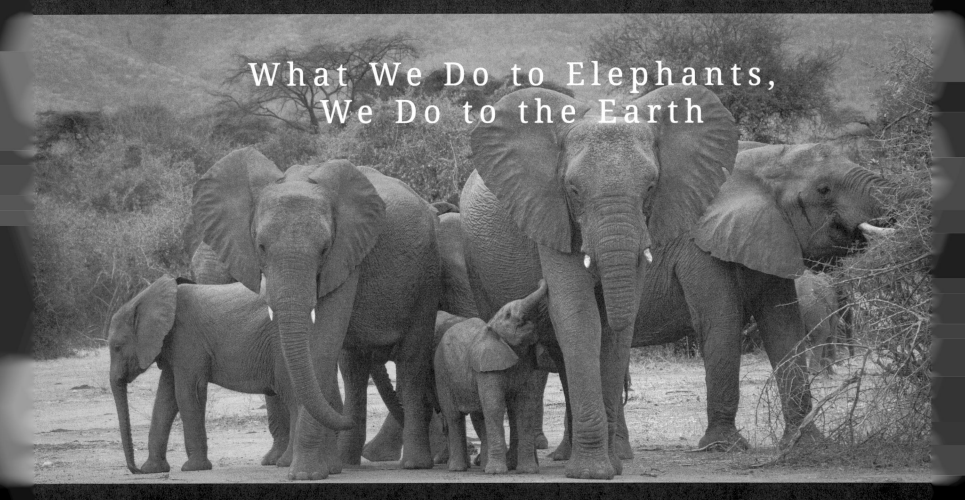

Something inside me knelt down. Humans took half her trunk--a hand, nose, and mouth combined-- but she learned to thrive. She was unable to pick up leaves or caress her babies with her trunk, but her spirit was unbroken. Grandmotherly, she was rooted in an ancient wisdom we had lost. Maps in her psyche knew the way to watering holes.

Her beloved friends had been massacred for ivory trinkets, yet she stood next to us, the murderous species. I sensed a sorrow in her. What we had done to her we are doing to the earth.

When her unblinking brown eyes got to me, she bowed, perhaps in recognition of my empathy. Goosebumps spread on my skin as I took in the gold flecks in her eyes. Warm waves of connection filled the space between and around us. I sank into a deeper part of myself and into a language older and deeper than words. My senses keen, my heart wide open, I felt gratitude for all living beings weaving around and through me. More than beholding me, she was transmitting electricity. The energy field awakened an underlying intelligence in the universe. Wiser species than ours follow natural laws that nurture the future by not taking more than they need.

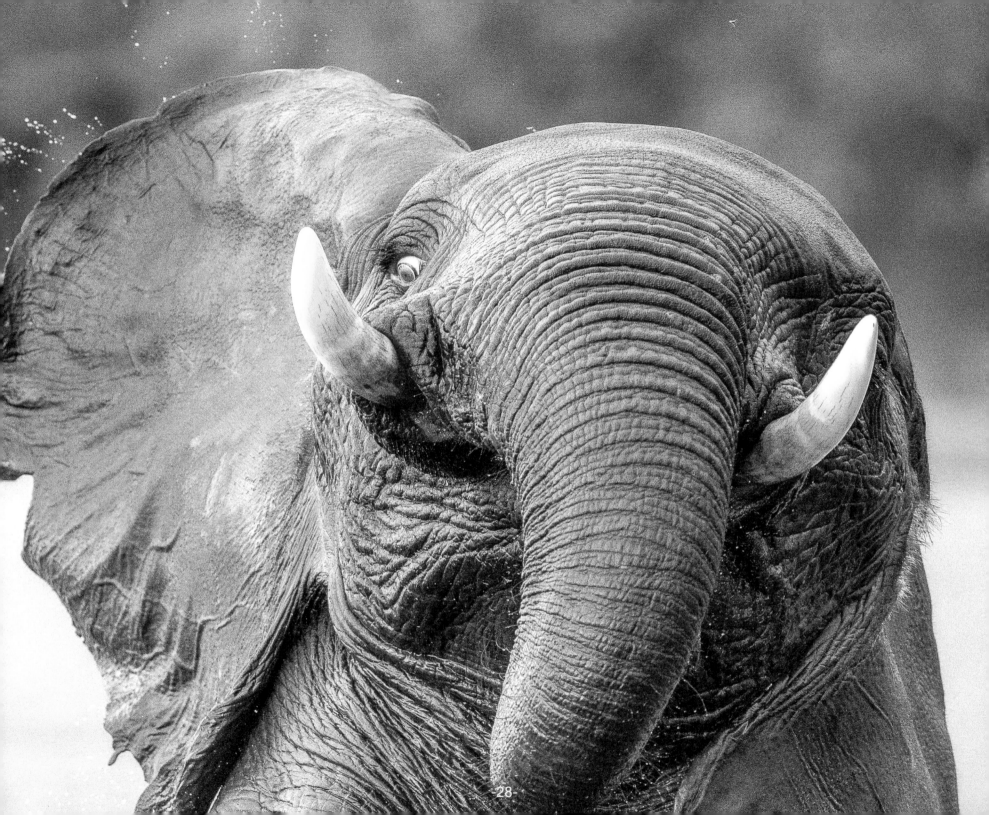

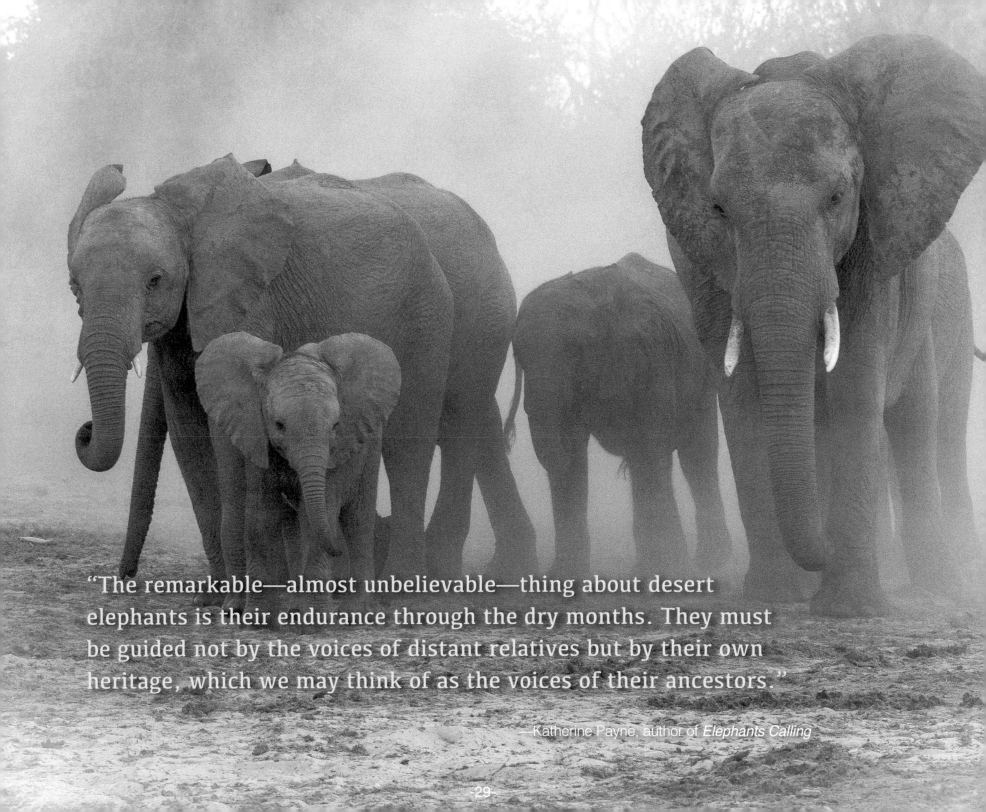

"The remarkable—almost unbelievable—thing about desert elephants is their endurance through the dry months. They must be guided not by the voices of distant relatives but by their own heritage, which we may think of as the voices of their ancestors."

—Katherine Payne, author of *Elephants Calling*

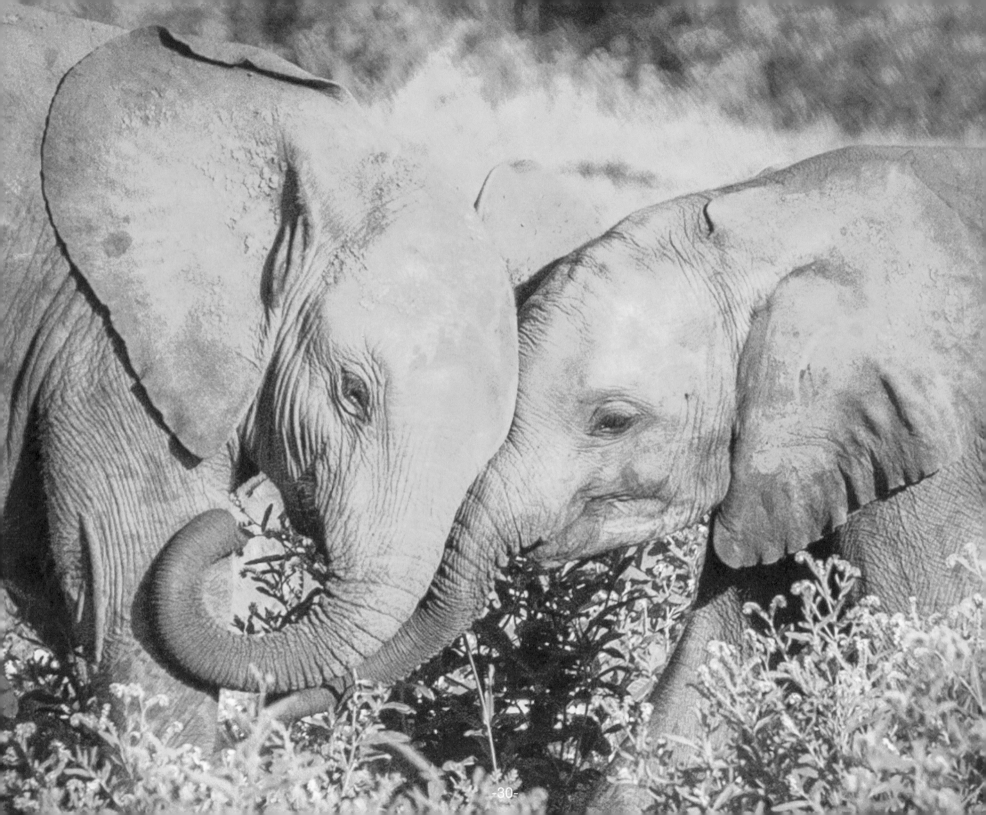

Love Heals Baby Elephants

I endure terrible heartache for innocent lives lost because we turn living, breathing beings into things. *Love Heals Baby Elephants – Rebirthing Ivory Orphans* grew out of my work as a trauma psychologist. I was drawn to the plight of baby elephants who watched their families massacred for ivory trinkets. I adopted one of the traumatized babies through an orphanage in Nairobi, Kenya. When Kamok was rescued, her petal pink ears and soft fuzz on her head showed she was newly born. Her umbilical cord was fresh. She was delicate and fragile. Her hardly used feet had been bent in the womb, so, just after birth, she wobbled on ankles, tripping on her elastic trunk.

On the run from poachers, a matriarch will not risk the whole family, so Kamok's mother abandoned her. I imagined the terrible loss for her mother in whose uterus she had been for two years and Kamok's terror of being alone without loving protection. But in the safety of the orphanage, she learned to walk and found surrogate mothering. Through updates about Kamok's recovery, I was drawn to adopting more orphans and saving elephants from extinction.

To turn my campfire into the light of the sky, I set the elephant holocaust into a tender survival story. The traumatized orphans, with innocence not yet of this world, almost drowned in a pool of their suffering. Many shut down and withdrew from the staff who looked like ones who chopped up their mother. The orphans believed the caretakers at the orphanage would kill them too and sank into a black emptiness where safety and belonging used to be. A piece of night detached from their mothers' death gathered into their hearts. The other orphans sensed their struggle and caressed them with trunks with heart-shaped lips. Safety and belonging bloomed into love. Cries of their dying families were replaced by playful voices calling their names.

After a time, love pulled them from the bottom of despair, and they found the will to live. They bounced back with a song in their step, a trumpet in their wiggly trunk, and the resilience to help others. Baby elephants teach us that no matter how badly we are hurt, love can help us come back from devastation.

After years of wildlife photography and writing *Love Heals Baby Elephants – Rebirthing Ivory Orphans*, I emerged a changed person. Before, when I saw a bee, I thought "Yikes. A bee. Don't bite me." Now I think, "Wow a bee. What big eyes you have. What a fuzzy gold coat. Glad you survived all the pesticides. Let me get you a drink. I'll show you where the dandelions are." When I see a caterpillar inching over asphalt in a parking lot, I say, "Hey, little guy. You are not going to make it. Huge tires will squish you." With paper, I airlift him to safety. In winter, my grocery store lists include carrots, apples, and nuts for rabbits, raccoons, and other wildlife who can't find food in the frozen earth. Throwing away food is against my values. Leaving restaurants, I fork uneaten French fries and rice into take-home containers for animals in wooded areas. I have evolved into seeing myself as interdependent with the lives around me. One of the signs of transformation is to view oneself and others in a new way.

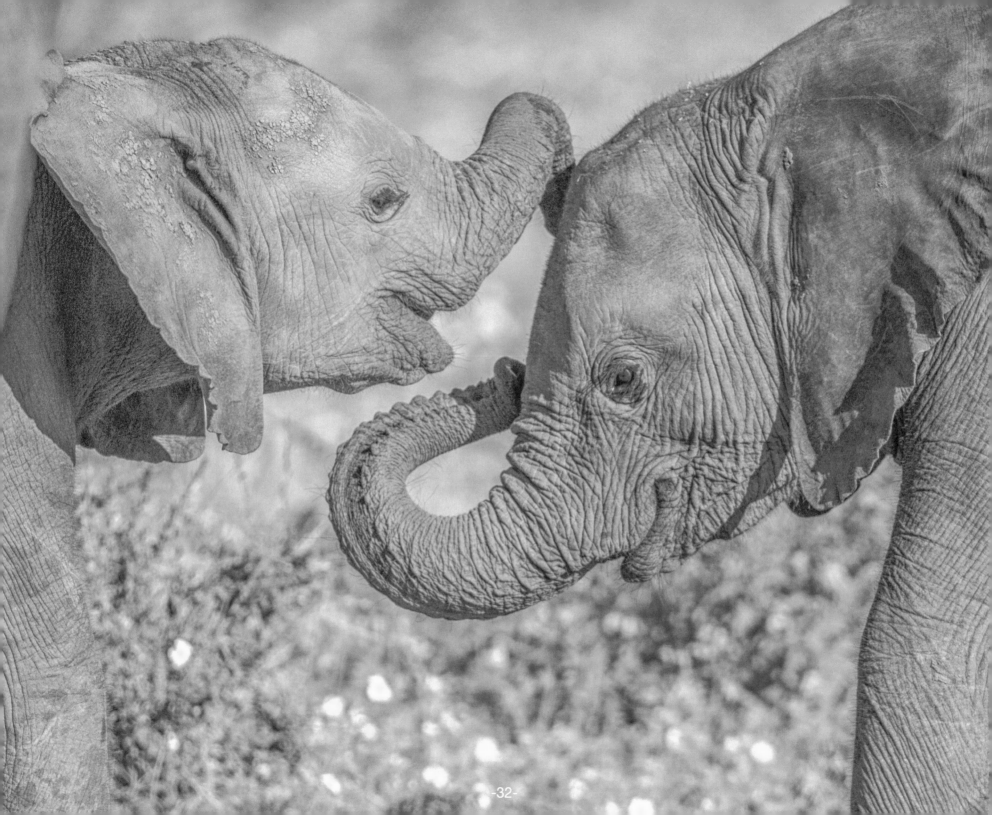

Mothering: Strength in Tenderness

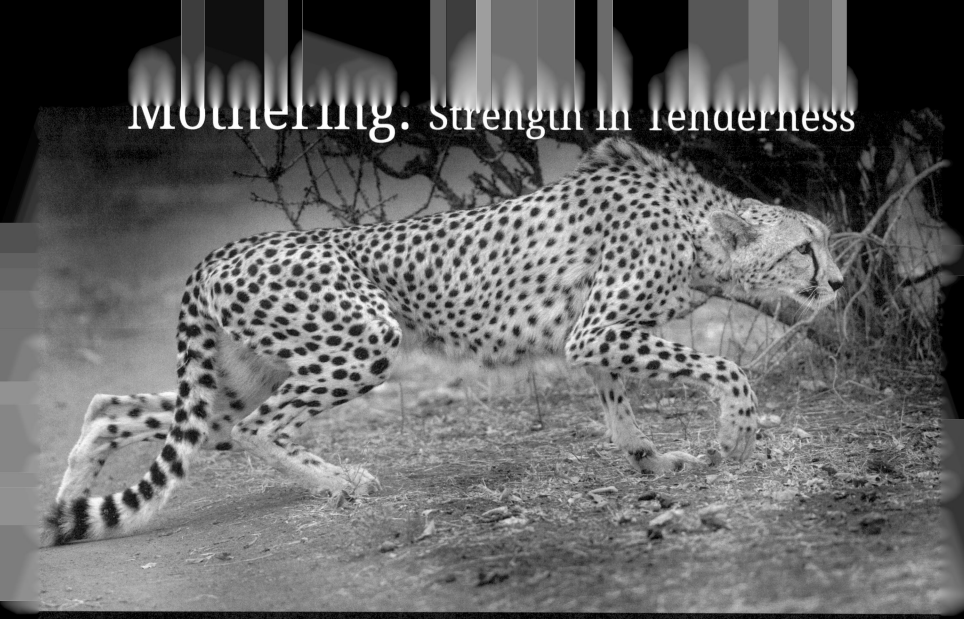

Watching mothers raising families in the wild teaches us about self-sacrifice. We saw a cheetah mom racing toward lions to entice a whole pride away from her cubs. She almost got caught but saved her babies who were hidden in the brush. In areas with many lions, 90 percent of cheetah cubs are killed while she is hunting. We saw this cheetah mom the day before, with her babies in tow. After she made two failed attempts to catch impalas, it seemed to me that she was sacrificing success in hunting for her cubs' safety. In the morning, we came upon her and her babies again. She froze and listened with ears standing to attention. Her cubs watched as she stalked quietly. Then, she became spots before

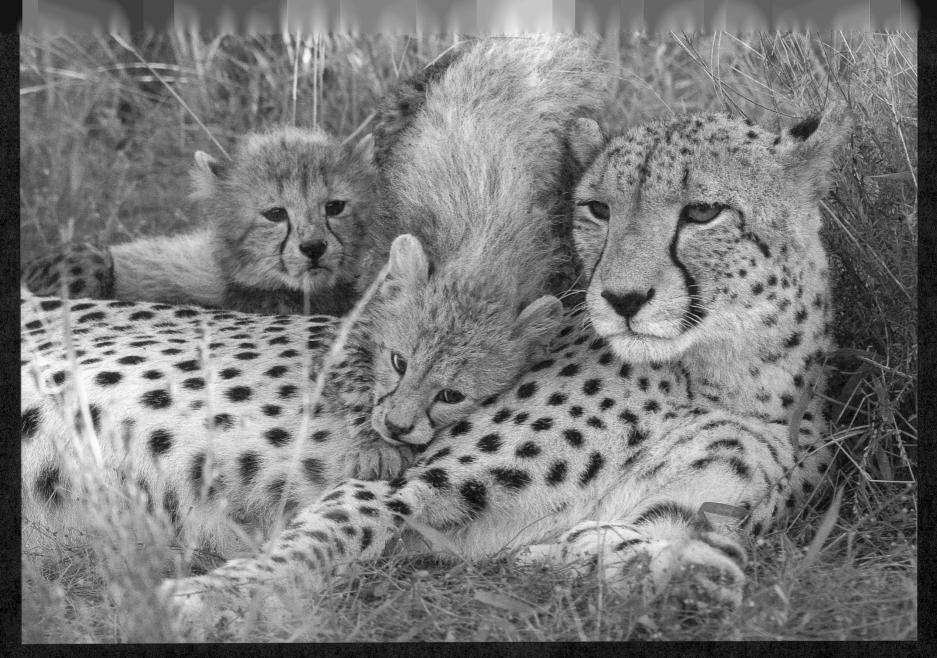

A cheetah's spots do not have openings the way a leopard's does. The black tear lines from nose to mouth minimize glare from the sun and are a kind of war paint when they snarl. We saw their teethy growl when a cheetah with a full belly was surprised by a hyena who sneaked up trying to scavenge a meal. The cheetah erupted with a hiss and swinging claws. They are built for speed, not for fighting. They lose many meals to

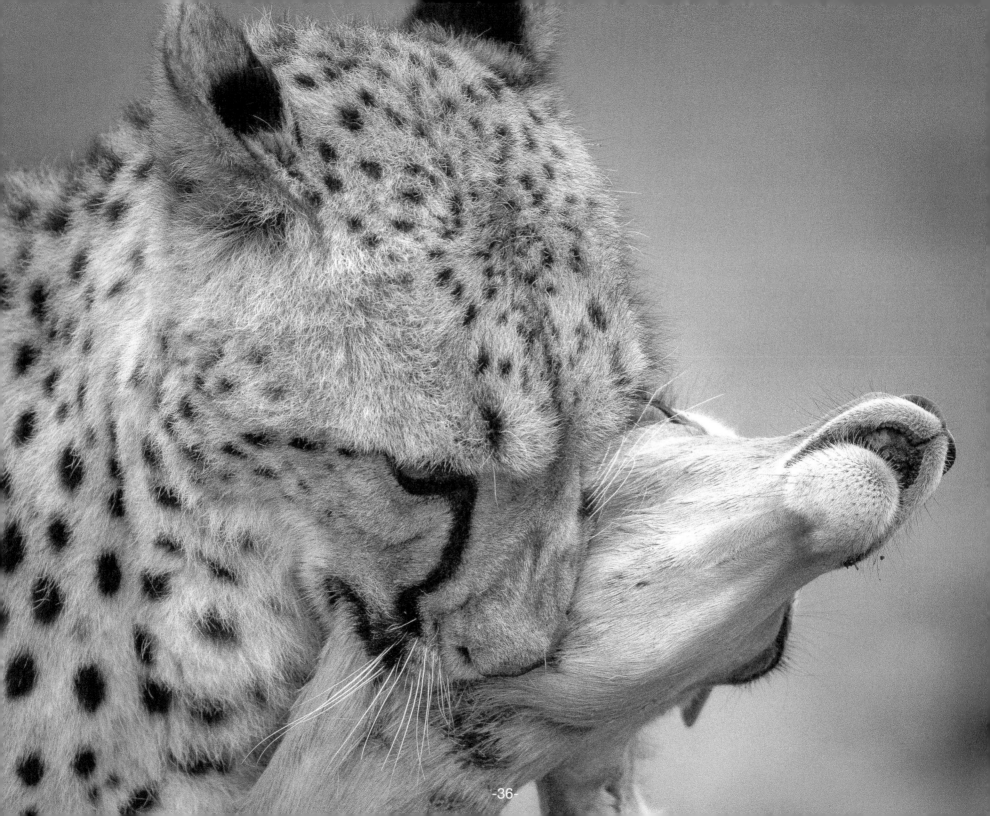

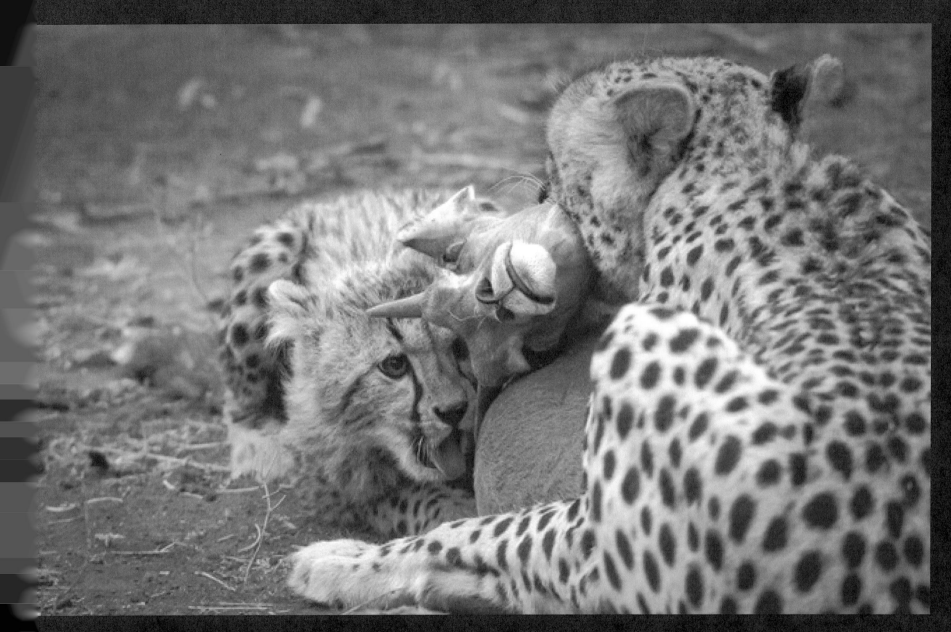

After mom caught their meal, one of the cubs tried to help her clamp down on the impala's windpipe. I focused on the cubs to distract myself from the horrific anguish for the impala. After the impala was dead, mom dragged the body into some shade. Mom's ears pivoted and her nose sniffed the wind as she checked for unwanted company. The other cub did a happy dance over their breakfast. Then their mother helped them open the impala's skin at the buttocks. Cheetahs have smaller teeth than other predators. Fed in captivity, they do not immediately have enough strength in their bite to kill an impala. Their jaw muscles are built up gradually since the time their mother teaches them to hunt.

A Leopard Mom

I had a song in my heart as our safari vehicle bounced through the South African bush to find leopards hunting at night. We watched Tamboti, a female, leap straight up a tree trunk holding an impala bigger than she was. Leopards lose 40 percent of their meals to hyenas and lions, so she had to get it out of their reach. She stopped every foot or so to rest. She must have used her energy for the chase and was depleted.

With her mouth, Tamboti dragged her kill out onto a limb. She was panting but had finally airlifted her meal out of the range of the competition. Blood glistened on her nose and snout as she secured the impala so it would not fall. Once she had it securely draped over a thick branch, we left.

In spite of all Tamboti's efforts, by morning, Paps, a huge male leopard, had stolen her meal. His face was wide compared to her more delicate one. Shafts of light from the rising sun cut through two small jackalberry trees. Dust particles danced in the air between them as Tamboti watched from the ground as Paps consumed her food. Tamboti seemed consoled by her daughter, who licked the blood off her face. According to our guides at the Mala Mala Safari Camp, Paps fathered Tamboti's daughter. I wondered if Tamboti accepted the theft as part of the gender roles of her culture.

Leopard Dads Sometimes Share

Over the next few days, after the kill got smaller, it was knocked to the ground. We watched a drama play out between father and daughter. When the daughter, mewing and whining, approached the meal, Paps growled at her, but it was a friendly growl in leopard-speak. He did, after many approaches, let her feed with him. The guides explained that although leopard dads do not help raise their children, they sometimes share a meal.

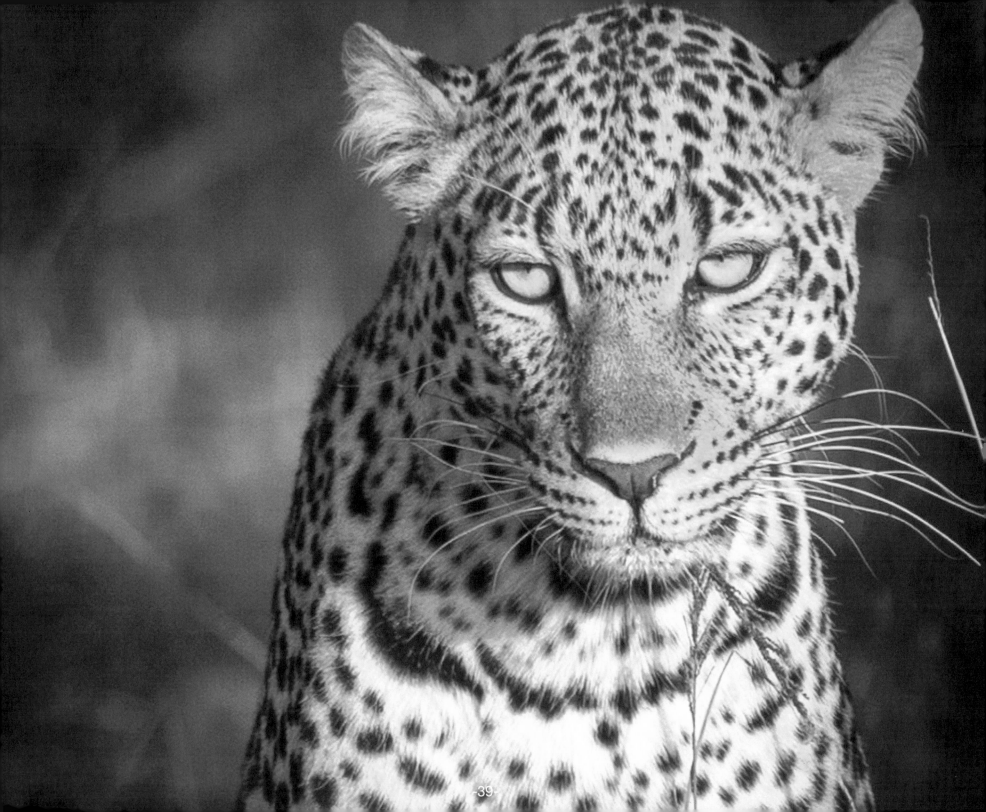

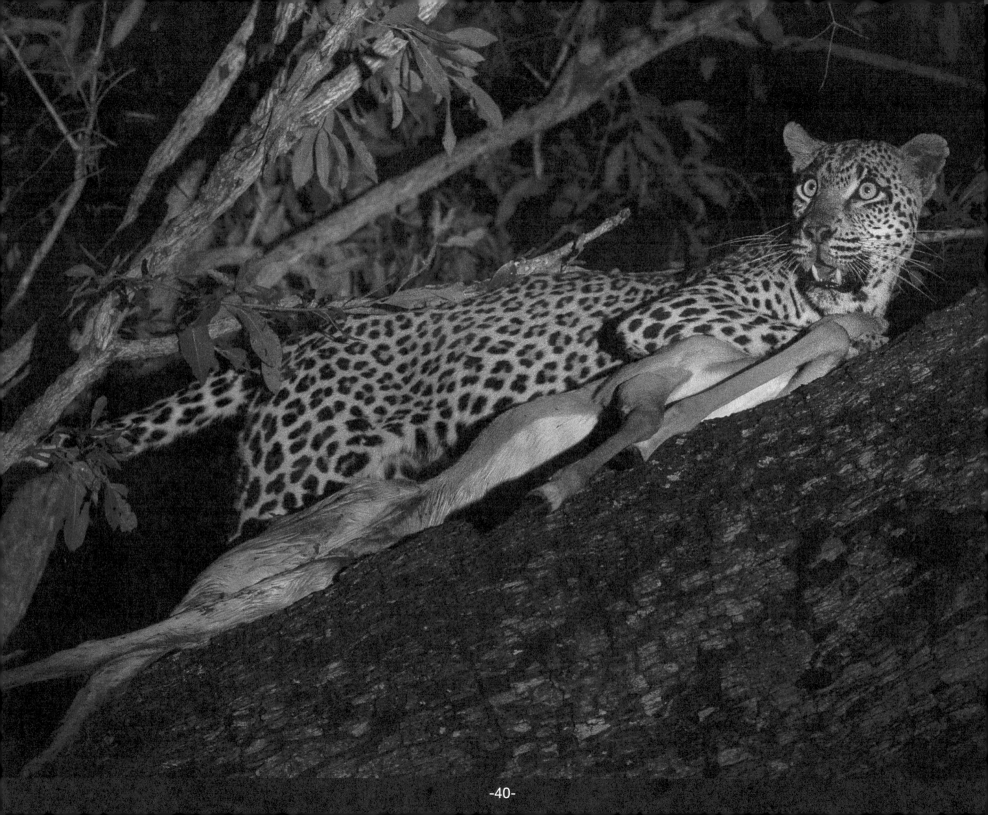

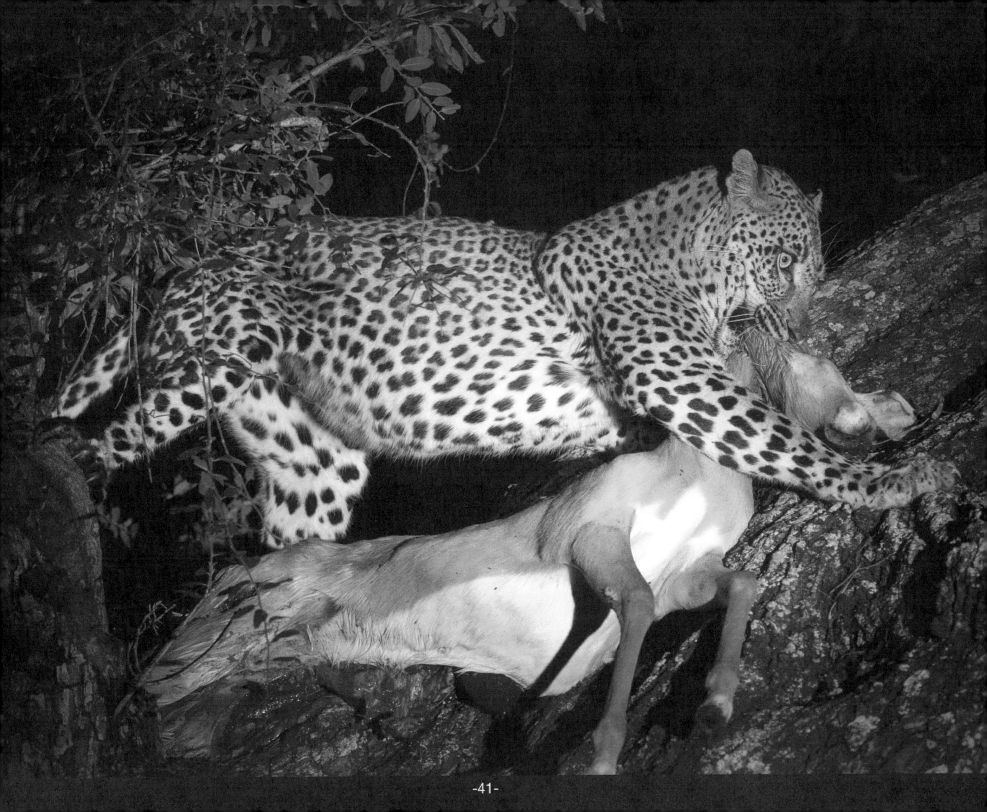

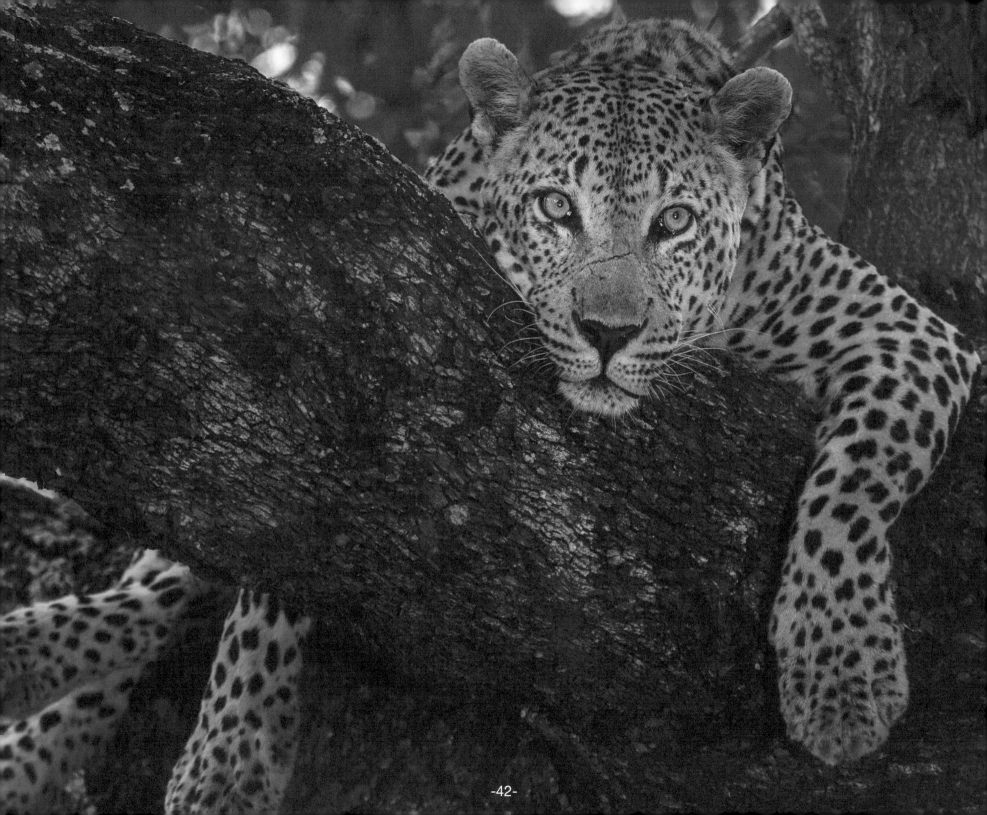

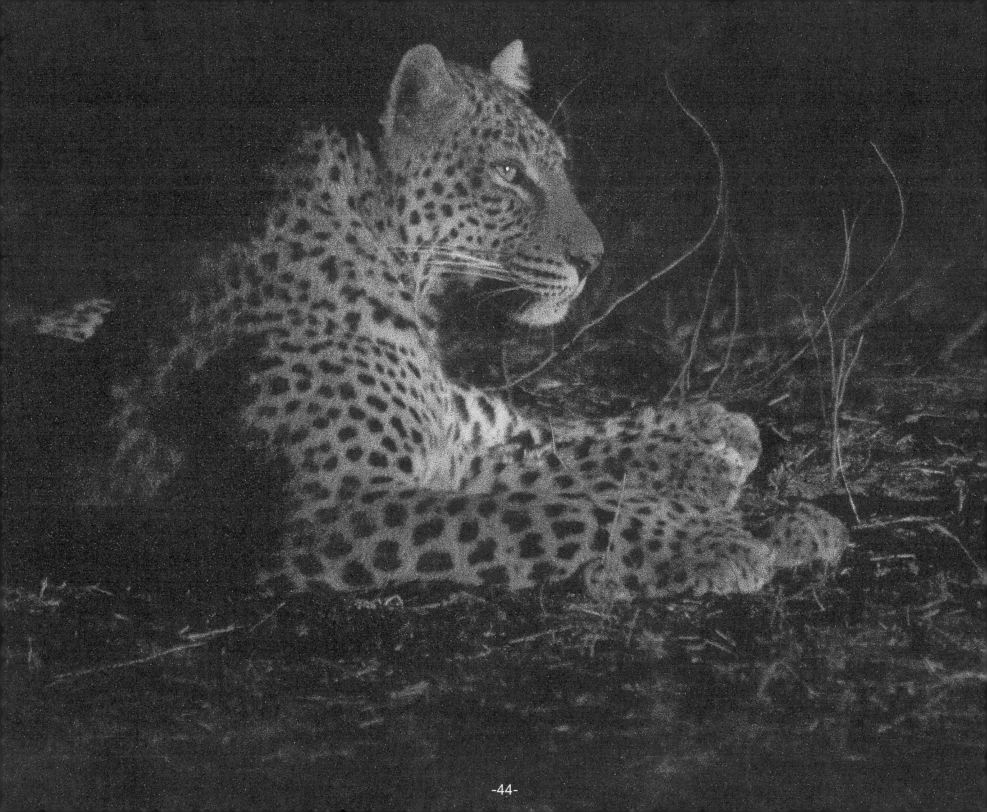

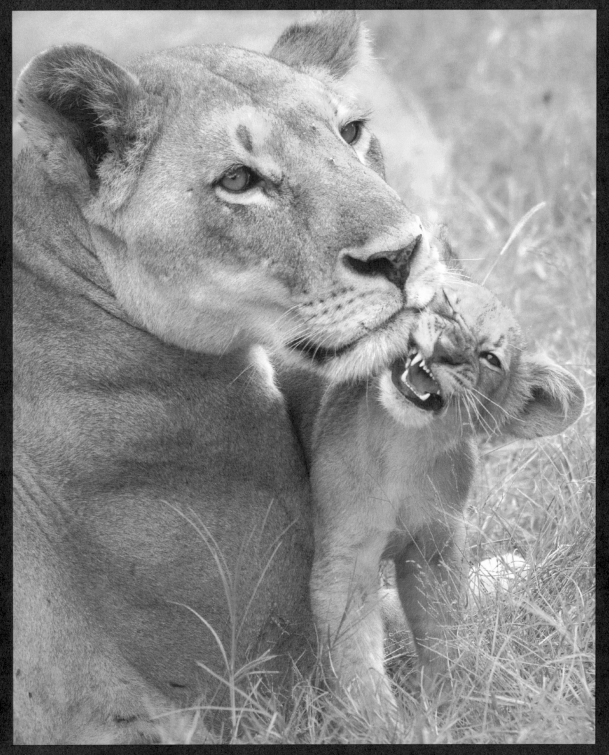

Loved-Up Lion-Style

Tawny Death Angels

Mothers tenderly licking their cubs quickly turned into tawny death angels. The love in their paws and tongue transformed into a survival instinct that urged them to snatch body after body for their own babies and the blood pulsing through them. When ready to hunt, their sleek bodies stretched. Whiskery faces yawned. Black noses lifted to a scent in the wind. Tufted ears rotated toward a sound beyond a clump of ebony trees. They are gifted with senses we have lost.

The one whose eyes sparked with delight when her offspring climbed on her head led the assault. Shoulders highest, head low, she crawled through the grass, side-stepping twigs that could crack. Her forepaws' bundle of blades were tucked away as she moved quietly like rain in the wind. We followed.

I felt the catch in her breath as she saw the antelope. Her face was focused, as was every fiber of her being. Her eyes were green-gold, as was the grass on her prey's tongue.

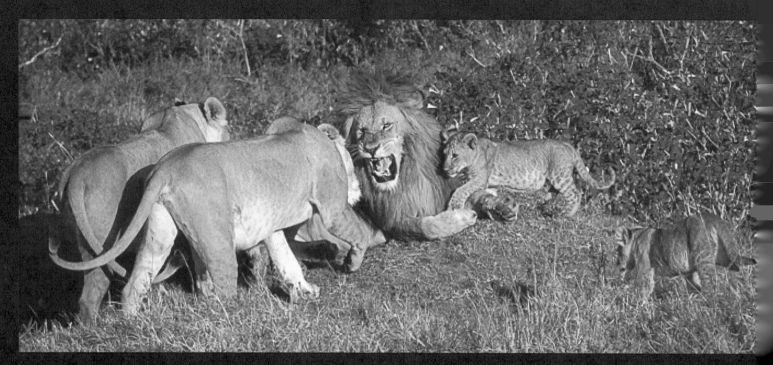

Balancing Male and Female Power

As females and their offspring came toward two males, the mothers seemed worried about the safety of their cubs. They approached carefully. We did not know the relationship between the males and females, but when males take over a pride, they are known to kill as soon as a little one approached a male, the females erupted into growls and hisses. Their warning was clear—maternal power was b and deadly.

I spent hours watching the Marsh Pride at the Governors' Camp in the Maasai Mara in Kenya. Motherhood was a constant lovefest of hugging, and allowing the little ones to climb on their heads, bite their tails, and suckle. The success of lion prides is the full expressi male and female qualities.

While males protected the family from invaders, females assured the survival of the next generation. They formed coalitions with othe and synchronized estrus so if a mother died, her cubs suckled from other mothers. Lionesses also provided most of the food for the r we correct our estrangement from the natural world, it is crucial we restore the balance between male and female energies.
Societies that temper male dominance with the nurturing qualities of females are more successful. Gary Ferguson, in *The Eight Maste of Nature*, says healing the planet requires us to recover our feminine qualities. He says it was a calamitous misstep when humans ch culine energy, which values dominance as our chief guide. "The success of elephants, wolves, and lions and countless other species

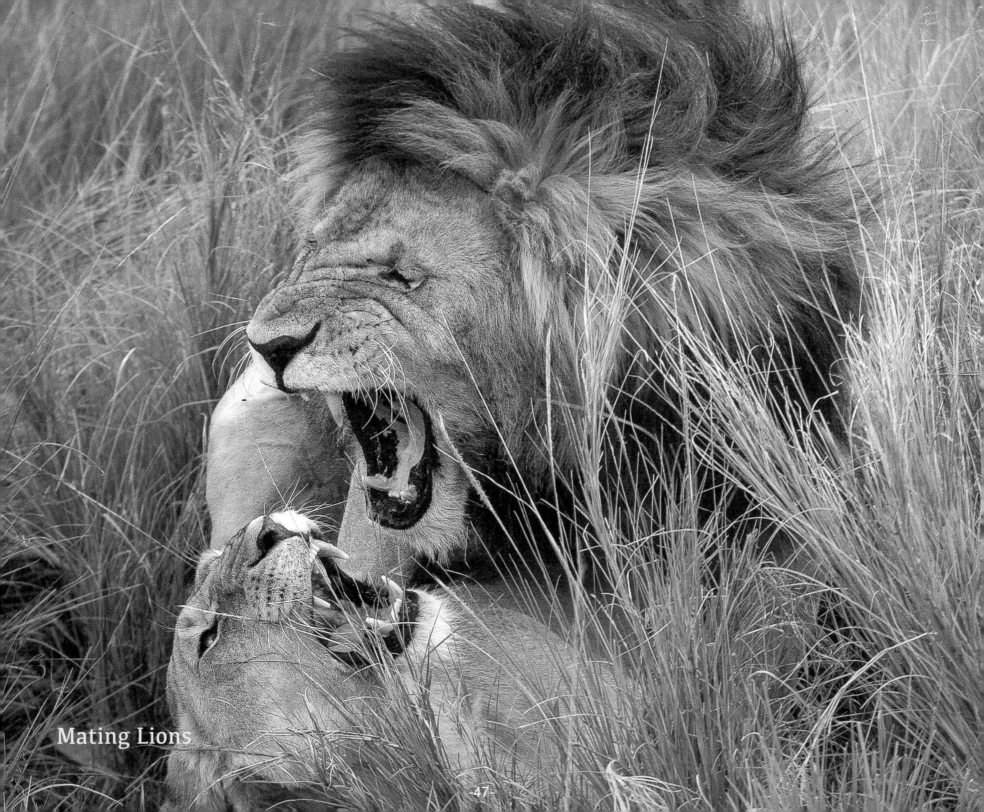

Mating Lions

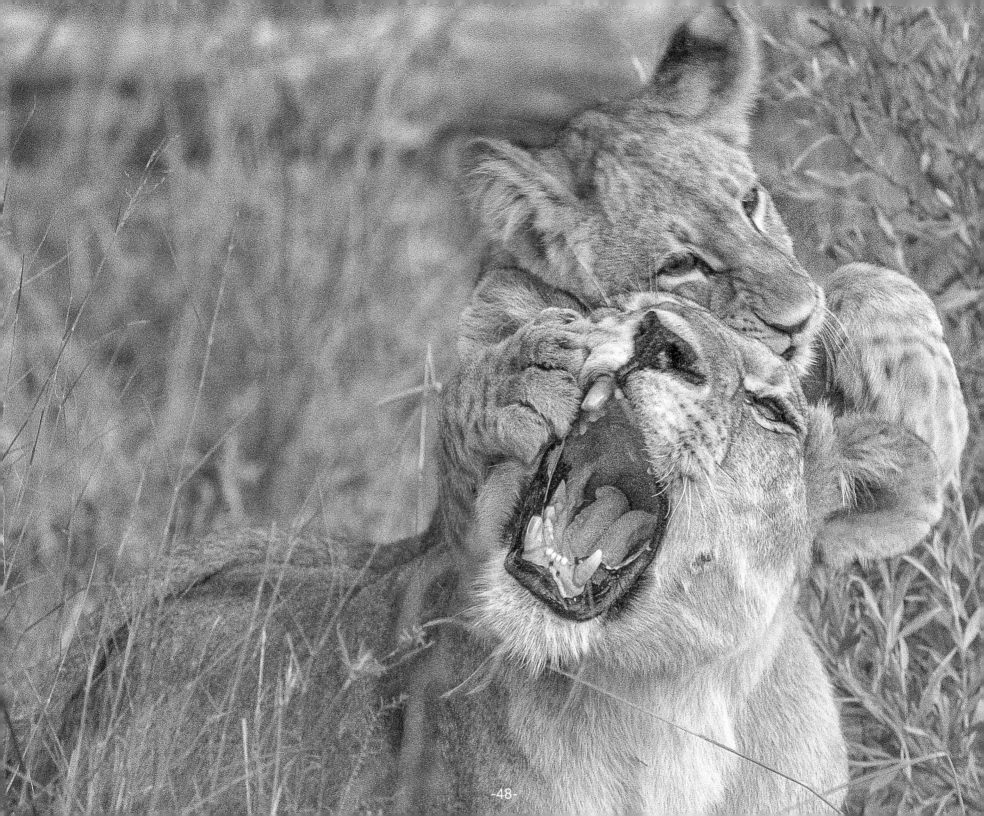

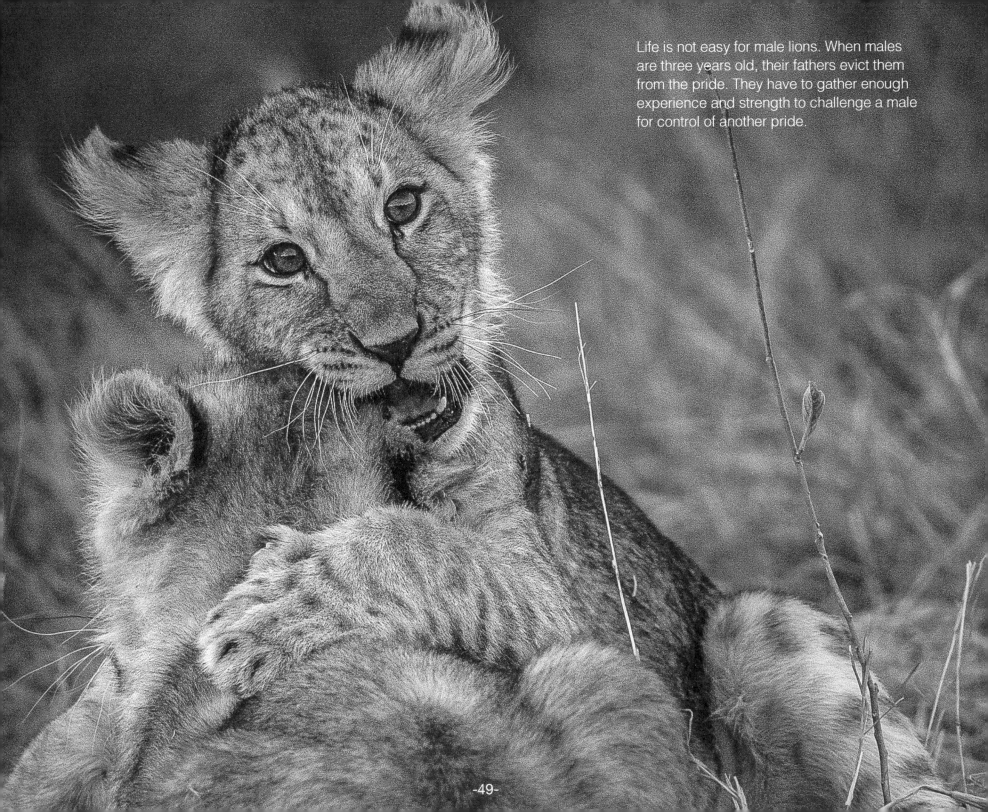

Life is not easy for male lions. When males are three years old, their fathers evict them from the pride. They have to gather enough experience and strength to challenge a male for control of another pride.

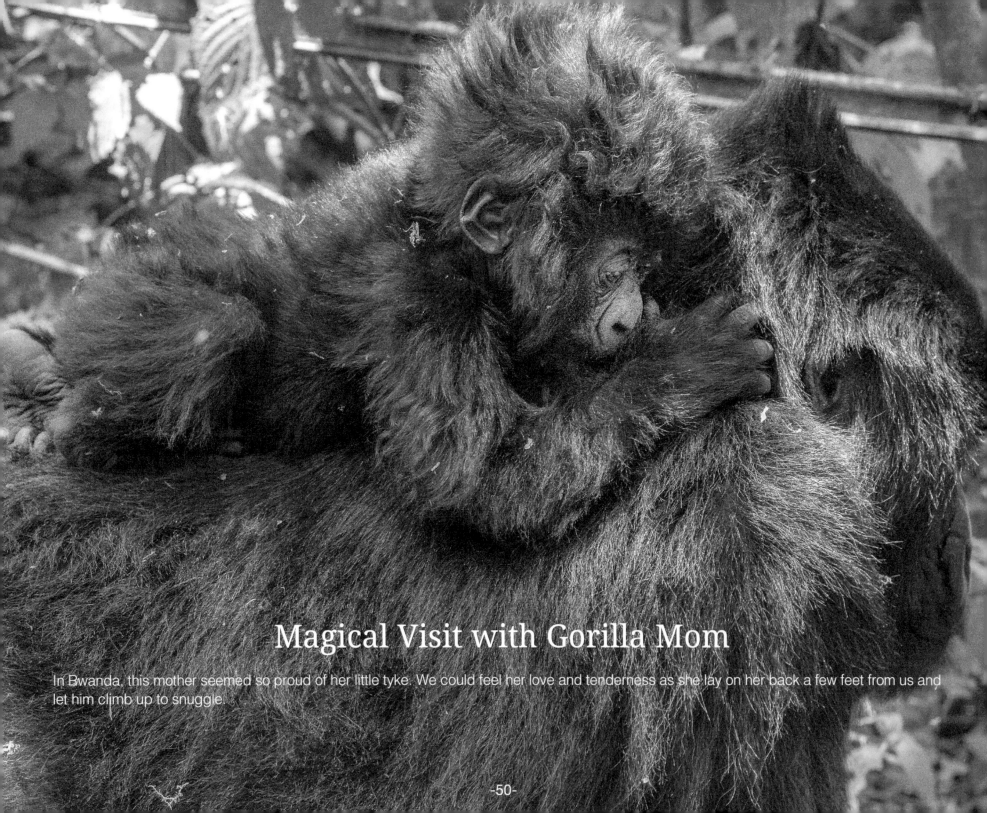

Magical Visit with Gorilla Mom

In Rwanda, this mother seemed so proud of her little tyke. We could feel her love and tenderness as she lay on her back a few feet from us and let him climb up to snuggle.

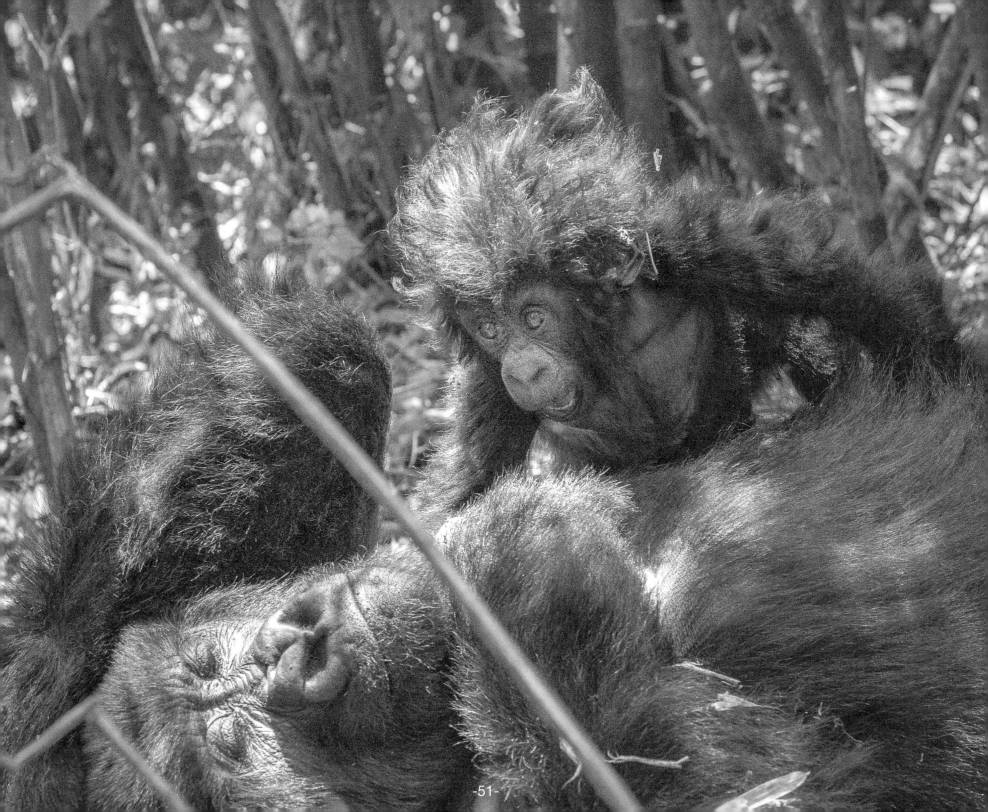

Mom and Baby Gorillas' Feet

Along with two other women, I sat down to capture two juveniles tumbling over each other. Backlit by the sun, they chased around a thicket of trees, then swatted and jumped on each other. One climbed a tree and then the game began again. Behind them, emerging from golden light, a mother, with a baby tucked under her arm, approached. About six feet from us, in the shade, she lay on her back as the baby scrambled up to snuggle.

There were other places flat enough to lie and cuddle her baby. Through previous encounters with humans, she may have sensed the excitement females have for babies. I felt her pride in my bones as she presented her baby boy to us. With a curly wild top knot, he glanced at me before zeroing in on his mother's face, the sun of his world.

Finely tuned to each other, after a long hug, they both seemed to glow. Then, she picked him up under his arms and enabled him to climb on her back.

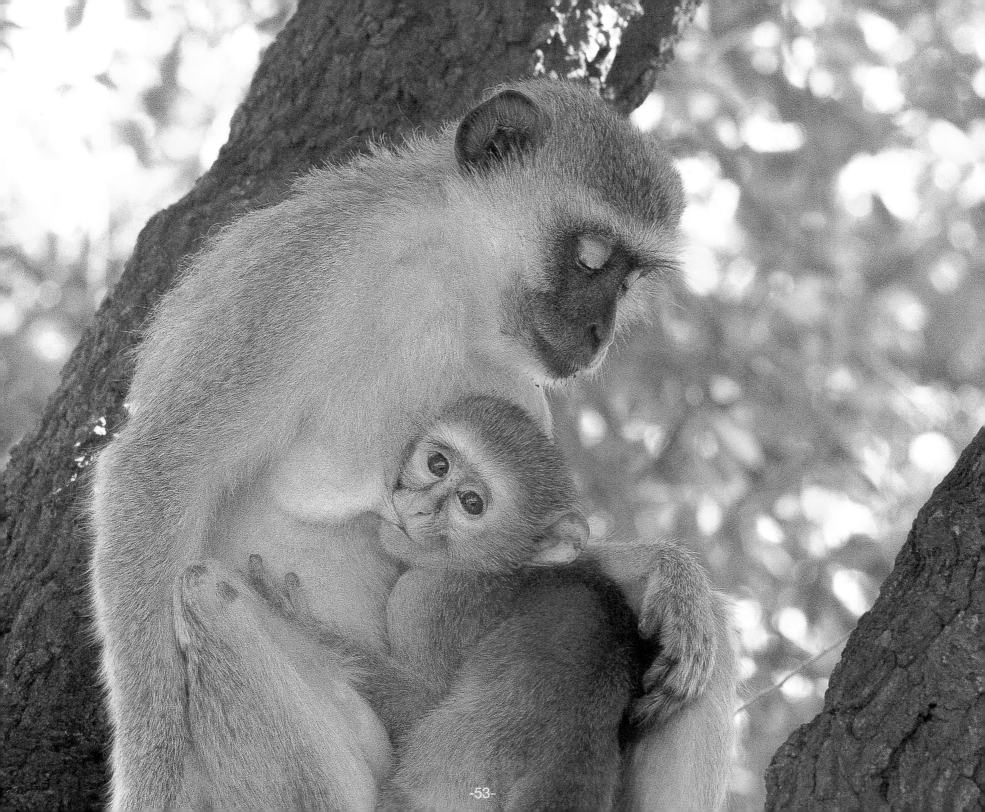

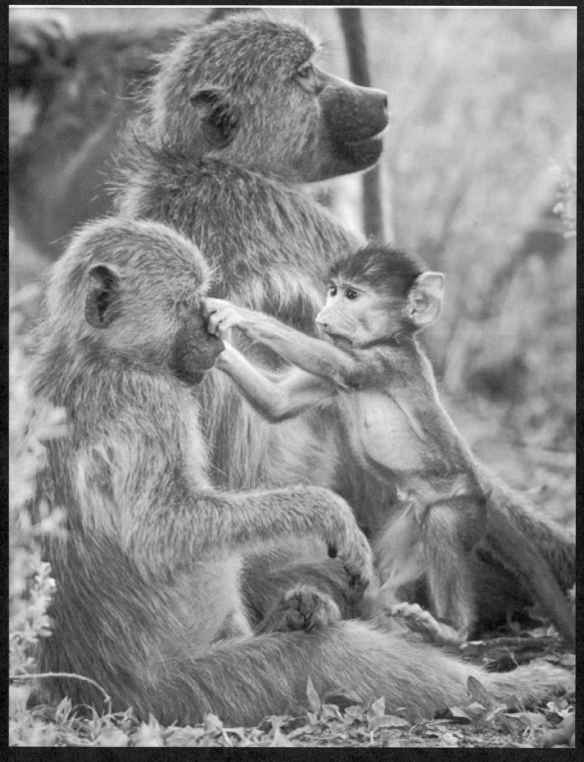

Our greatest strength
lies in the gentleness
and tenderness
of our heart.

— Rumi

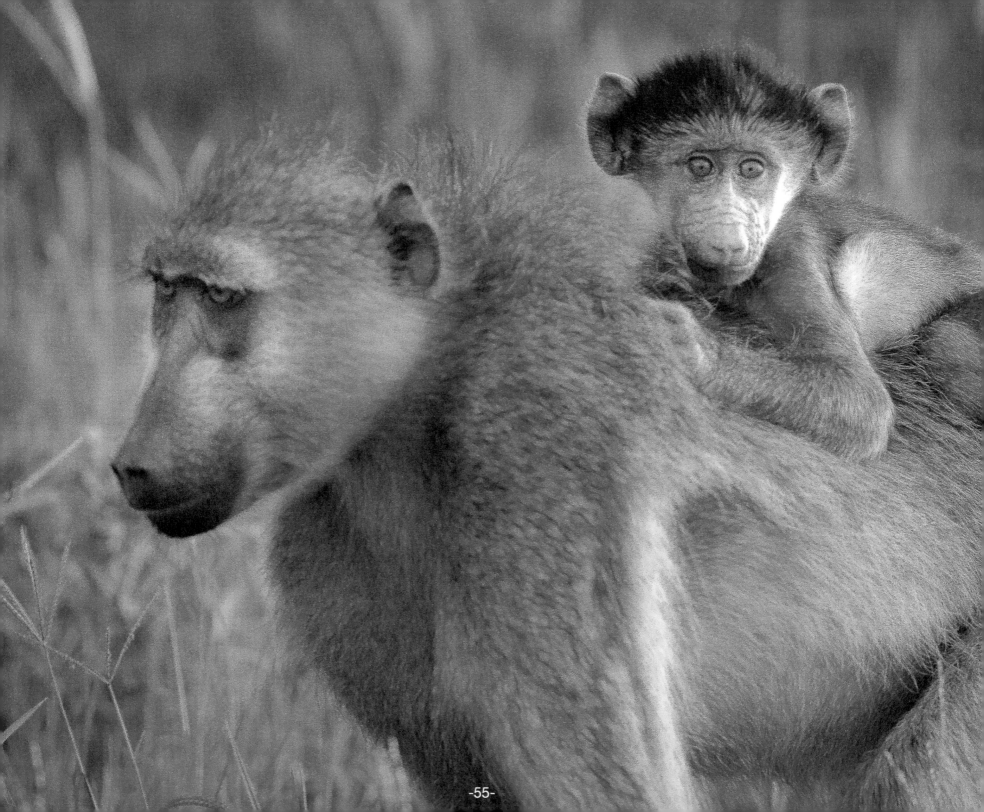

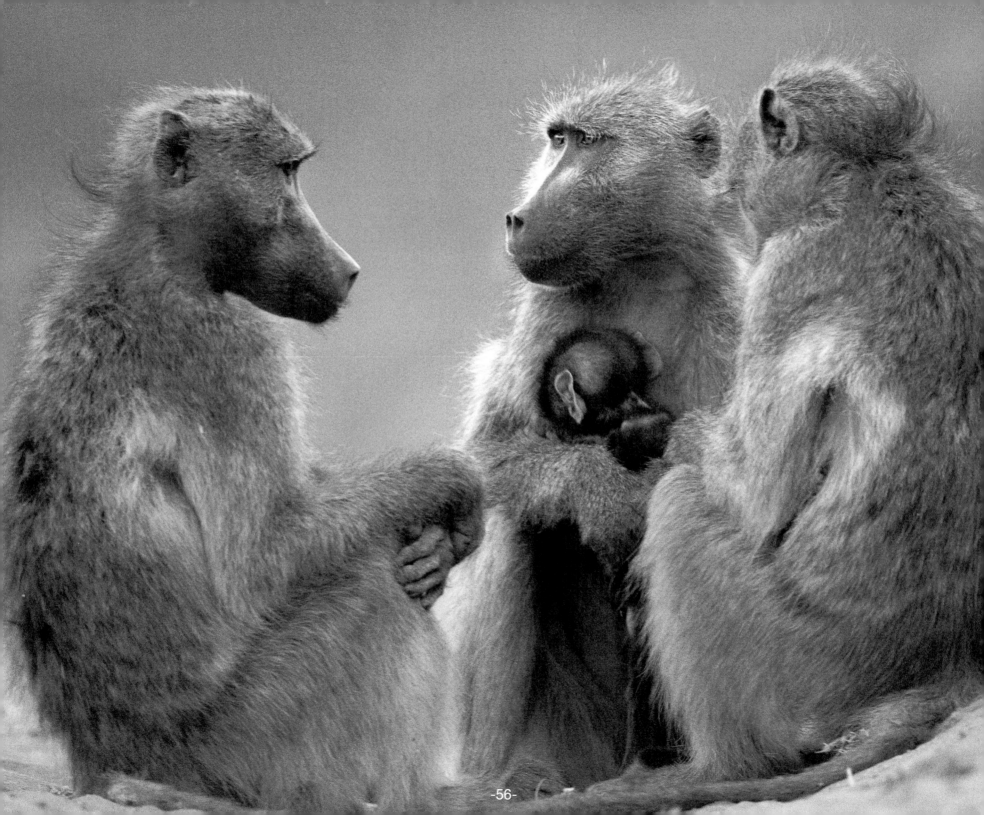

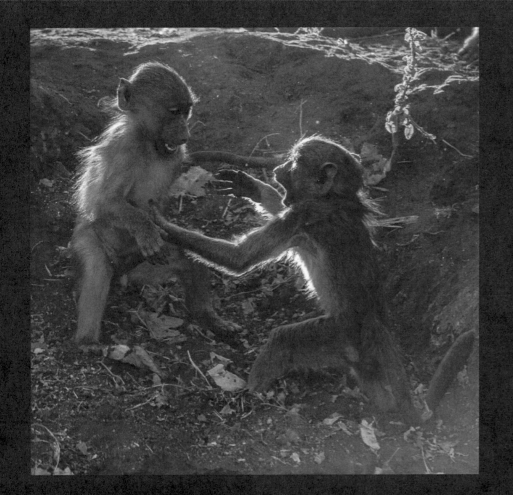

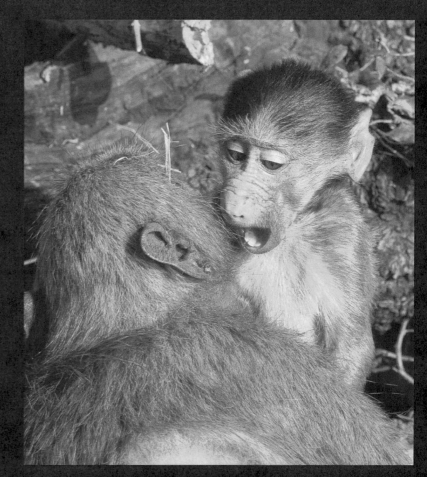

"Then he bit me and it really hurt."

As historian Lewis Namier says, "In every act of kindness we hold in our hands the mercy of our Maker, whose purposes are in life and not death, whose love does not stop at us but surrounds us, bestowing dignity and beauty and hope on every creature that lives and suffers and perishes . . ." Like the Earth Mother herself, mothers shelter, guide, and nurture life.

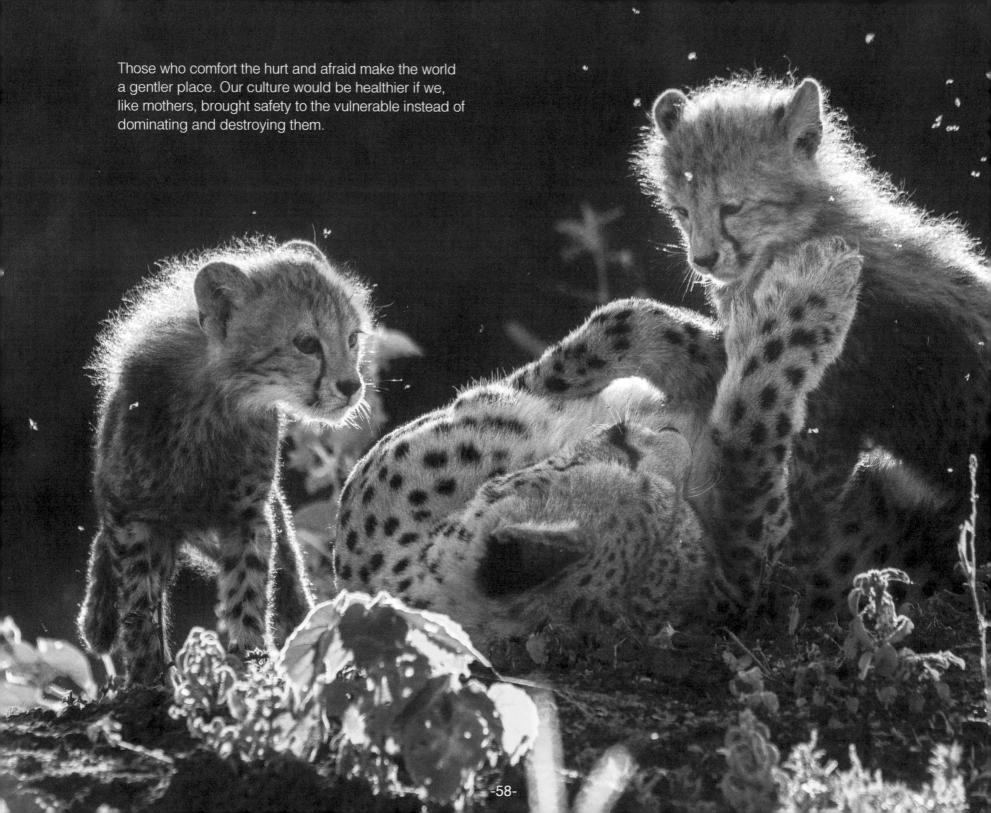

Those who comfort the hurt and afraid make the world a gentler place. Our culture would be healthier if we, like mothers, brought safety to the vulnerable instead of dominating and destroying them.

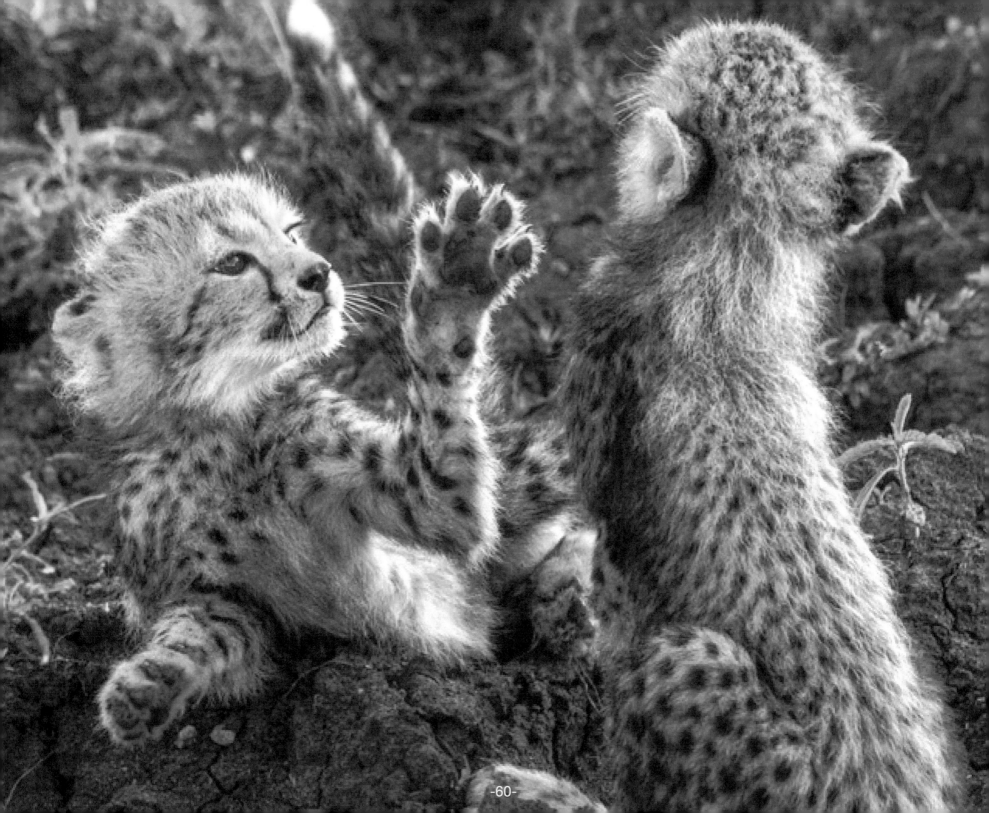

Part 3
Enchanted Encounters

Spotted Ghosts

Leopards know the art of camouflage. Dark rosettes dot their yellow coats so they look like branches and leaves. They are sly loners—a dappled haunch in a baobab tree before they erupt in lithe power. They slink through trees and brush like a ghostly mist, appearing and disappearing magically. Trees are a vital refuge for them, both as a disguise and as a retreat from attacks by lions and hyenas. Although trees provide some protection for cubs, the canopy is invaded by baboons who kill tiny leopard babies. My first lengthy visit with a leopard cub was near the Mombo Camp in Botswana, deep in the Okavango Delta. In a Land Rover with wildlife photographer Grant Atkinson, we plowed over bushes and crashed over dead trees until we found Legadema, star of *The Eye of the Leopard,* and her new cub.

The Eye of the Leopard tells the story of the first four years of Legadema's life. The filmmakers, Beverly and Dereck Joubert, spent many months with Legadema and her mother, Tortillis, who had lost five previous cubs. Named for the Acacia tortilis treetops she hid in, Tortillis could move from total relaxation on a limb to flinging herself off and onto the neck of an impala below. Legadema became so habituated to their vehicle following her that at one point when the Jouberts held back, she waited and called to them in a squeaky replica of her mother calling her. After a loud storm terrified her enough to seek shelter under their vehicle, she was named Legadema, which means light from the sky or lightning. Identified by a single stray just under her top row of whiskers, she was mischievous and refused to conform.

Mombo is on the biggest island in the Moremi Game Reserve, where the film was shot. A dramatic part of the film was the cub's narrow escape from an attack by baboons while she cowered under some logs. She also evaded a pride of lions by scampering up a tree just in time. A prolific squirrel hunter, she made acrobatic leaps through branches to catch them. The most tender part of the film was a scene of the leopard cub softly caressing a just-born baboon of a mother she had killed. Legadema's maternal instincts were aroused by the pink-faced baby

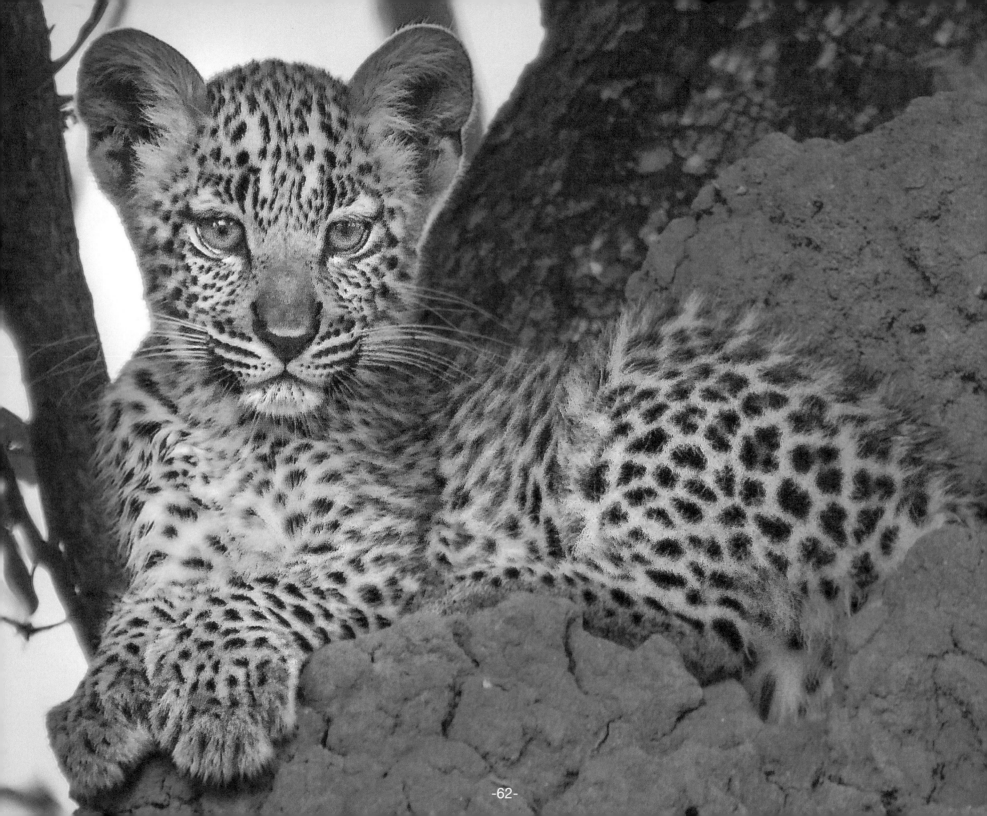

Legadema's new cub stalked her mother's tail, pouncing on it, batting it, and clawing it with tiny paws. After licking, hugging, and nursing her son, the new mother slept. The cub pounced around tree branches, practicing skills he'd need to evade baboons and other predators. Then he became fascinated with us. With a wide-eyed and curious stare, he peered down at our Land Rover. Lenses pointed at him. Click, click, click. His mother's calmness told him we were safe.

The wind brought in smells that lingered. A flurry of birds twittered that predators were approaching. Distant monkey calls signaled a warning between mother and son. Some tacit visceral communication encouraged the cub to scamper down the tree. His furry little body crouched low as he raced to the underbrush. The tiny cub blended into the tangled web of branches, a space too small for an adult lion, hyena, or baboon. Unlike lions, whose sisters care for the cubs while they hunt, leopards have to leave their babies for hours while they get food.

Hunting with the Moon

Later that afternoon in the library at Mombo Camp, I found *Hunting with the Moon*. Fifteen years earlier, I used photos from the book to paint a series of nocturnal lions. The book is by Beverly and Derek Joubert. Goosebumps went through me. When I had earlier abstracted paintings from their images, I didn't notice the authors who I just realized filmed *The Eye of the Leopard*. That I'd unknowingly been painting from photos by the filmmakers felt like some unseen hand choreographing me. An eerie force seemed to lead me to one of the most remote areas in the world.

My next encounter with leopard cubs was in February 2013 at Mashatu Game Reserve, in a remote corner of Botswana, converging with South Africa and Zimbabwe. Our guide, Bashi Petane, a huge black man with an easy smile, asked me what animals I wanted to see. "Leopard cubs," I said in jest as I felt finding them would be impossible. He drove to the edge of a riverbank where a large tree had fallen into the dried riverbed below. The root structure was a tangled web of tiny branches.

"Two leopard cubs are in there—a boy and a girl. They are probably looking out at us. When it is safe, maybe under the cover of darkness, their mother will lead them to her kill." It was the perfect home for cubs. There was no way predators roaming around could get to them.
The next morning, Bashi drove straight down the embankment while we kept our camera gear from flying out of the vehicle. We followed miniature leopard tracks to a tree where a small dead kudu was draped over a limb. On branches, both cubs investigated us as our vehicle cracked twigs under the tires. There's a timid and tender edge to connecting with babies in the wild. We could have gotten closer but gave them space.

The female had possession of the carcass and resumed eating while the male, a few branches below, meowed his impatience for his turn. When he began to climb up, she let out a loud, guttural growl. Her sweet, furry face became all teeth in imitation of the killer she would one day become.

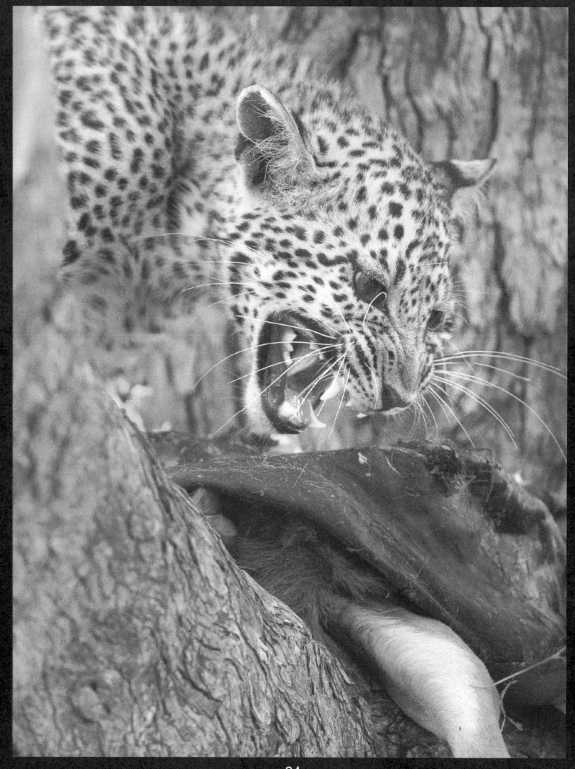

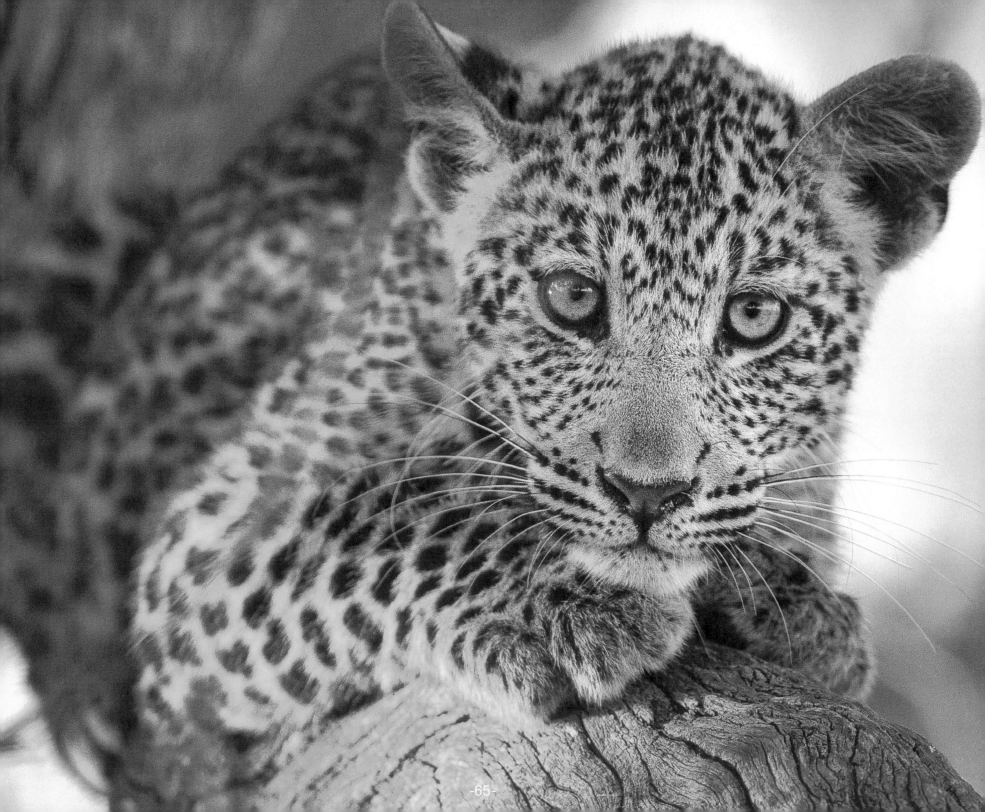

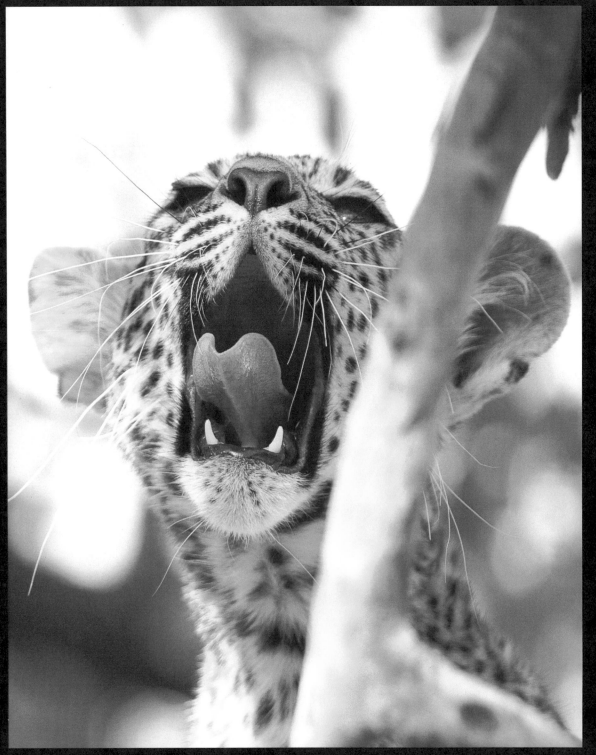

There's a timid
and tender edge to
connecting with
babies in the wild.

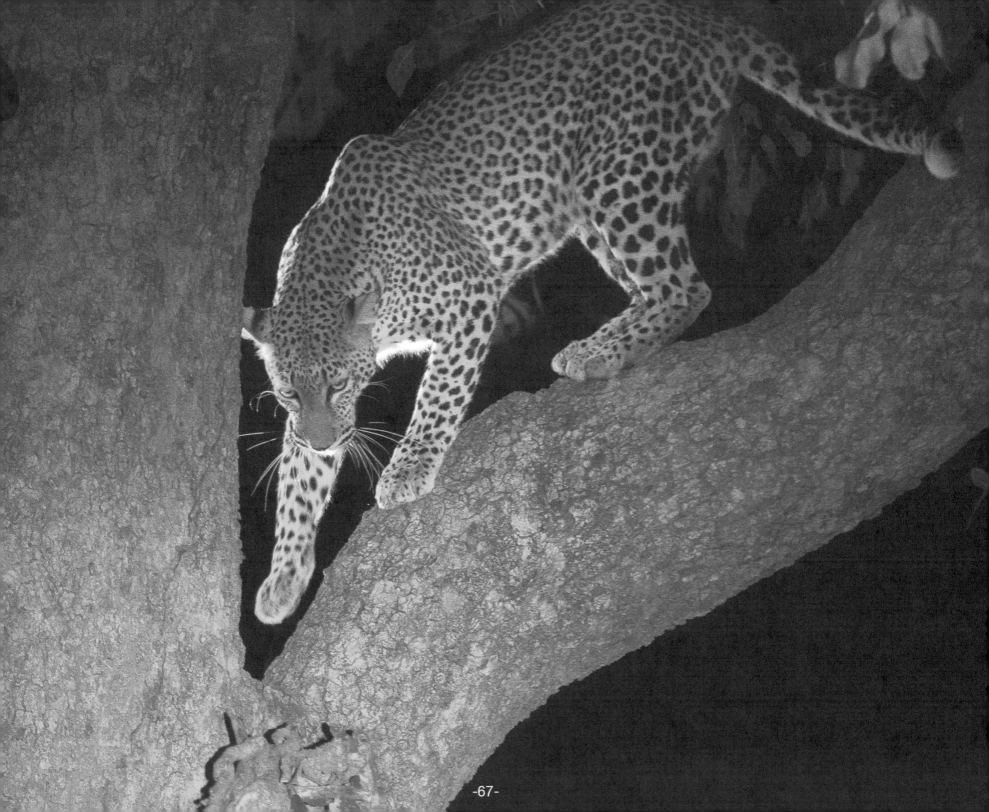

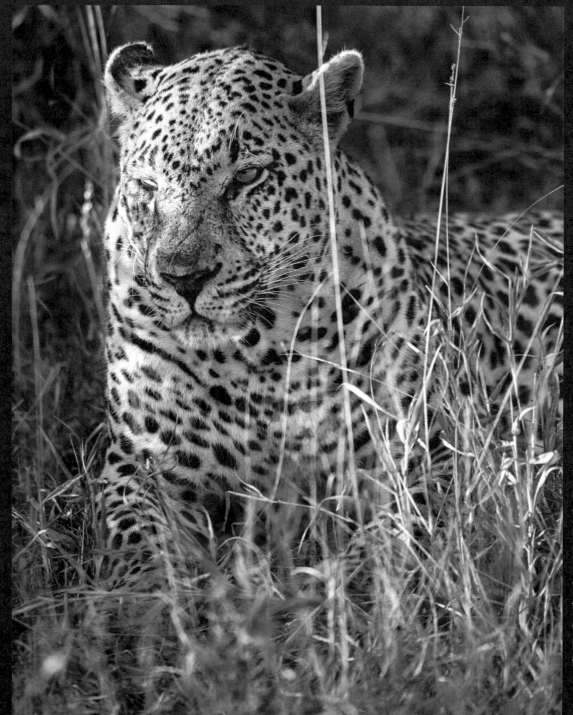

Epic Duels for Territory

As people push wildlife into smaller patches of land, battles over remaining hunting grounds are fierce. Bike, the fourteen-year-old dominant leopard at Mala Mala Safari Camp had an ongoing struggle to defend his territory from Treehouse or Tree, a five-year-old.

At first, we saw Bike stalking an antelope until he smelled his competitor. With fire in his eyes, Bike forgot his prey. Jaw clenched, nose to ground, he zigzagged in pursuit of Tree, who'd been doing figure eights through Bike's property. Bike growled and coughed his displeasure at Tree, who used our vehicle to hide.

When Bike found him, the fight was loud and vicious. In the flurry of swinging claws, Tree tried to blind Bike. A deep red line from a claw came from Bike's eye. It bled profusely, but he could see. Bike licked his wrist and cleaned his eye with saliva.
The two leopards settled into grass, yards apart. For hours, they hissed and coughed about who owned the territory. Between conversations, they exchanged mean looks and urinated while growling and posturing.

With saliva from the back of his paw, Bike continued to clean his eye, which was swollen shut. Our guides explained that Bike was still strong enough to hold his territory but that at some time in the future, he would be unable to.

Bike Was Wounded Defending His Territory

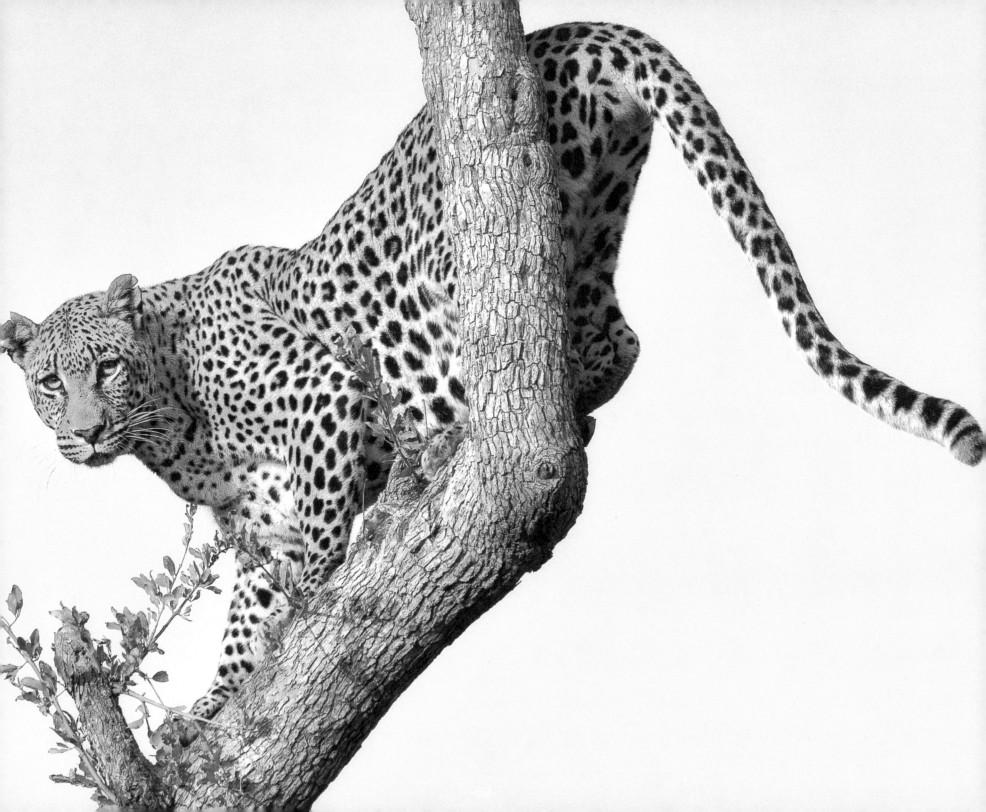

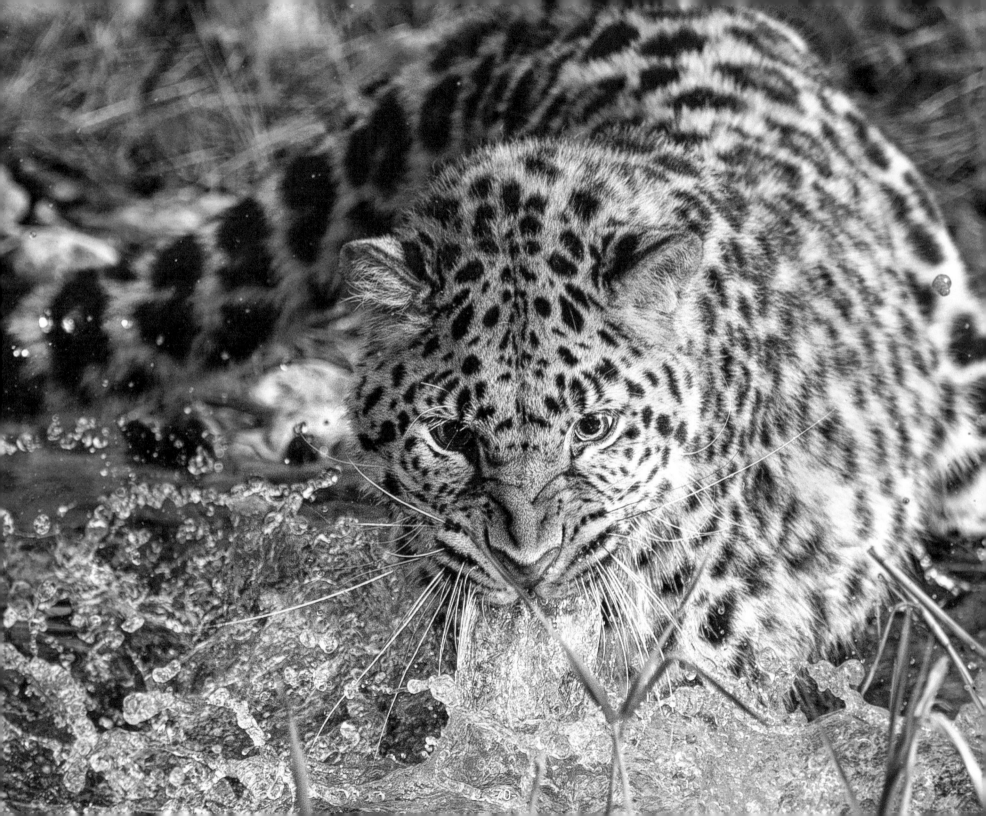

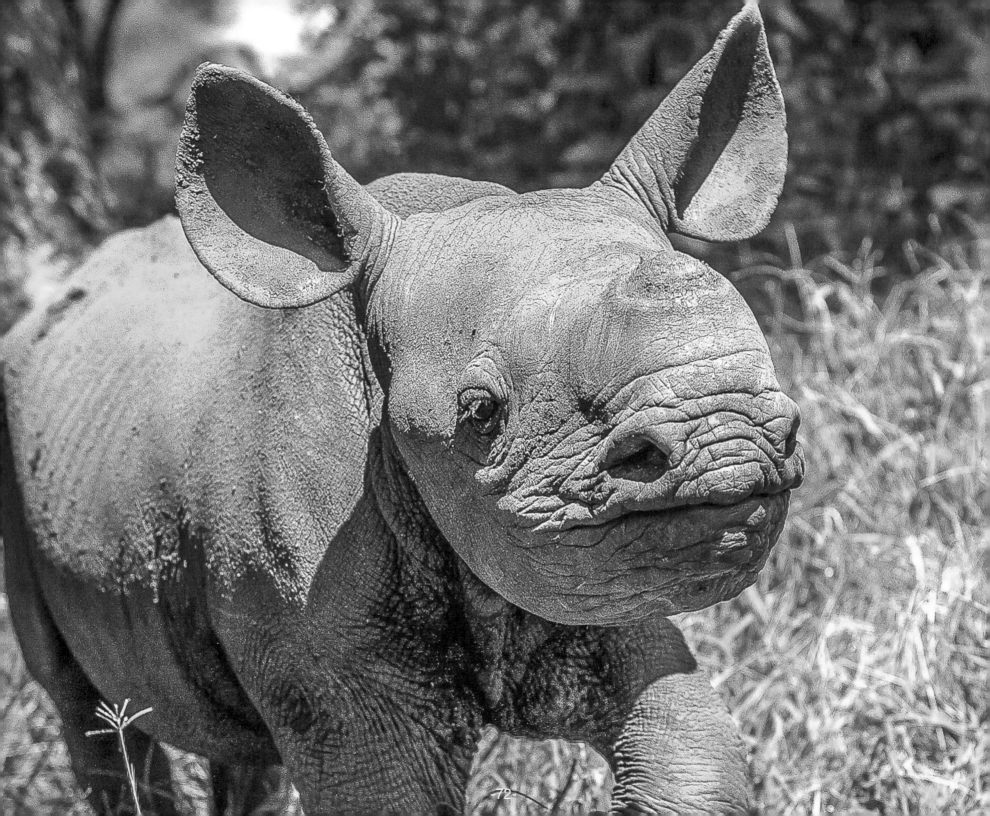

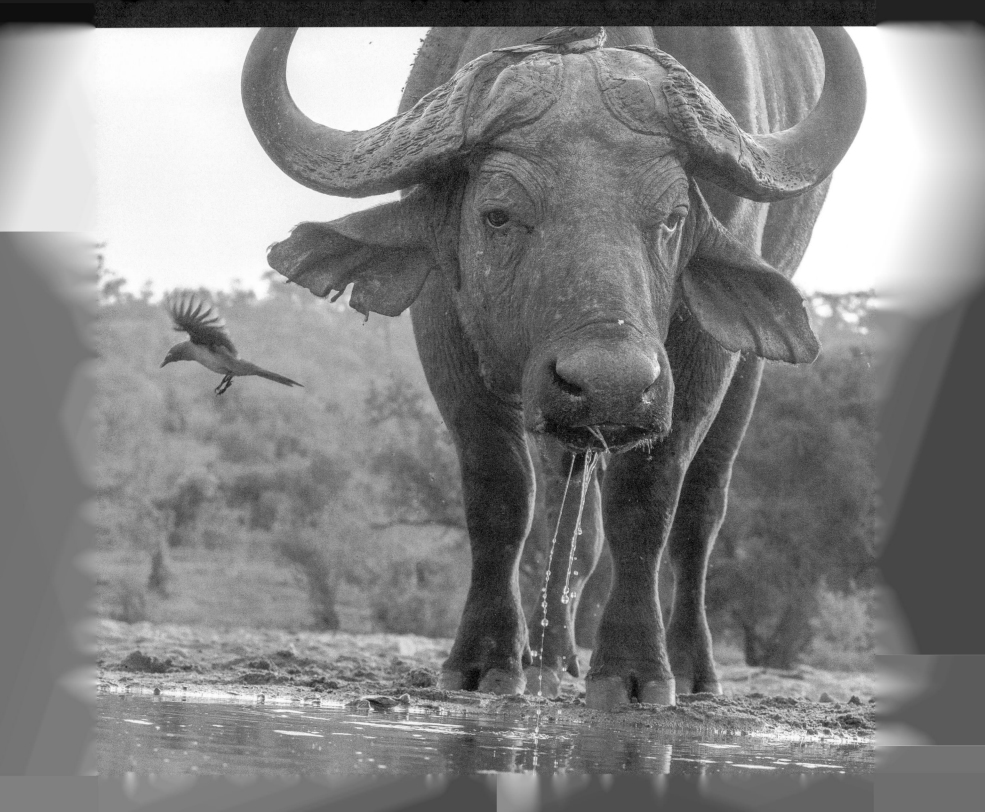

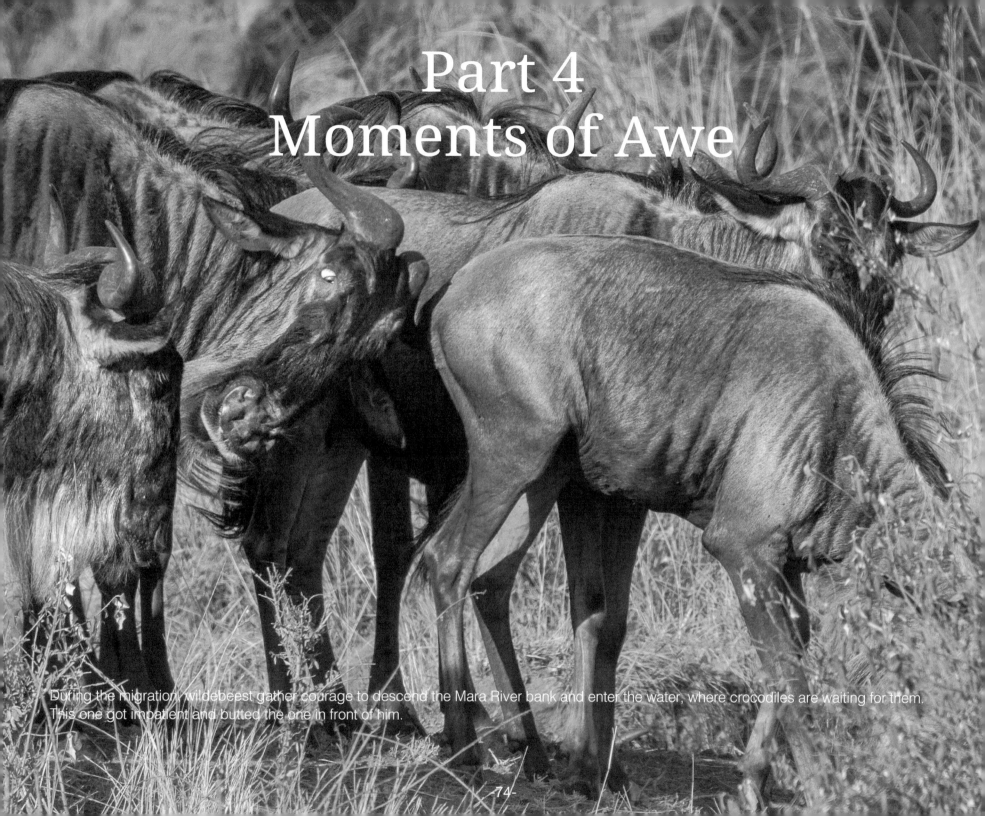

Part 4
Moments of Awe

During the migration, wildebeest gather courage to descend the Mara River bank and enter the water, where crocodiles are waiting for them. This one got impatient and butted the one in front of him.

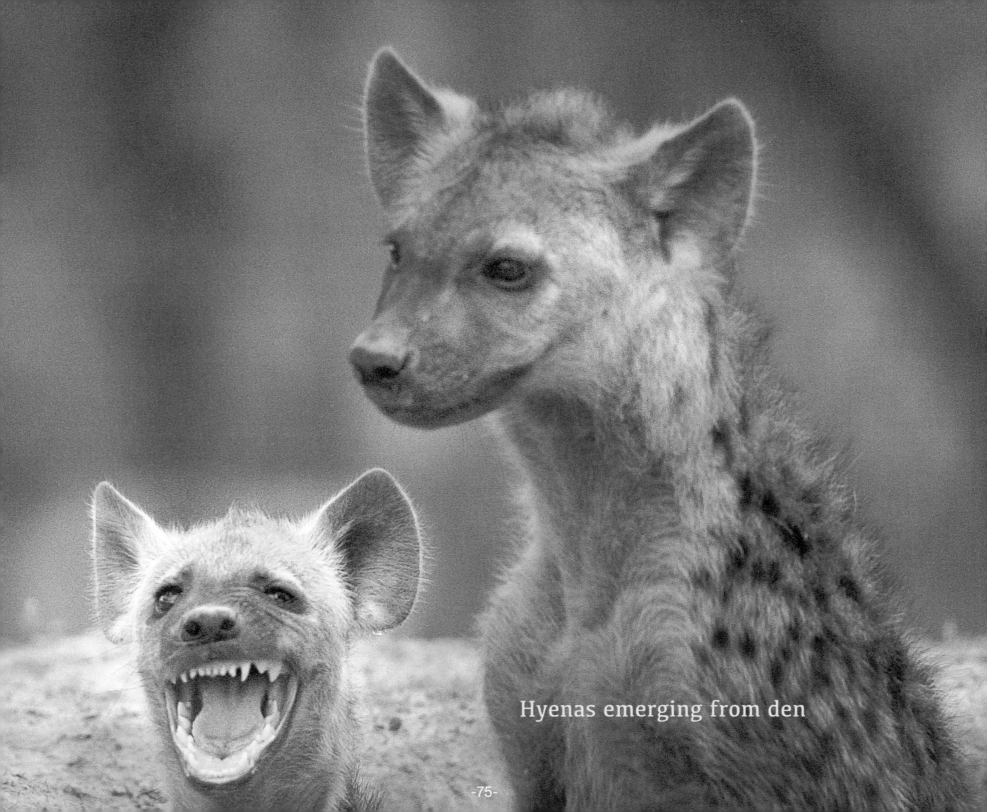

Hyenas emerging from den

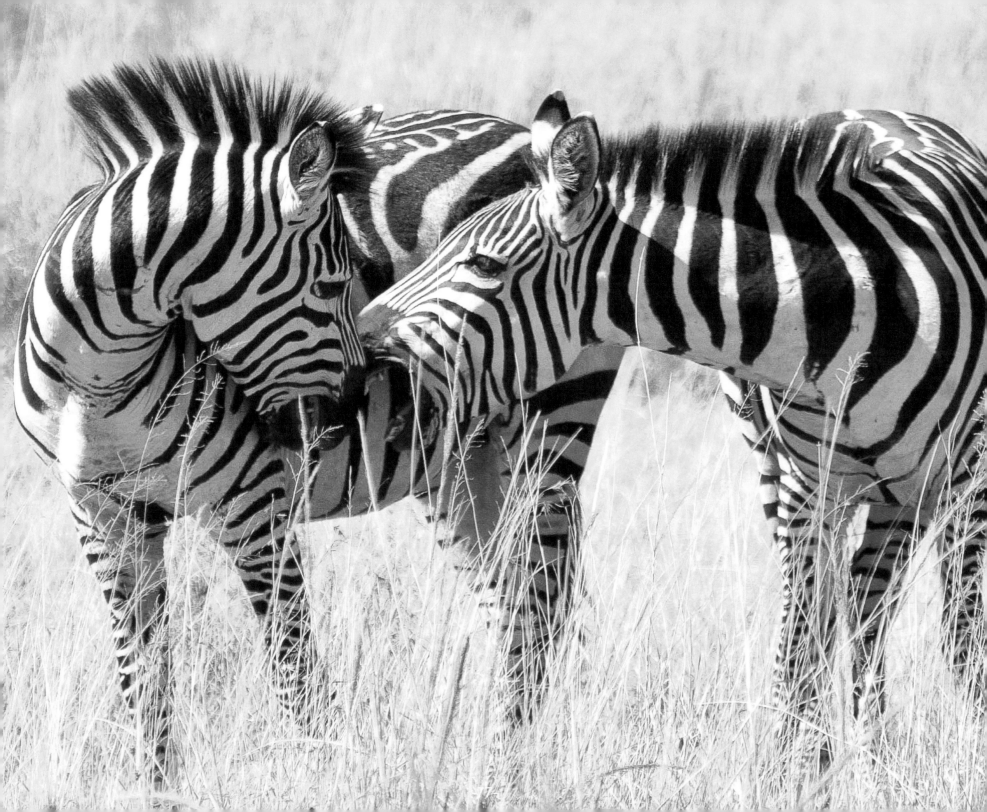

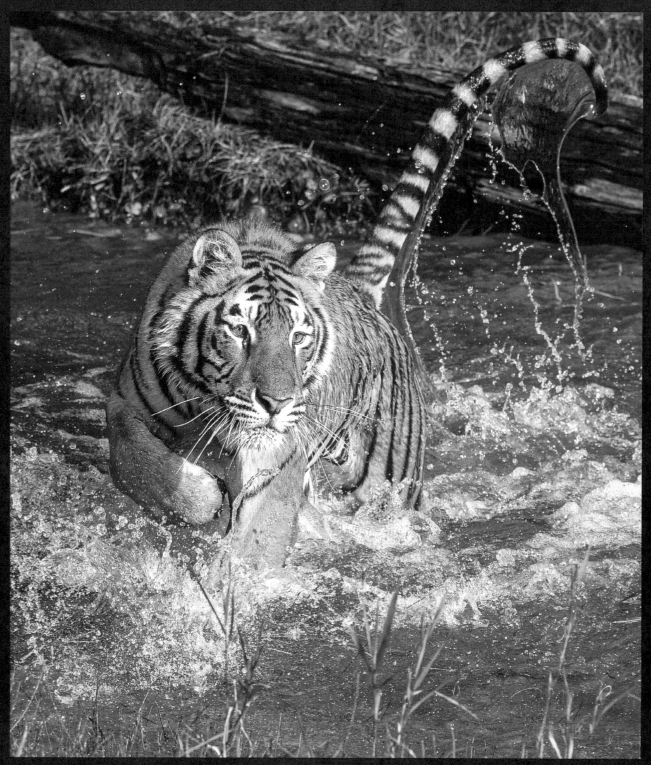

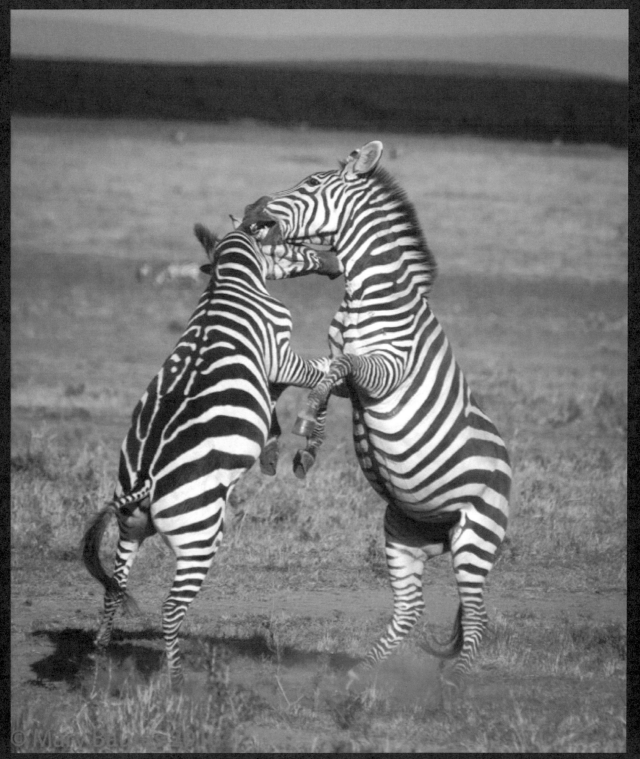

© Mark Bal... 2011

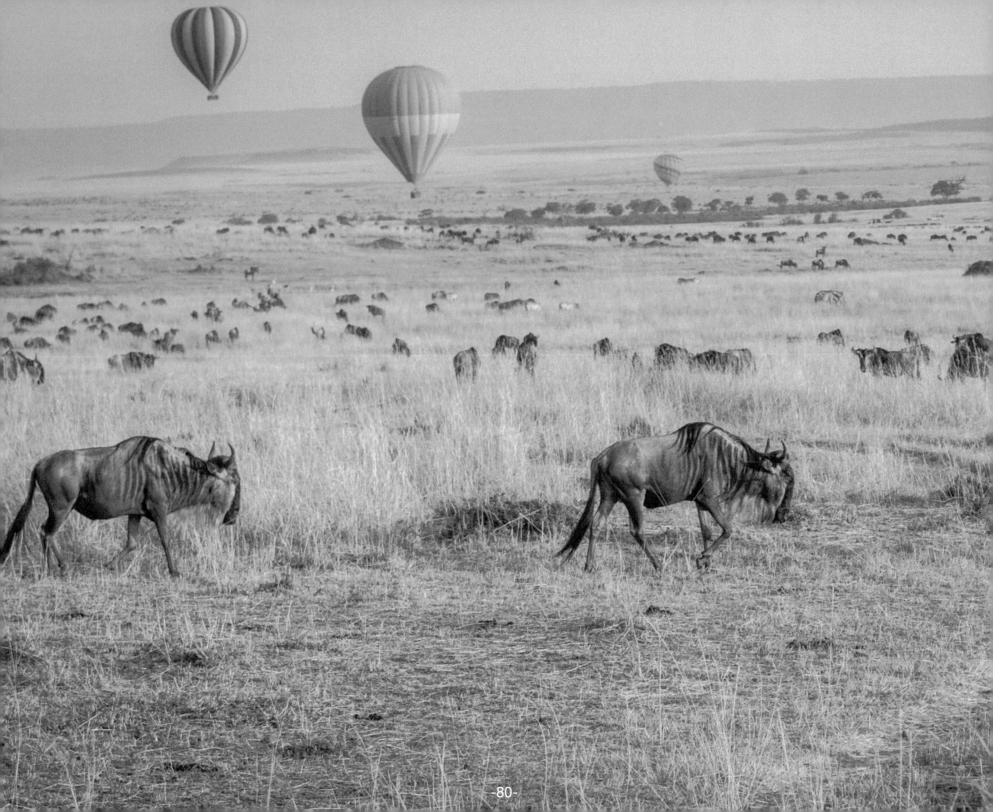

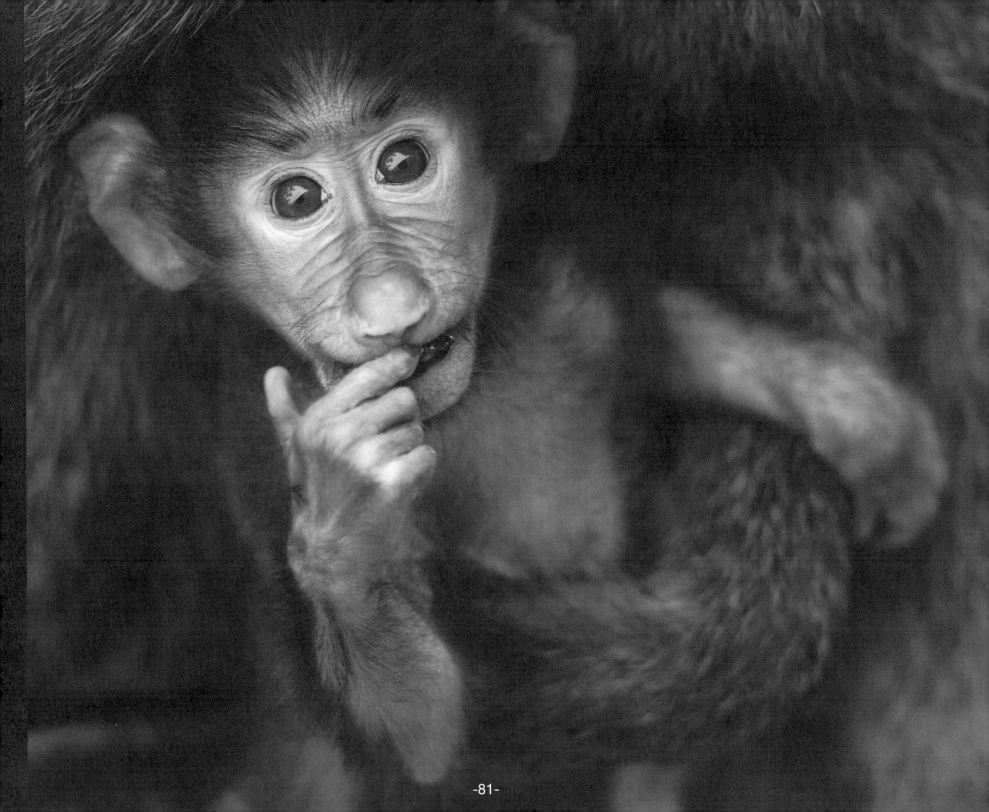

When a meerkat emerged from her den in Botswana and stood up to say hello, time stopped. The encounter started with the catchlight in her pupils and radiated out to dark fur around her eyes, down her long nose, to the glistening black end, and then to a pup who popped out of the burrow. After a wobble, the baby stretched up to suckle.

A stream of happiness poured over me as other mongoose-like adults emerged and stood, paws at their waists, using tails as kickstands. Along with them, I, too, scanned the sky for predators as the mobs' pointed noses moved back and forth, until one spotted an eagle. When he gave a shrill call to take cover, I, too, felt panic and wanted to hide. We are in the world. The world is in us.

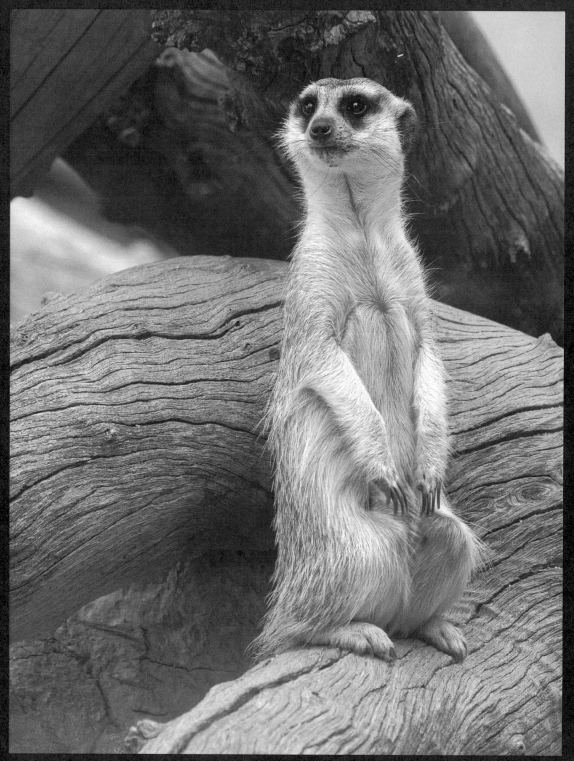

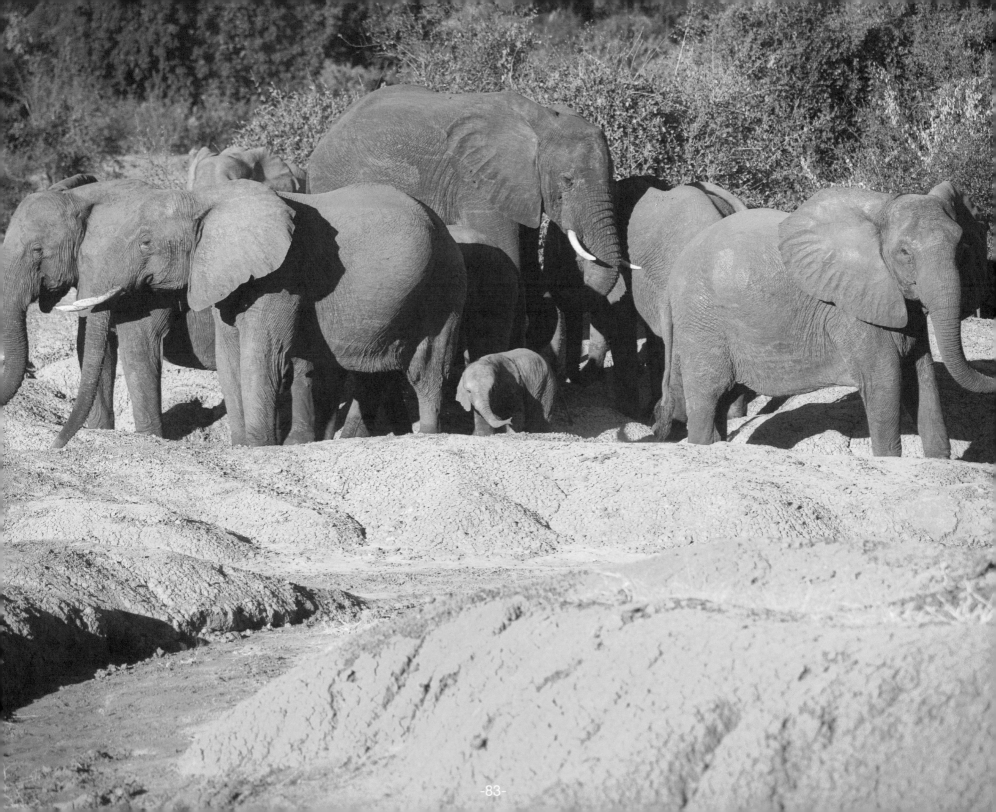

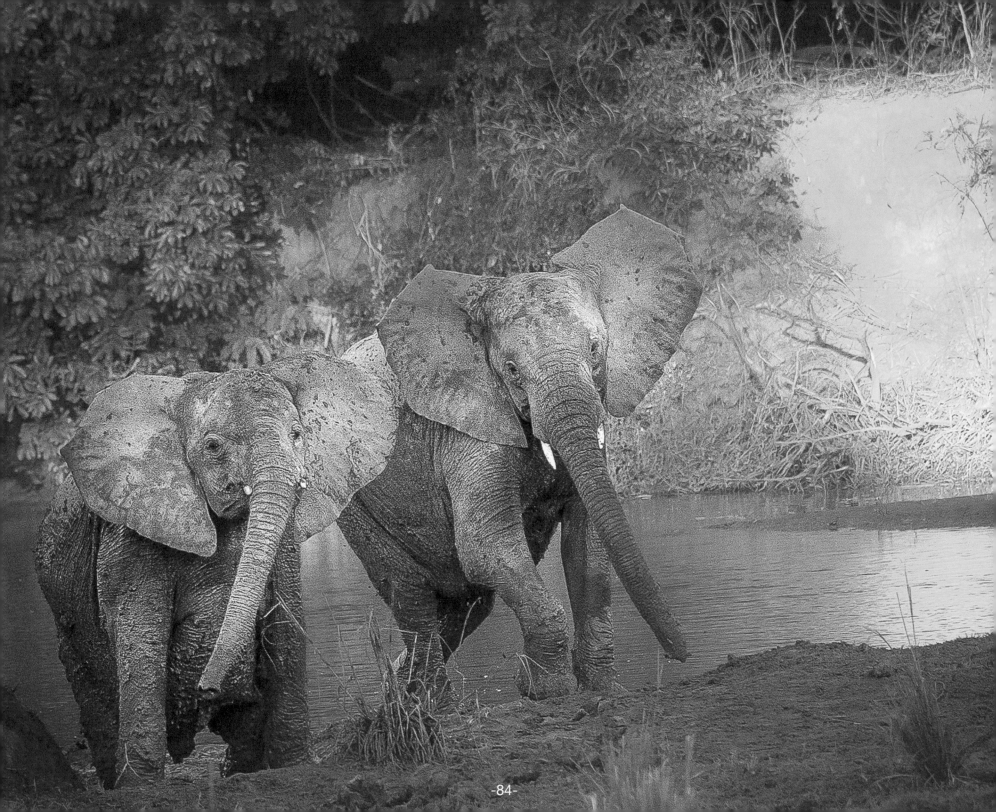

Hides

My friend Marg Wood arranged for us to spend the entire night in a hide complete with a bathroom and dinner delivery. To get there, we crouched over and walked in an underground tunnel so our smells would not scare the would-be drinkers. Our first visitor was a warthog who splashed around happily. Next, rhinos and buffalo appeared. We got eye-level, up-close shots of a rhino mom and her calf. On a couple of occasions, we dropped lens caps and silverware, which scared the buffalo away. When thirst lured them back, they suspiciously eyed the place where our cameras were, ears alert and noses wiggling.

Two buffalo were drinking together when a rhino became annoyed with one and stormed it. The buffalo made a mock charge with his horns before he scampered away.

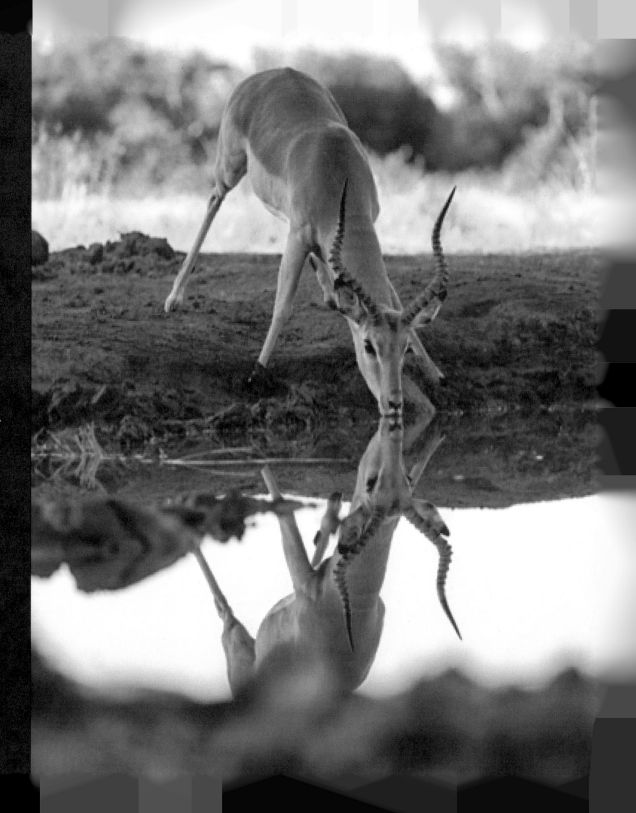

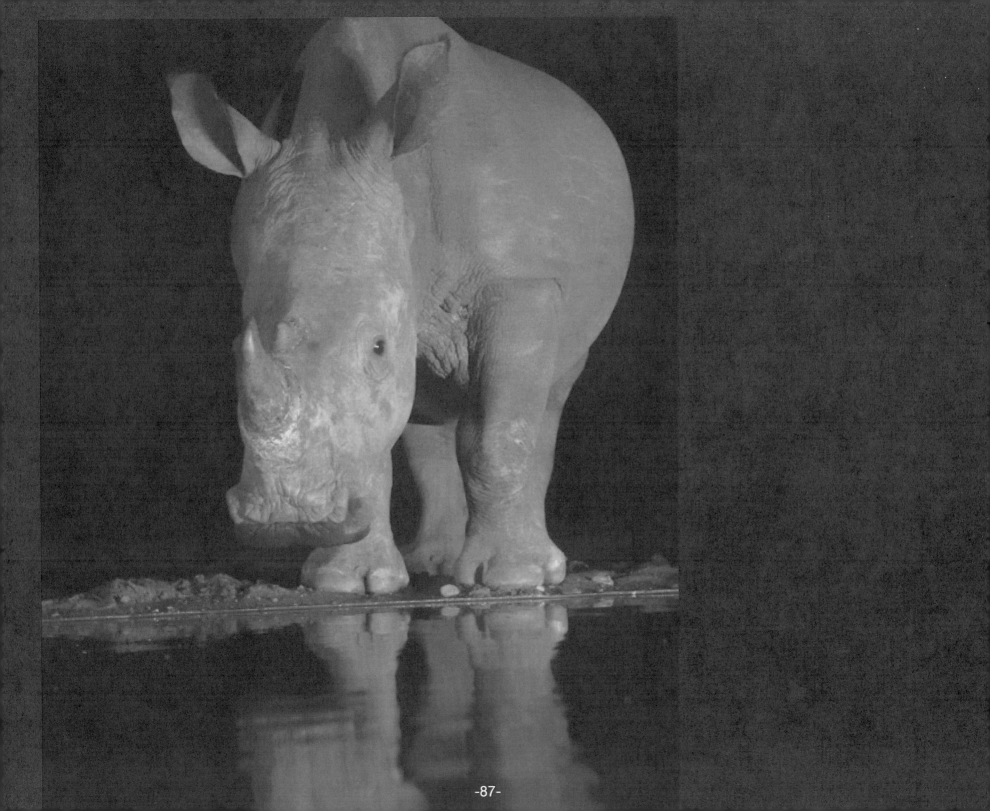

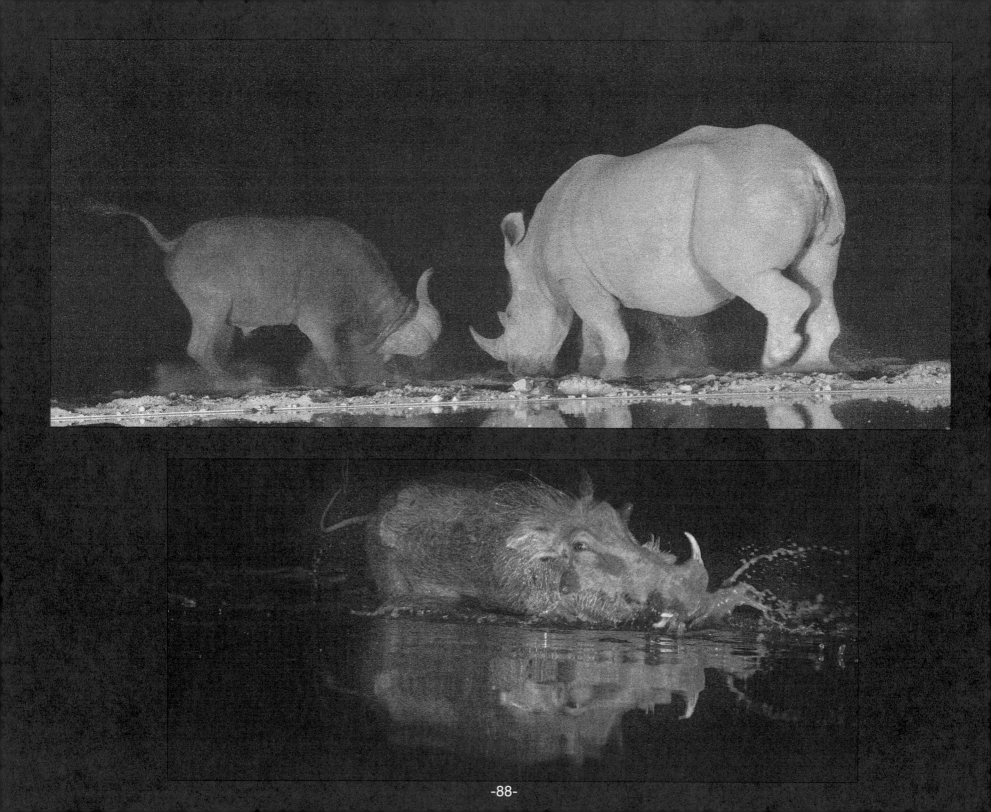

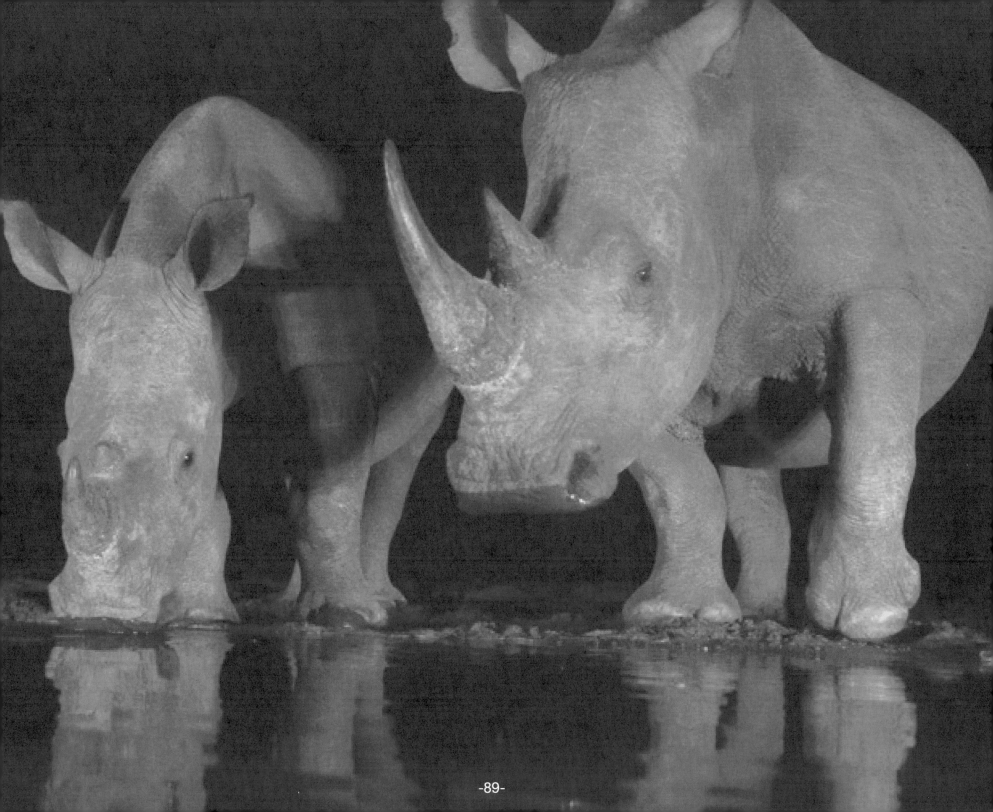

Jacana dads sit on eggs and take care of chicks when they are born. Their long toes spread out to walk on floating lily pads.

We surprised this little chick who raced under Dad's wing, where his brother was also hiding.

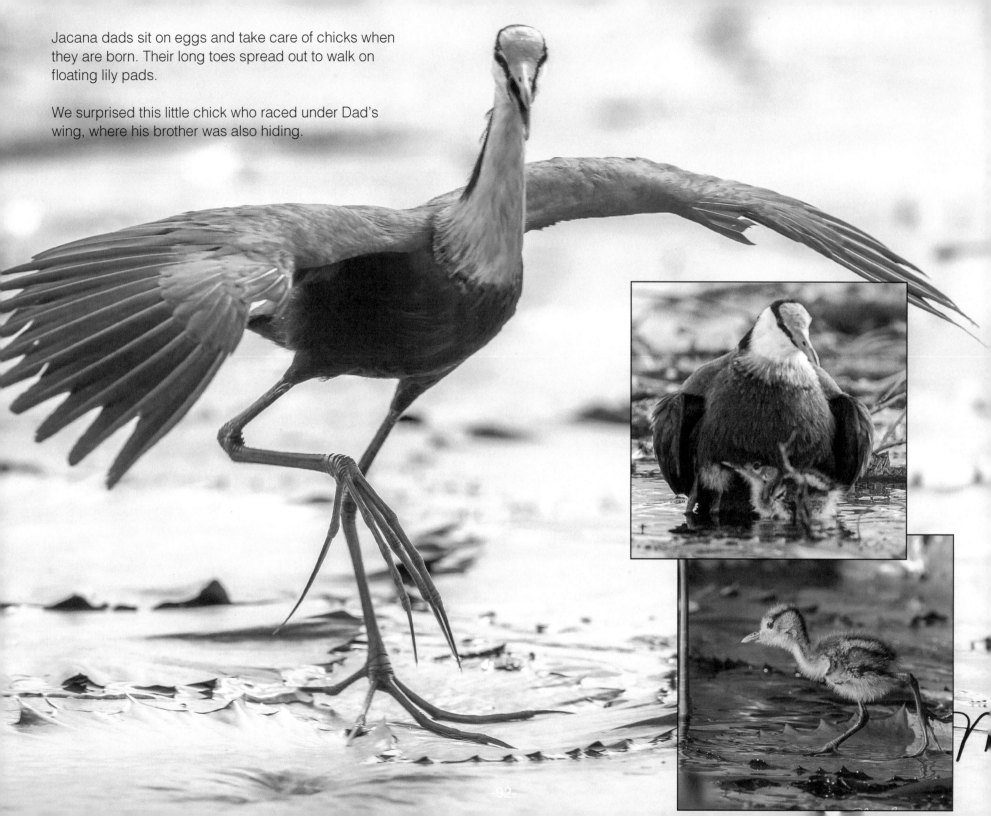

Chobe River, Botswana, Africa

On photo boats at Pangolin Safari, we got eye-level shots of elephants and birds. The boats have tripods mounted in them. Guts, the owner, gives lessons in capturing rim-lighting and birds in flight.

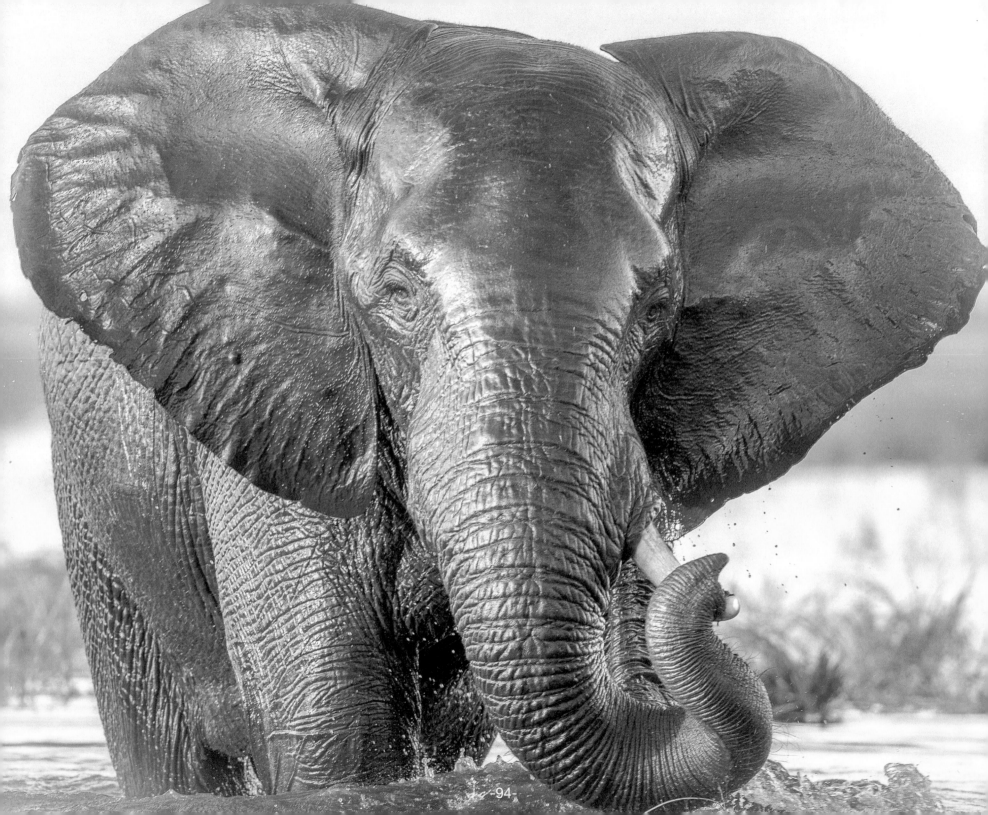

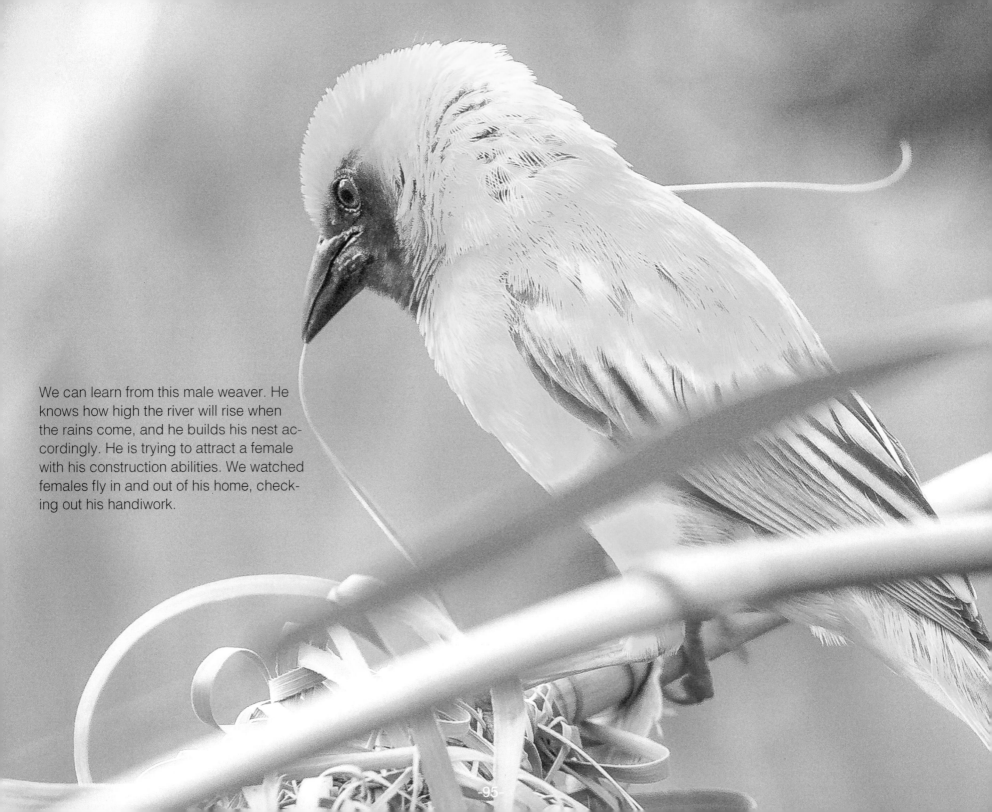

We can learn from this male weaver. He knows how high the river will rise when the rains come, and he builds his nest accordingly. He is trying to attract a female with his construction abilities. We watched females fly in and out of his home, checking out his handiwork.

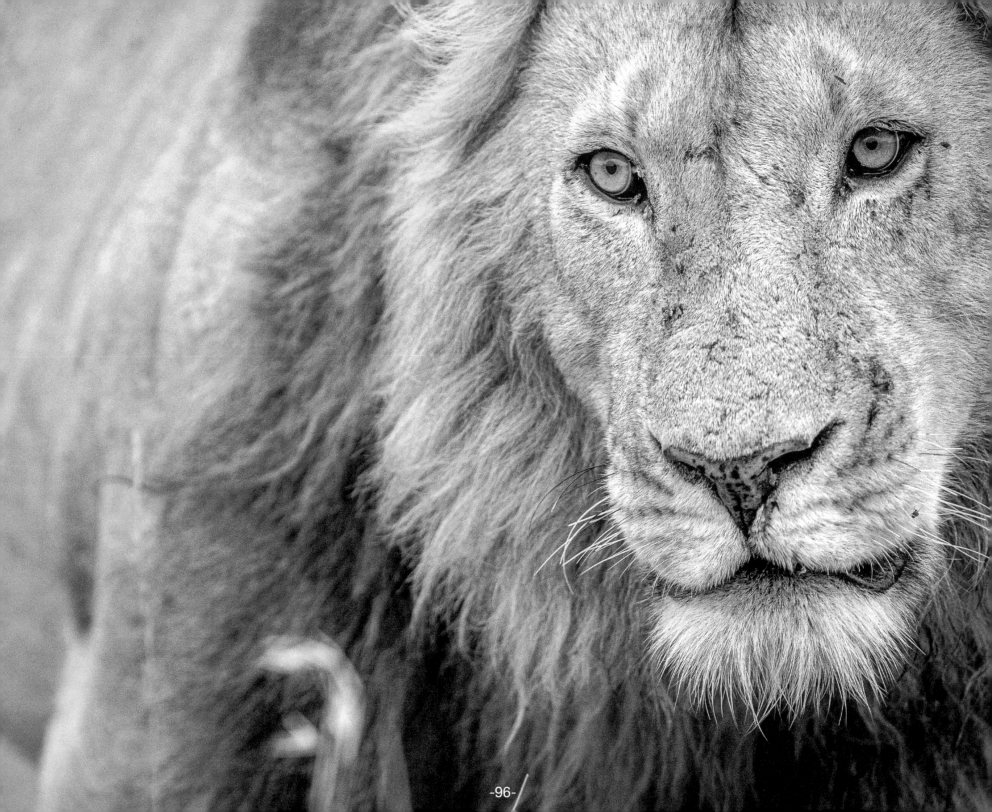

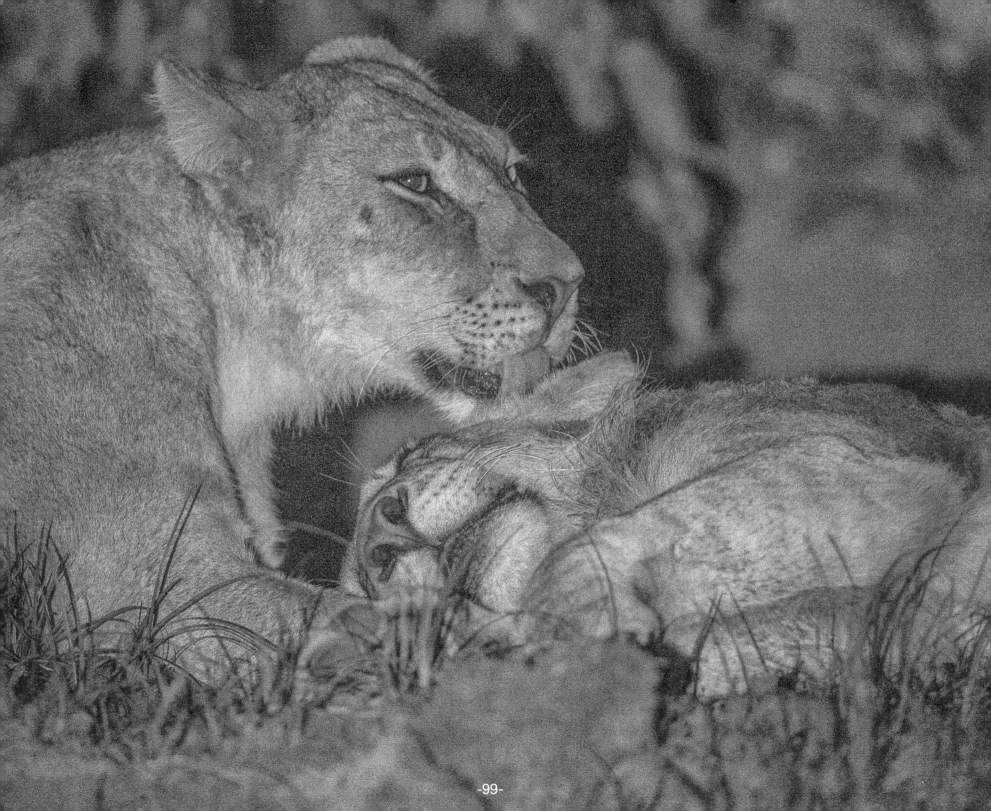

Kananga Views Himself as Part of a Living Network

Kananga's underlying assumptions about his place in the universe teaches us how to coexist. Kananga views himself as part of, not above, a fragile system of life. In what is often a beneficial symbiosis, pastoralists in the South Rift Valley, in a rural part of Kenya, have been coexisting with wildebeest, elephants, and lions for centuries. Unlike our view in the West, rural pastoralists do not destroy what gets in their way. They adjust their behavior by avoiding aggressive animals.

They believe Engai (the God of the Sky) put animals with us to teach us things. Their wisdom of Ubuntu, "I am because we are," honors all life that has a place and a right to be.

The pastoralists have weathered terrible challenges in a modern era, but their coexistence with wildlife has been empowered by modern technology. The Oxford University research project fitted some lions with GPS collars.

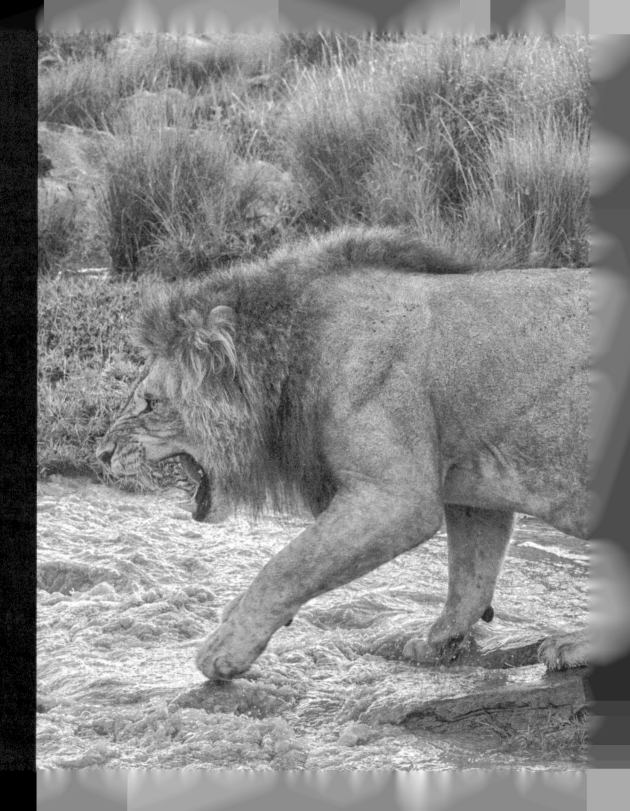

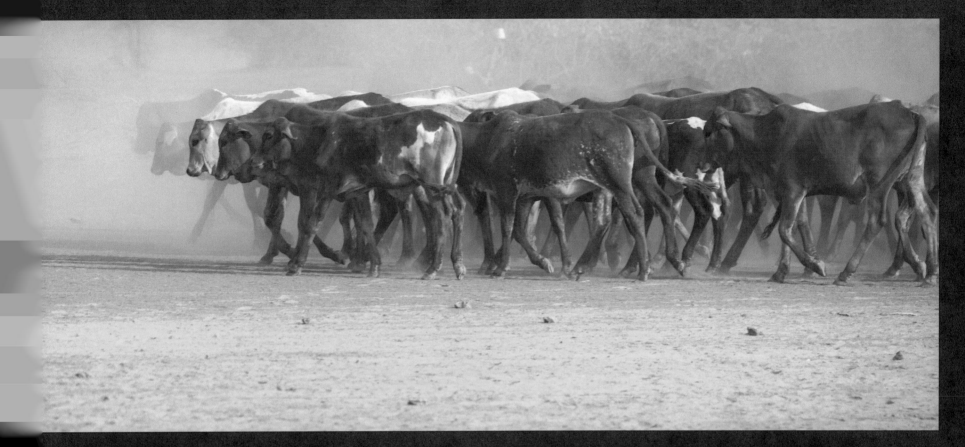

Oxford University Lion Research

Guy Western, who was completing his doctorate at Oxford, drove one of the safari vehicles along the Ewaso Nyiro River in the Sycamore Fig Forest. He explained the dynamics of one of the last free-ranging lion populations. "There's a lot of doom and gloom among conservation groups, but down here we have hope. Our pace is very much like wild Africa. It is better, not worse, than several years ago."

The landscape seemed alert, like the wading impala whose ears were cupped and rotating, scanning riverbanks for lions. Energy from bees, wood-borer beetles, and cicadas buzzed around us as a clearing revealed a baboon galloping toward a giraffe in the distance. At any moment, through a thicket, a buffalo, leopard, or elephant could have emerged.

"This is not a formally protected area," Guy explained. "Seven years ago, there were only ten lions here and now there are well over sixty-five. Allowing trans-border movements in dry times helps carnivores find food and has increased the number of lions."

In Guy's mobile monitoring program, Maasai rangers, already equipped with super tracking skills, documented the movement of predators during the night and called the community in the morning before cows were led to graze.

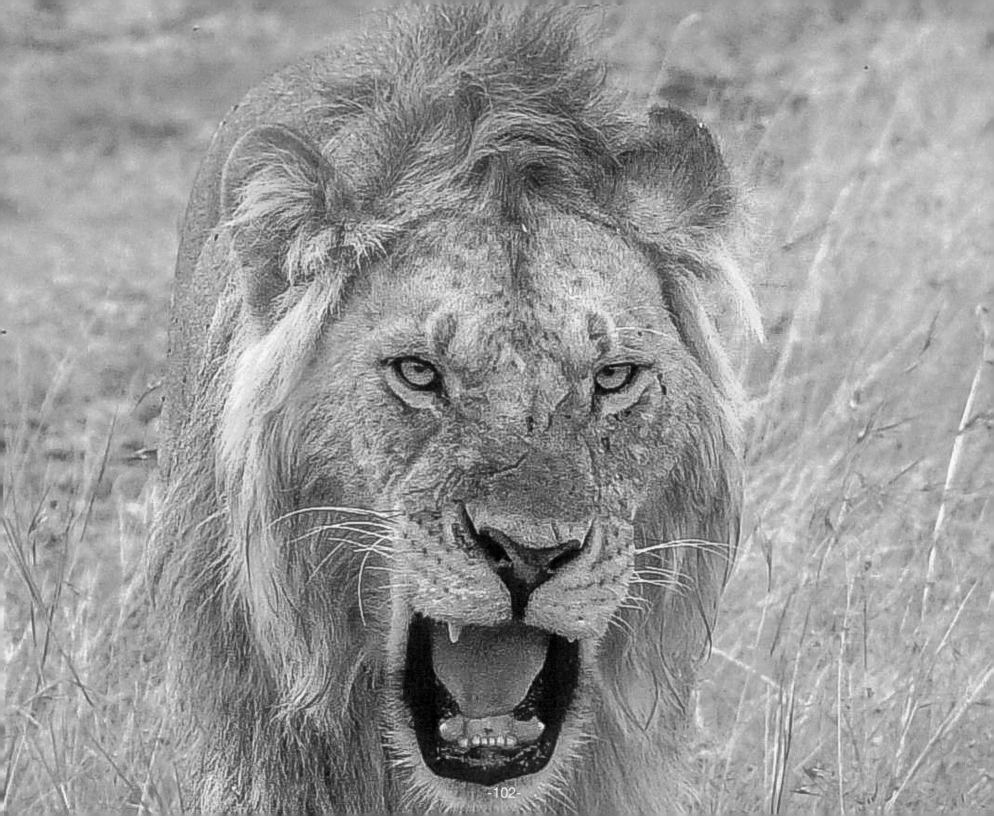

Underlying Assumptions about Land

John Kamanga, head of SORALO, a Maasai landowner group established in 2010, was invited to the Shompole Camp on the bend of the Ewaso Ny'iro River to have lunch with us.

When younger, John was clawed by a lion. He sometimes dresses in the red shuka, which lions usually avoid. (Maasai used to kill lions as part of their manhood ceremony, so lions fear their red shukas. Red symbolizes the blood of their cows.) But that day, he wore slacks and a button-down shirt. Although John studied at Daystar University, his wisdom came from his community, working close to the earth, and watching it change through the seasons.

Our group sat in the shade of fig and cedar trees while John explained his worries about development. "The world is going toward the individual. Can we maintain our culture or will we subdivide our land, encouraging individuality? Or will we own it as a community? We have pressure from the outside to give up community and turn toward the individual. Subdivisions and boundaries are not good for wildlife."

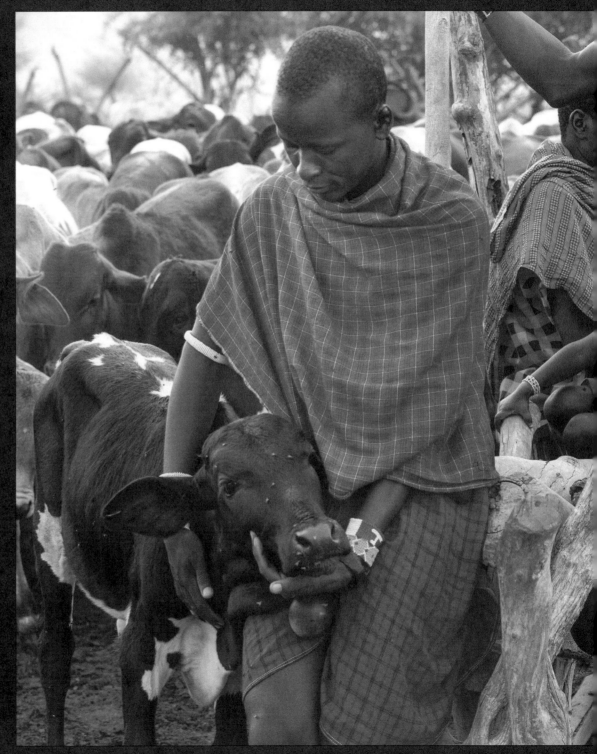

Although parents resisted change, it invaded them through their children. "Our future starts with family. Will my children love cows? Eventually, I will not be able to take care of them. If my children don't want them, I will give my cows up. Have they got cultural pressure from the outside? Once they get an education, will they come back to their culture? We need an education that assumes that their culture is good."

After lunch with John Kamanga, we gathered around a table inside. Guy Western showed slides and presented his research on lions. "When I grew up, we always coexisted with animals. But when you go into national parks, you don't see signs of people. My dad worked in conservation and my mother worked with bonobos, so when I came here, I fell in love."

After Guy presented his monitoring system for Rebuilding the Pride, Greg du Toit, famous for his photographs of lions and leopards at night, showed animal portraits using moonlight to create a mood.

His images told stories with rim lighting creating dramatic contrasts while other wildlife photographers strived for sharp-focused action shots.

He explained the next morning's activity. "This Maasai village we are visiting is not like the ones near Nairobi. No one will dance or sell souvenirs.

We will see them milking cows, then herding them against the backdrop of the rising sun." Imagining the dramatic scene painted excitement on his boyish face.

In the morning, we hiked with Samantha, one of the owners of our camp and a SORALO researcher, and Seyia and Taru her blond-haired children to another part of the river where we boarded rowboats. A rope strung across the water helped us pull our watercraft to the other shore to avoid getting our khaki-clad legs wet. Two safari vehicles waited for us in the shade of trees.

Once we left the thicket, we entered a world cleansed of civilization. Tires from the jeep in front of us whirled up dust and hazed out the road ahead. The ghostly stripes of a zebra stood like an apparition at our side. Our pants and camera bags became shades of earth as we stopped to let the dust settle.

"This is the Africa the great explorers discovered," Greg said, gesturing to the zebra unveiled by the settling sand. "Zebras and cows graze together." Our trip to the South Rift Valley of Kenya was a trip back in time for Greg and his wife, Claire. Ten years earlier, they lived nearby in a shack with a tin roof, four hours away from any town.

Every day, he disappeared into the bush where lions were so shocked at seeing a jeep, they fled. During this time, Greg sat submerged in a waterhole to get eye-level shots of free-roaming lions. In national parks, rangers would not let him in water where lions, leopards, hyenas, and cheetah drink.

After sixteen months of being immersed in water and photographing zebras, warthogs, and other animals, there came a day when lionesses with their yellow eyes and bulging muscles lapped water five yards from him. It was just before dusk. The sound of his camera clicking stopped their drinking. Three lionesses and five cubs fixated on the big eye of his camera and his brown hair. His heart stopped. They finally decided he wasn't a meal and began drinking again.

He had to flee before the darkness hid where the lions were. The rule of encountering lions on foot was, "Don't run." It triggers their prey instinct to chase. Greg inched backward toward shallower water on the opposite shore. Half of his body protruded so he flopped on his belly and swam. Numerous eyes followed as Greg rose like a giant sea creature, startling the lions out of their prey instinct. He raced back to his Land Cruiser, looking back at their wide-eyed shock.

Although he contracted bilharzia and numerous water-borne parasites, the shots of the pride watching him across the pond are breathtaking. The water-mirrored images of the pride as they stared at his camera appear on the cover of his coffee-table book, *African Wildlife Exposed*.

Children in bright-red-and-blue shukas and elders gathered at the entrance of a settlement surrounded by a thorny-branched fence. A tall, white-haired elder shook our hands and gestured to a line of children. We were asked to place a hand on each child's head as we entered their home. These pastoral people had little contact with Westerners and seemed as curious about us as we were of them. The children surrounded us to peer at their images in the back of our cameras. They giggled and pointed to the child whose picture they saw. Some of the men had cell phones, baseball hats, and sunglasses. The corral of cows fenced at the side was their lifeblood—used to settle debts, give dowries, and provide food and milk. A woman in a bright-blue cloth led a calf to drink from his mother's udders. She crouched on the other side and squeezed milk into a plastic bottle.

I peeked inside the Inkajijik where they cooked and slept. Sticks formed the walls, while mud, ash, and cow dung formed the roof. It was dark inside but provided protection from rain, wind, and predators. It was biodegradable and could be built quickly as they moved from one side of the river to the other.

This community, with its clear duties and roles, was elegant in its simplicity. An appetite for unnecessary things weighs you down when you have to reassemble your house and corral with the changing seasons. They lived sustainably, close to the earth where they believed real power came.

Buffer Zones for Drought

Maximizing productivity required open rangeland because unrestricted mobility during a drought was so vital to survival. Fences starved cattle and other animals during the dry season. John's community set up zones, one for grazing and migration for most of the year and another unoccupied buffer zone for the dry season, only used during drought conditions.

John Kamanga believes individuals owning the earth displaced indigenous people from their homeland and took land where wildlife and cattle roamed. Fences and boundaries set up by real estate developers and farmers parceled land into small uneconomical units. In the dry season, animals couldn't move to areas with better grazing. They were vulnerable to starvation and dehydration.

John learned from "cowboys in America" who subdivided their land, which became dry and eroded. (John was referring to the Dust Bowl in the Southern Plains in the 1930s, a consequence of unsuitable farming practices.) "Do we have to go through that cycle? Can we stop and reflect? We don't make the same mistake."

John's culture was caught between the old and the new. While the elders clung to cultural traditions, at school children developed new priori-

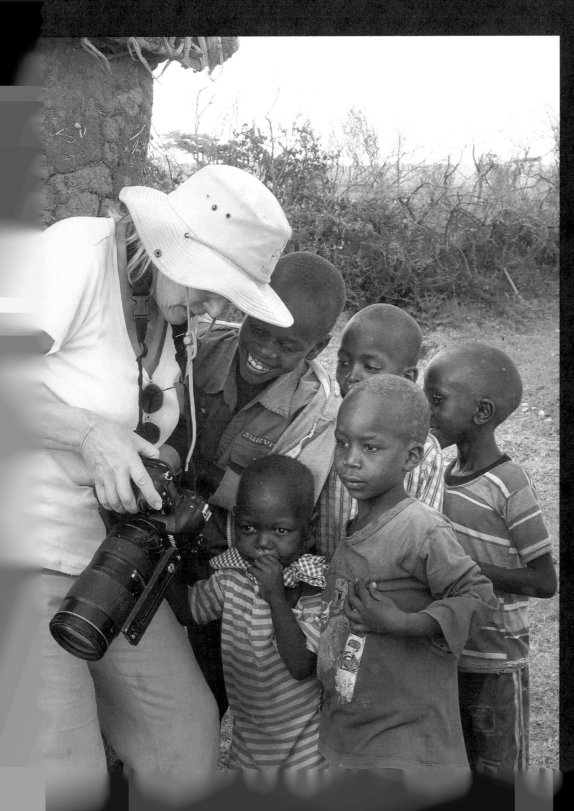

As we awaken, we become
truly at home on earth and
take our particular place
and do our part as souls
in the needed matura-
tion of the species.

Heaven or hell are here now,
and we awake to the fact that
we make life what it is with
our choices and actions rooted
in our higher self or soul.

— Dr. Thomas Yeomans, Concord Institute

Photo by Greg Harvey

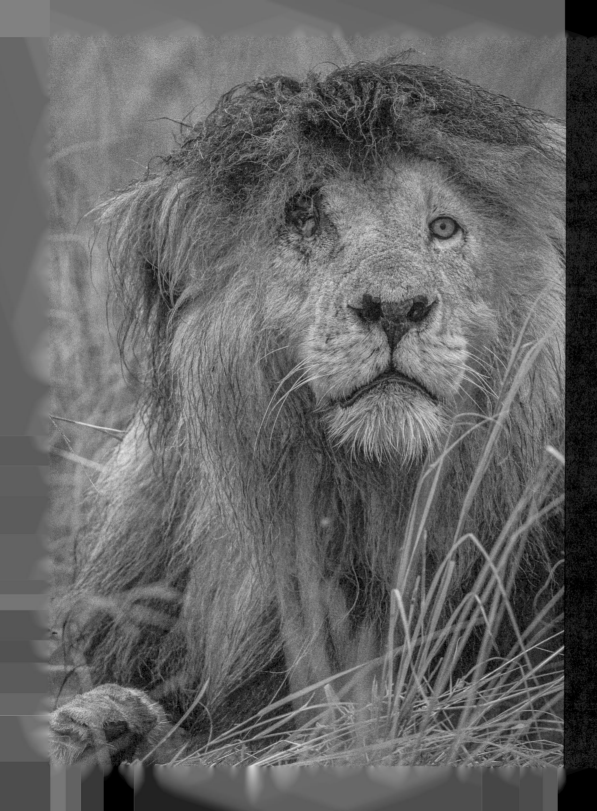

Scarface

I think of Scarface as an old war general. He narrowly escaped death when a Maasai warrior, who was protecting his cattle, threw a sword into him. Then in 2012, he lost his right eye while making a territory grab. His coalition with Morani, Sikio, and Hunter was known as the Four Musketeers. They took over the Marsh pride in the Maasai Mara in 2011. Scar fought off many rivals. His virility was made legendary by BBC's *The Big Cat Diary*.

We saw Scar at the age of thirteen, when he was unable to hunt well because one of his rear legs was crippled. With a black mane surrounding his war-battered face, he and his buddy Sikio were consuming an entire buffalo. A low guttural rumble that became fierce at times passed between them. It was lion-speak for enjoying a meal together.

A bleeding puncture wound on Sikio's forehead matched the point of a buffalo horn. Scar survived because his friends shared their kills.

Forest People of Borneo

When we arrived at the Camp Leakey dock in Tanjung Puting National Park in Borneo, one of the refugee forest people emerged. An orange ape mom, who only gives birth every eight years, cradled a wild-haired baby. At four feet tall, with long arms, orangutans share 97 percent of our DNA.

Camp Leakey is an orangutan research outpost, created forty-six years ago by anthropologist Biruté Mary Galdikas. Galdikas loved Camp Leakey because it was a magical, primeval Eden where "you could interact with great apes as equals." Many of her interactions with red apes were "epiphanies or almost religious experiences."

In 2015, when I photographed sun bears, orangutans, and other primates in Borneo, it was very different. "Words cannot describe," Galdikas said, "what palm oil companies have done to drive orangutans and other wildlife to near extinction. It's simply horrific."
We saw it on the way to the camp. The river was lined with miles and miles of regimented spikey rows of palm oil trees. They were set in red mud rutted with puddles. Bulldozers flattened the canopy. Chainsaws destroyed food for countless lives. Caterpillar tractors dug out root tips, which we now know can communicate with each other about insect invasions or a coming drought. A barren emptiness replaced a vibrant, alive community. Instead of birds and animals calling, shovels scraped up their homes.

Because orangutans released from Camp Leakey did not have enough food, twice a day, the camp fed them on a platform deep in the jungle. Along the river, we sometimes saw them swinging gracefully through the branches with thumb-like toes, but we could not get close. As we hiked on wet leaves over roots and branches toward the feeding station, gibbons' high-pitched music mixed with the twittering of birds and the croaking of frogs. Since Indonesia is one of the five most species-diverse places in the world, Camp Leakey was home to 230 bird, 29 mammal, and 17 reptile species.

Hoots and long calls through the canopy announced the arrival of food. On the platform, a mother orangutan wrapped her toes around a pine-apple and her fingers around bananas as a baby clung to her. Another mother guided a toddler through a pile of fruit to a pan of milk. With milk dribbling off his mouth, he looked up with dark eyes made more piercing by the white surrounding them. Like with a human child, his mother had a guiding hand on his back. She gathered bananas before they disappeared into the forest, as two males and a gibbon, with acrobatic agility, swung in from nearby branches. The males, with big cheeks and throat sacs to help with their long calls, peacefully shared food as wild pigs snorted up the droppings.

We cruised by boat through the Sabah, in the northeast corner of the Borneo, viewing white hornbills and macaques in a cathedral of tangled green. Between tightly packed trees and vines, a patch of gray appeared, then an elephant's trunk. Deep rumbles reverberated through the vegetation as branches broke and a trumpet announced the arrival of pygmy elephants. A mom led her baby to the river for a drink. Mom lifted water into her mouth with her trunk, which darkened with a water line. But the calf didn't know how to use the thousands of muscles in his trunk.

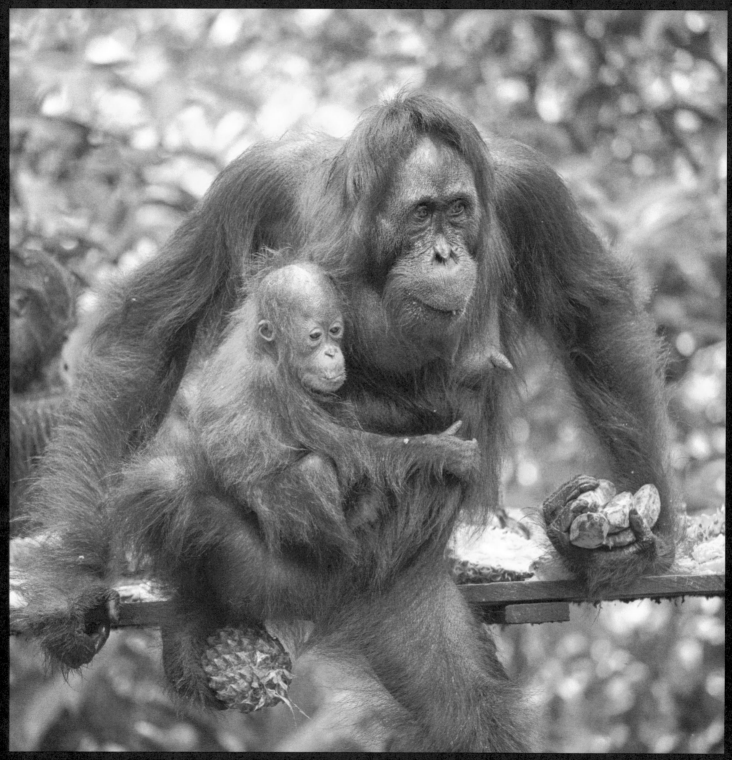

Small for elephants, even the adults have a babyish look with large ears and heads and rotund bodies. As their home was being cleared for palm plantations, the elephants were trapped in a small sliver of forest between the Kinabatangan River and the palm oil plantations. When elephants felled trees on the palm oil plantations, workers killed them. The Sabah's wildlife department had been helping to manage the conflicts and encouraged staff to burn tires to scare them away, but the elephant population has decreased by 50 percent in the last three generations.

Palm oil is found in processed foods like Oreo cookies, potato chips, shampoo, toothpaste, margarine, and chocolate bars. Trees with palm oil can be planted in a responsible way, leaving forests for animals, but it's not as profitable as burning and planting large areas all at once.

To love wildlife is to live in a world of wounds and with a grief that sometimes doubles you over. Just after I left, palm oil companies torched the forest and some of the animals I photographed. When they slashed and burned, the forest floor of decayed vegetation became a flammable accelerator. Rain did not extinguish the flames, because they were in the ground. The land itself was burning as bogs up to sixty-five-feet deep smoldered under the earth. The inferno burned up clouded leopards, sun bears, pygmy elephants, tigers, gibbons, horseshoe bats, Sumatra rhinos, proboscis monkeys, and orangutans. Smoke, like their ghosts, drifted out of the charred woodlands.

There was little visibility through ochre air as embers and an acid haze poured into the sky. Toxic smoke caused respiratory infections in over half a million people as the inferno smoldered for months. Children died. A large percentage of the world's biodiversity became carnage, soot, and ash. What nature evolved over billions of years, we burned up in a week for cheap snacks. The Guardian's George Monbiot described the eco-apocalypse as the greatest environmental disaster of the twenty-first century. He found it baffling that the media was more interested in "the dress that the Duchess of Cambridge wore" or "the latest James Bond premiere."

The grief I felt about the cremation of the rain forest could not be pushed aside, so I focused on orangutan orphans whose mothers were sacri-

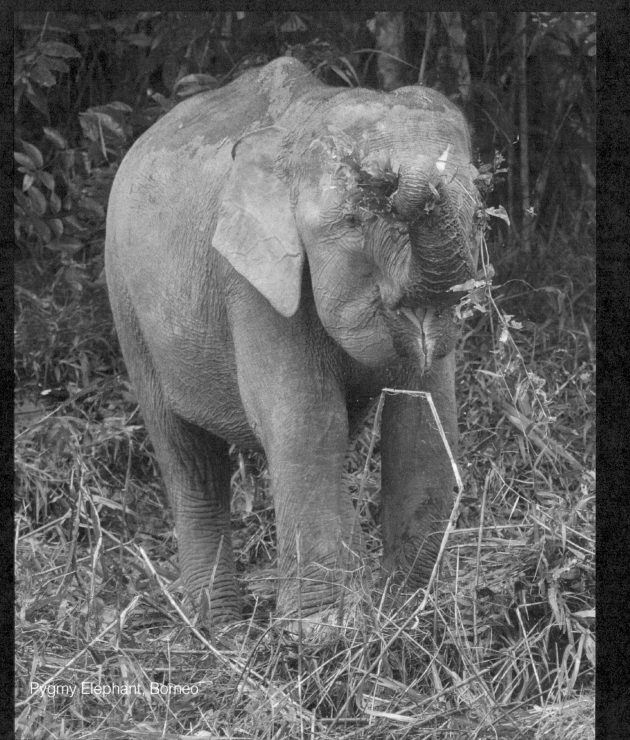

Pygmy Elephant, Borneo

Everything we buy is a vote for what kind of world we want. Consumer power enables us to reward corporations that protect forests and the home of pygmy elephants, orangutans, and clouded leopards, and to bankrupt those who rape the earth for corporate profit.

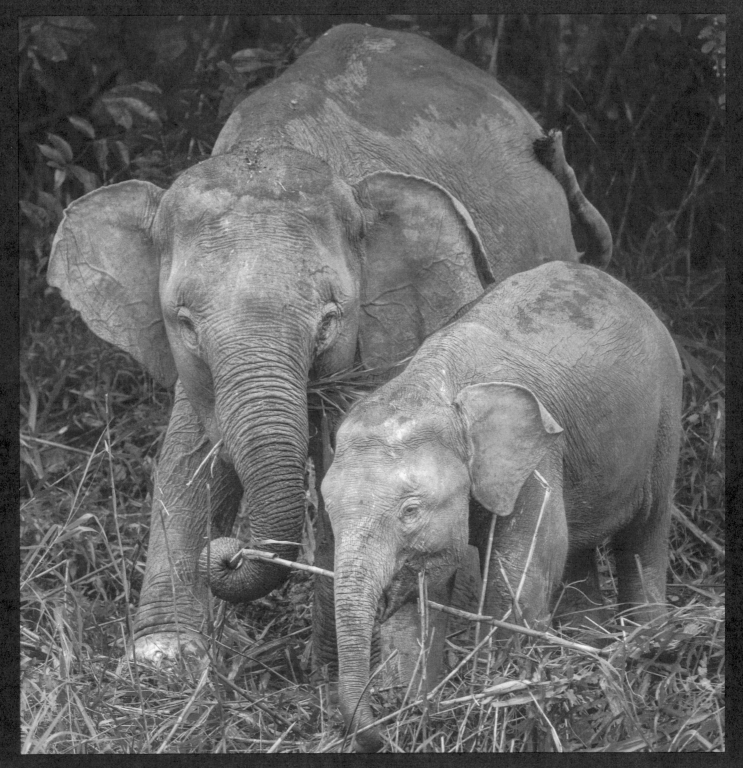

Forest School for Orphan Orangutans

"Time's march is a web of causes and effects, and asking for any gift of mercy, however tiny it might be . . . "

—Jorge Luis Borges

At forest school at the Orangutan Care Center in Pasir Panjang, orphan orangutans learned to forage for food, move through the canopy, and build night nests, skills they would have learned from their mothers. In the wild, infants have a close maternal bond for eight years, so intense relationships developed with caretakers and buddies.

Surrogate moms hid peanuts, raisins, and popcorn in rattan balls wrapped in reed mats. As toddlers climbed to forage, one youngster, Mara, noticed a wound on her friend Panahan's arm and leaned down to smooch her forehead. Panahan hugged her back. Mara's wild red hair had blond tints. Pale circles around her eyes were more oval than those of her best friend. They both arrived at around the same time at the Orangutan Care Center. After the hug, Mara dug in the ground and smiled as she dumped dirt and leaves onto her head. More independent, Mara spread calmness to others.

Losing forests starves orangutans, and migrating closer to humans enables poachers to steal babies for pets. Many of the orphans have injuries they suffered when their mothers were killed. When kidnappers slaughtered Didik's mother, they wounded Didik in the shoulder. The bullet created swelling in his chest. The poachers did not know how to treat his wound, so he was given to a storekeeper.
Doctors at International Animal Rescue said his "crushed spirit" from watching the death of his mother was far worse than the physical wounds. By the time he and his classmates attended their first day at baby school in a wheelbarrow, he'd come out of his shell. He climbed up a ladder with the full use of the injured shoulder and into the arms of his surrogate mom.

Budi and Jemmi

On December 14, 2014, Budi was rescued from a dark chicken cage where he'd spent ten months and was fed nothing but condensed milk. Bloated from malnutrition, his limbs were bent and swollen with fluid. Unable to move, he cried when doctors touched him, but after calcium pills, fruit, and loving attention, he held a bottle. Budi's arms developed first, so doctors walked him holding his hands until he could put weight on his legs.

On March 19, 2015, he was introduced to Jemmi, who was rescued at the age of four months from a box in his owner's yard. Neither of them had seen another orangutan since they were captured. Dr. Ayu Handayani carried Budi, whose limbs were still weak, to Jemmi and sat Budi with his new friend. Jemmi was younger but Budi's physical and psychological development had been delayed by his neglect. They locked eyes, drank each other in, then moved closer to inhale each other. Jemmi reached out with much handholding and hair-pulling.

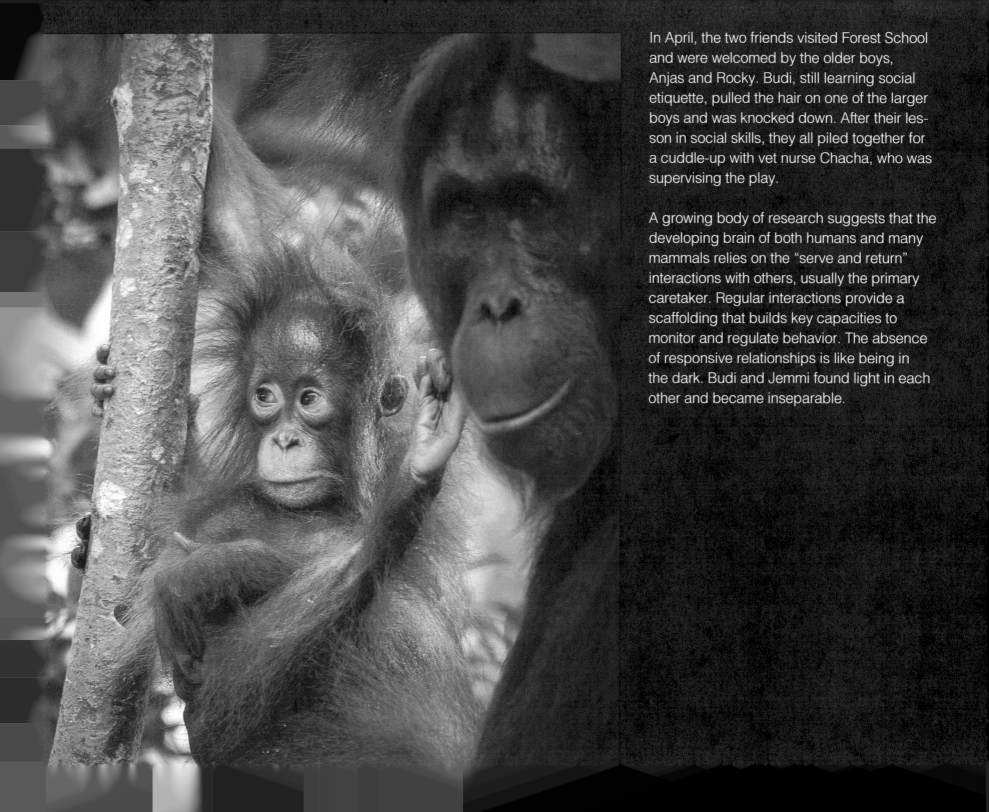

In April, the two friends visited Forest School and were welcomed by the older boys, Anjas and Rocky. Budi, still learning social etiquette, pulled the hair on one of the larger boys and was knocked down. After their lesson in social skills, they all piled together for a cuddle-up with vet nurse Chacha, who was supervising the play.

A growing body of research suggests that the developing brain of both humans and many mammals relies on the "serve and return" interactions with others, usually the primary caretaker. Regular interactions provide a scaffolding that builds key capacities to monitor and regulate behavior. The absence of responsive relationships is like being in the dark. Budi and Jemmi found light in each other and became inseparable.

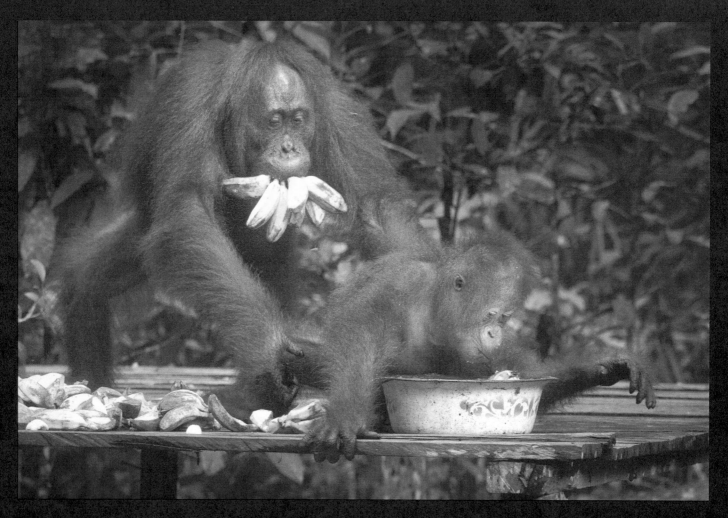

Forests are Necessary for Life

The burning in Borneo is happening all over the world. More than half of the Amazon's tree species are threatened with extinction. Every tree creates oxygen for four people, yet we destroy fifteen billion a year. Trees hold heat in at night and block the sun during the day. Without a canopy of trees, soil dries out, creating droughts. Without trees to turn water vapor back to the air, forests become barren deserts. Without forests, extreme swings in temperature kill plants and animals who need large areas of interconnected woodland. A diversity of animals burrow, till, and excavate nutrients in soil to keep it healthy. Snails and other animals clean algae and slime from ponds.

Forests play a critical role in absorbing greenhouse gases that fuel global warming. In a forest, trees lean on each other, so when loggers cut a mother tree down, others wobble and bend in the wind. Forester Peter Wohlleben showed how trees live together with their children, communicate, and support each other. When giraffes start eating acacias, the trees warm their neighbors. Other acacias pump toxic substances onto their leaves so giraffes have to move on to distant trees to start eating again.

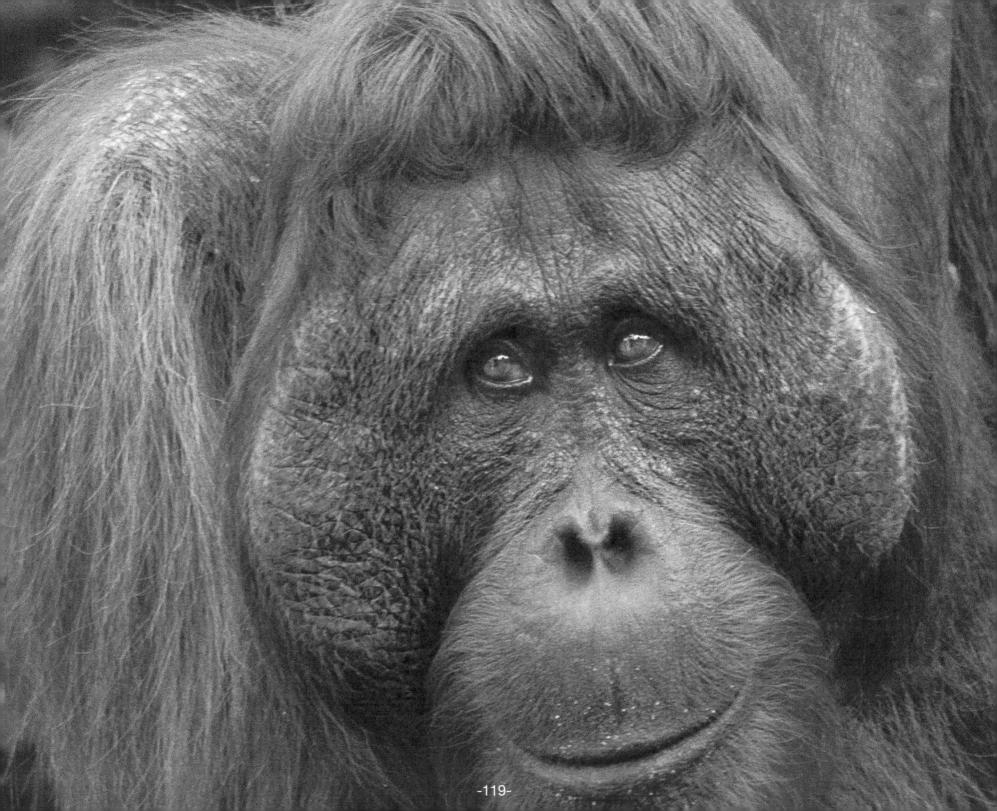

Deforestation Causes Viruses to Spread

Trees have a social life and go to school. If trees don't pay attention to their lessons, nature punishes. One lesson is thrift—to ration water for times of drought instead of just pumping water out in the spring even when there is plenty of moisture in the ground.

Pulitzer Prize–winning historian Jared Diamond in *Collapse – How Societies Choose to Fail or Succeed,* found that destroying natural habitats led to the death of societies. Diamond says societies who collapsed in history failed to see the dangers of deforestation and destroying wetlands. After they cut down trees, the animals died. Birds built nests on the ground, but rats who had stowed away on ships ate the baby birds. With no leaves and roots, soil eroded. With no wood for canoes, they could no longer fish. When they began to starve, they ate each other. Then the society died.

They did not have modern forms of communication, so they did not know about the Greenland Norse society and the Khmir Empire, whose deforestation led to their collapse. We, however, do know about the collapse of these other cultures yet we destroy forests creating droughts. Our delusion that the world is a warehouse for humanity is digging our grave.

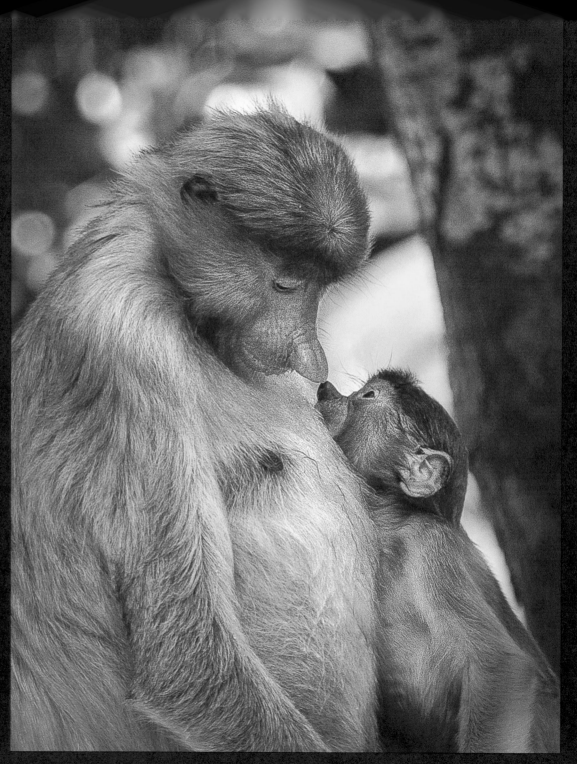

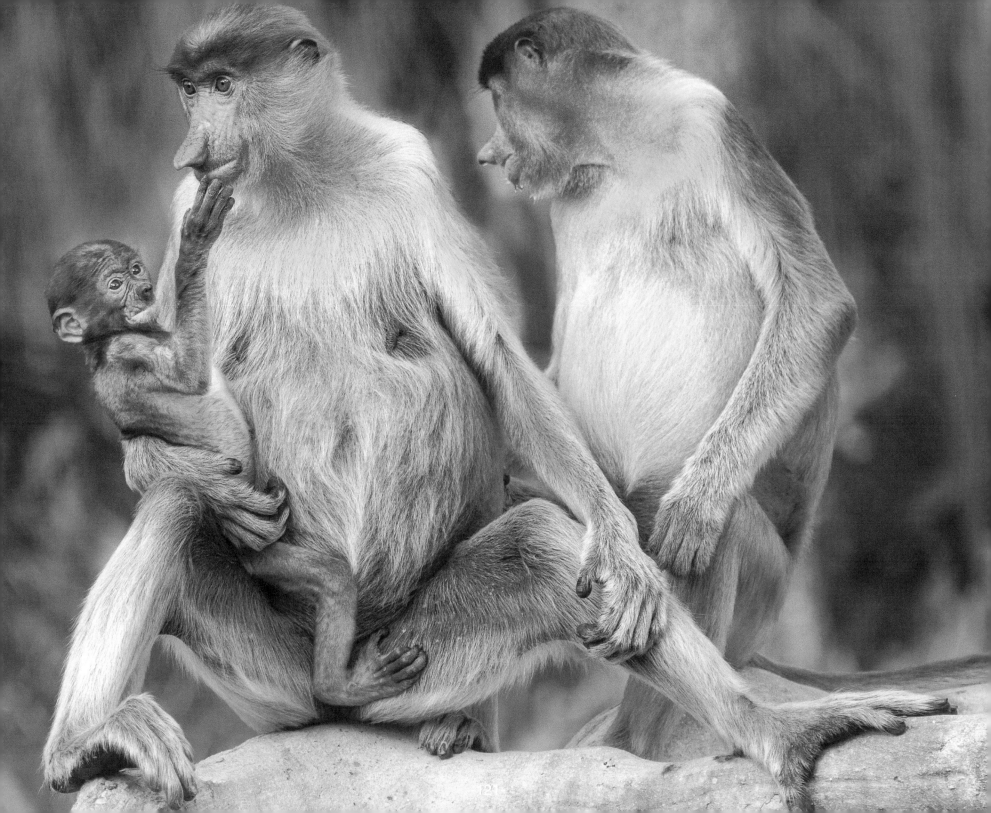

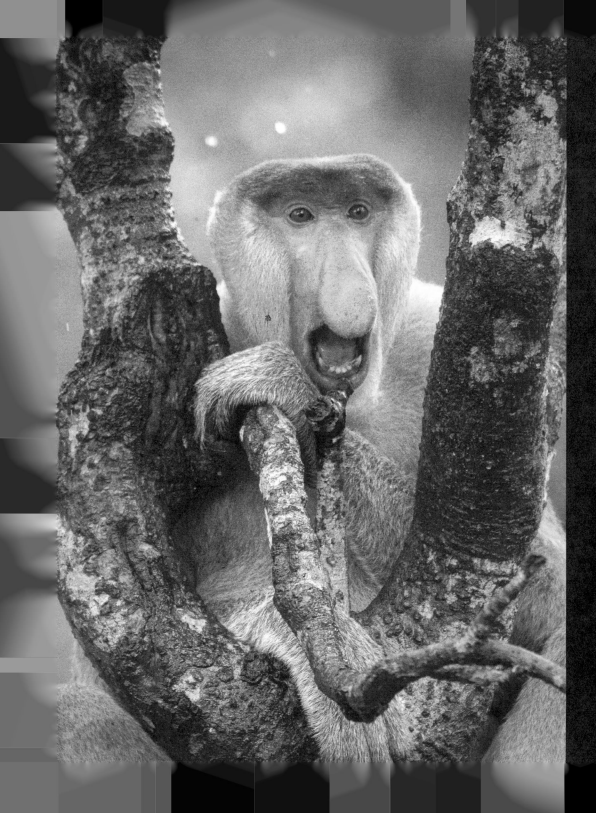

The Mother
Is Reacting

"Our DNA is made out of the same DNA as the tree," explained Hopi elder, Floyd Red Crow Westerman. "Trees breathe what we exhale. We need what the trees exhale. So we have a common destiny...when the earth, the water and the atmosphere is corrupted, it creates its own reaction. The mother is reacting."

Scientists agree that pathogens spreading through a Chinese wildlife market started the COVID-19 pandemic, but deforestation may be the culprit of the next epidemic. Viruses live harmlessly in animals until their homes are gone. The Ebola outbreak came from deforestation in Central and Western Africa.

Experts say wildfires such as those in Borneo, Brazil, and Australia will create more epidemics. In 1988, the huge blazes in Indonesia created conditions for the Nipah virus, with a mortality rate of between 40 to 75 percent of those infected. Fires forced bats out of their forest homes so they roosted in farms and orchards. When pigs ate fruit the bats tasted, they became infected. Humans ate the pigs and died from brain hemorrhages. In June of 2019, the Nipah virus resurfaced in Kerala, India after an outbreak a year earlier.

Only a small percentage of wildlife pathogens are known to science. They are locked in balanced ecosystems until our deforestation spills them out. Diseases from mosquitoes are also linked to forest destruction. As leaves and roots disappear malaria-carrying mosquitoes breed in puddles. We are learning what indigenous cultures have known all along. The forest is more valuable that short-term profits of ranchers, loggers, and home builders.

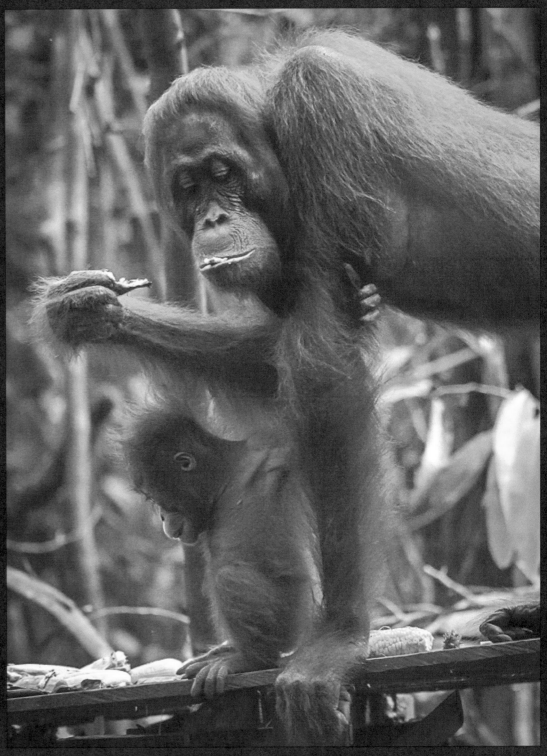

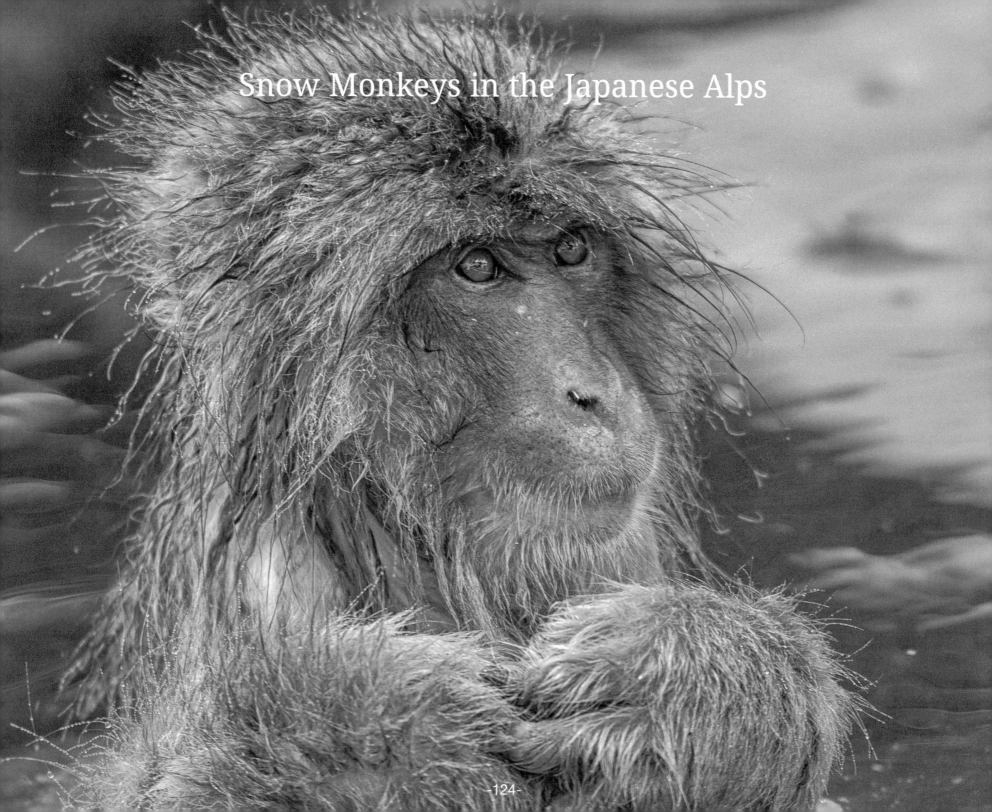

Snow Monkeys in the Japanese Alps

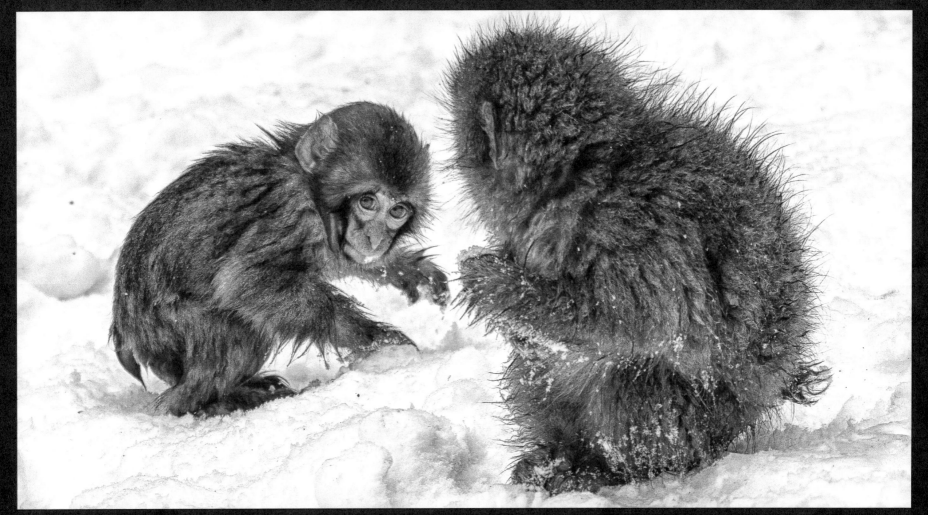

When the power of love overcomes the love of power.
The world will know peace.

- Jim Hendrix

These Japanese macaques were forced out of their habitat in the 1950s by ski resorts. They relocated to the hot springs of Hell's Valley in Japan. Since tourists could no longer use the springs, a separate one was given to the monkeys. The Jigokudani Snow Monkey Park was established in 1964. As the macaques survive freezing temperatures by soaking in their own private hot tub, they provide financial support to local shops and hotels. Busloads of tourists come to see them. This is one example of how communities can coexist with wildlife.

The troop is hierarchical, led by an alpha male and female who inherit their status from their parents. These toddlers made snowballs and rolled

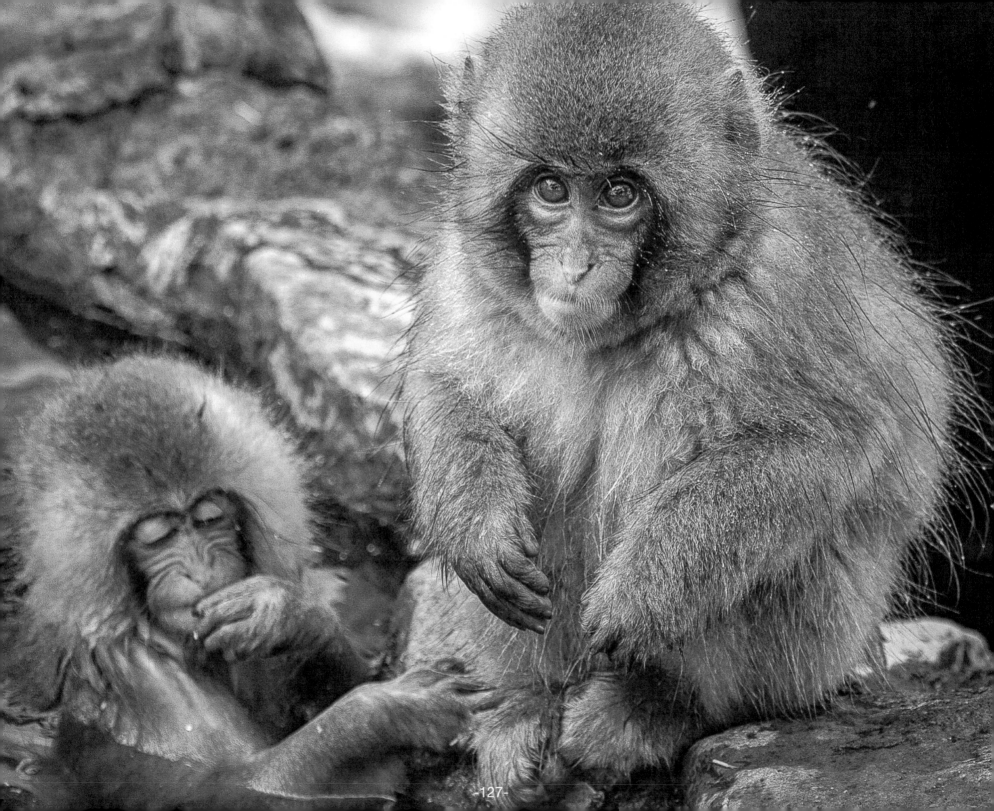

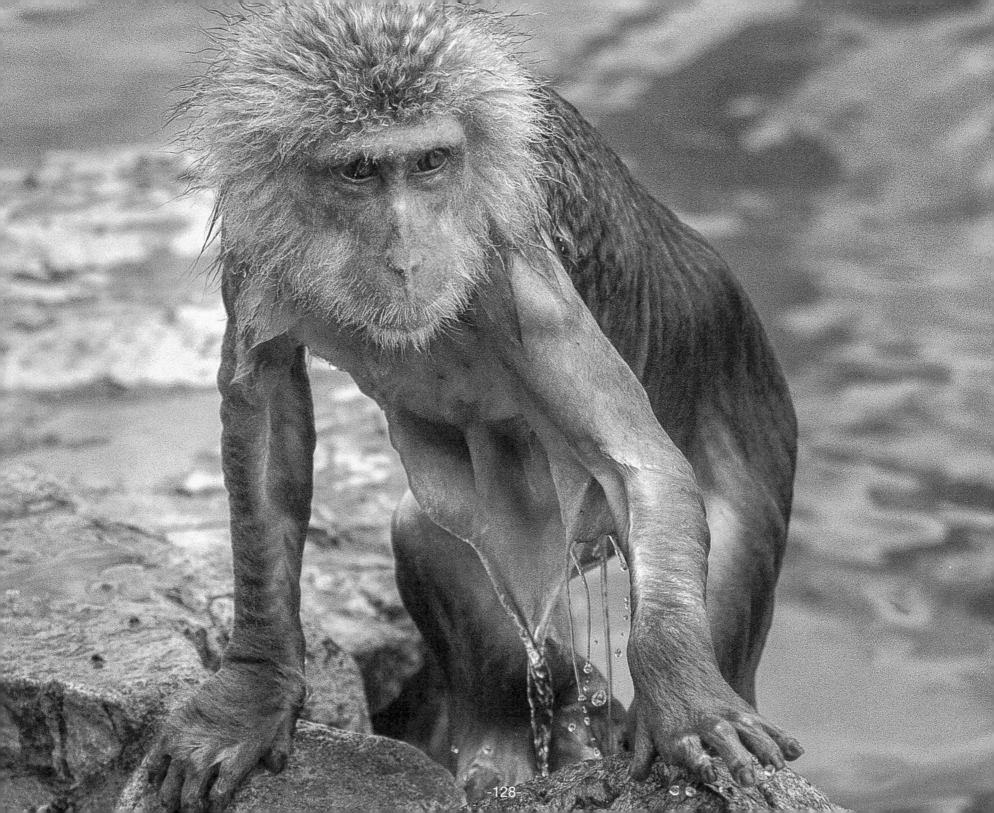

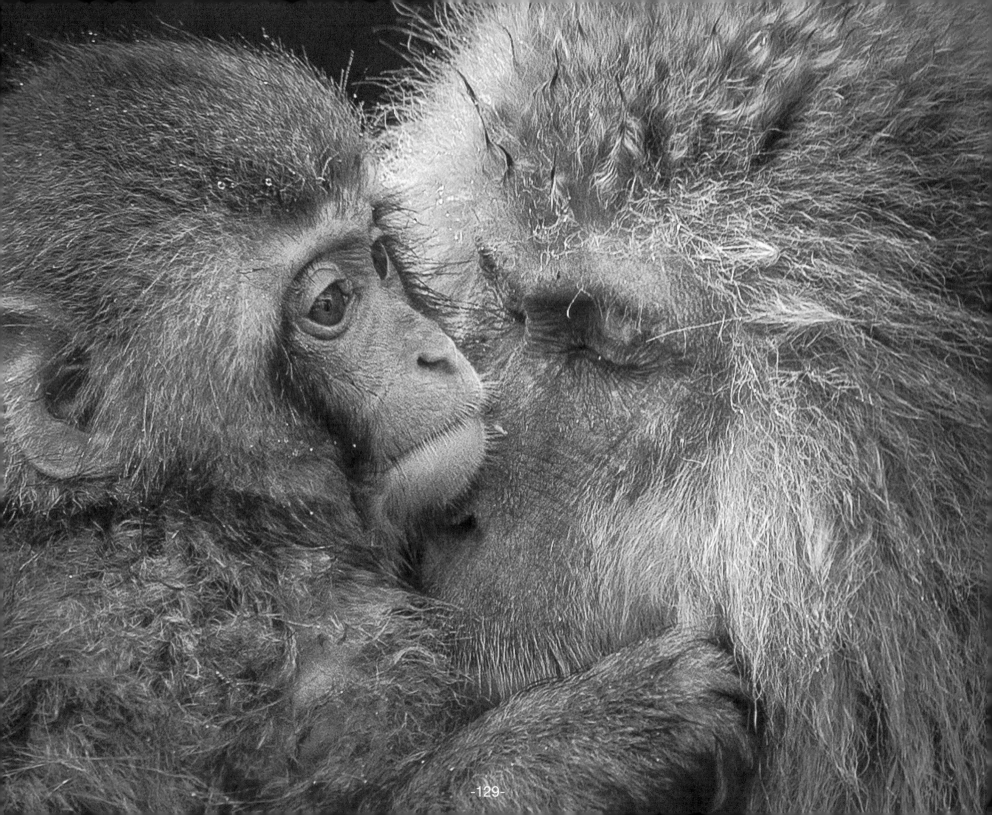

"Perhaps we only seem like islands because all our shared underpinnings lie unseen below the surface. Now and then we might detect submerged connections by a whiff of something familiar, by an upwelling of memory or empathy, or the urge to show kindness to another creature, like a visible pattern of ripples at the surface caused by something lying far below. What a different view of life we would have if we mapped our islands not by their perimeter as seen from the surface but by their profile and foundation, showing always the roots and connections within the shared mountain chain."

—author Carl Safina

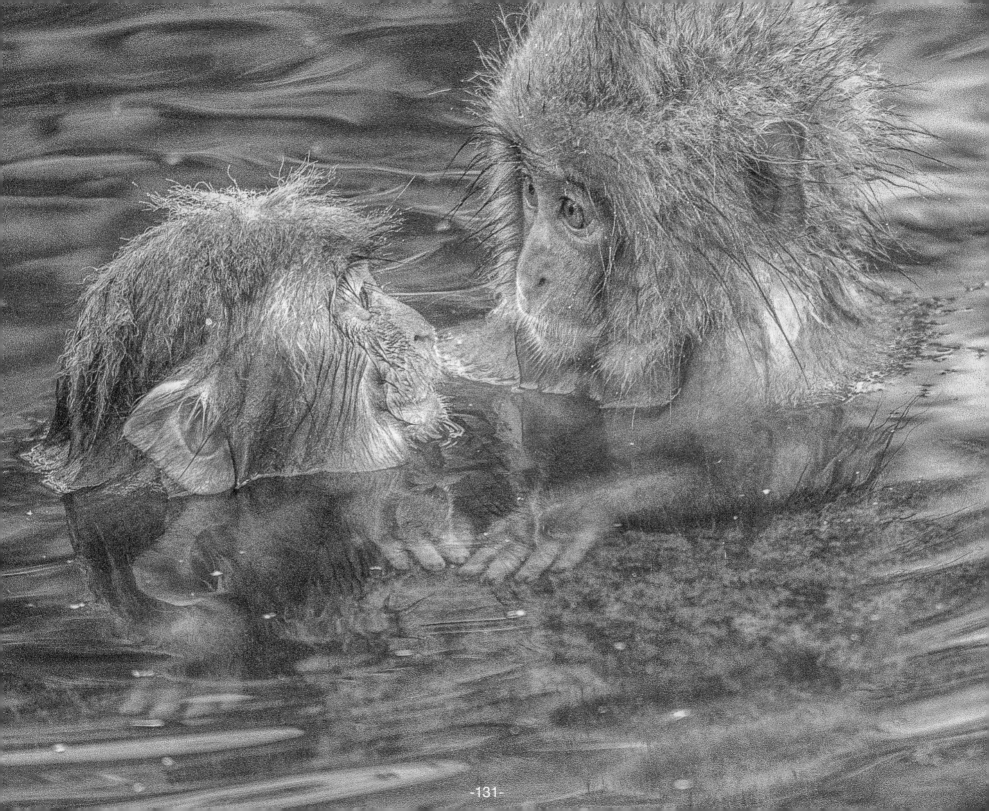

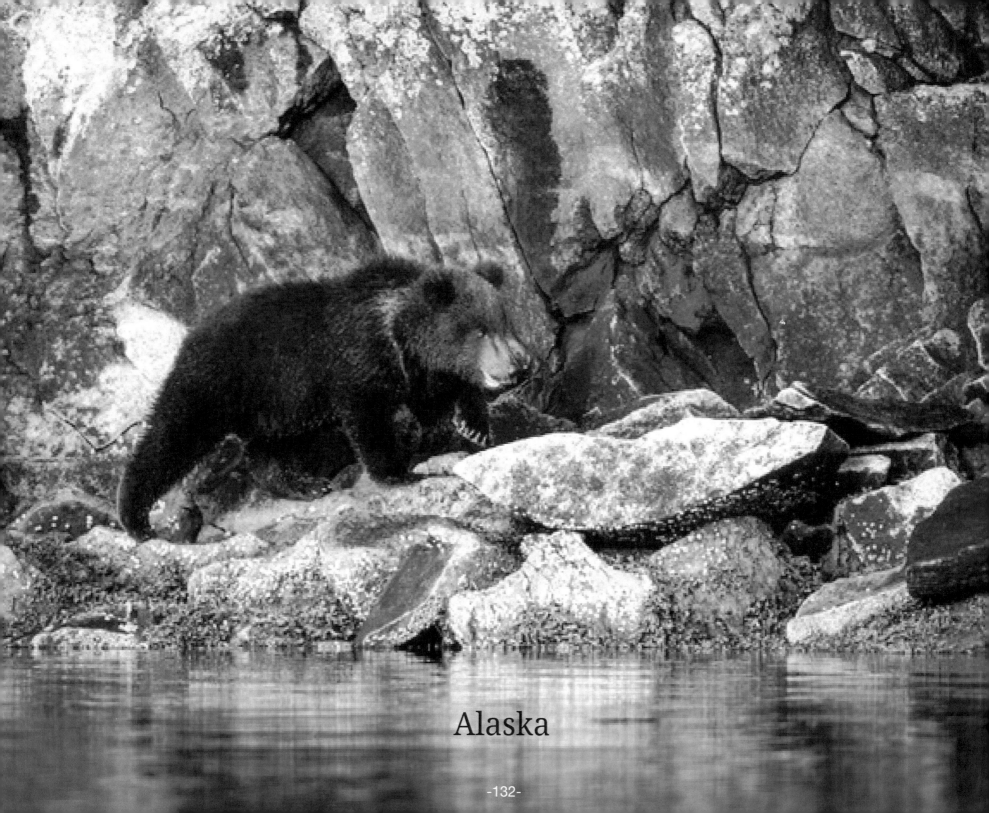

Alaska

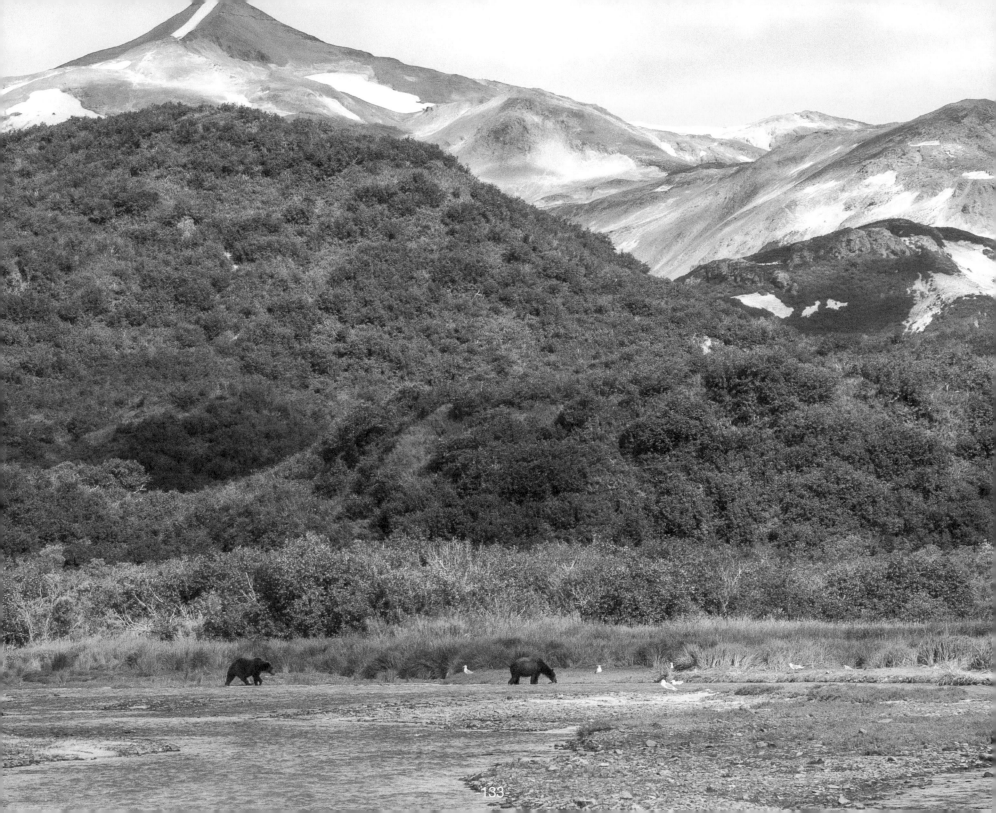

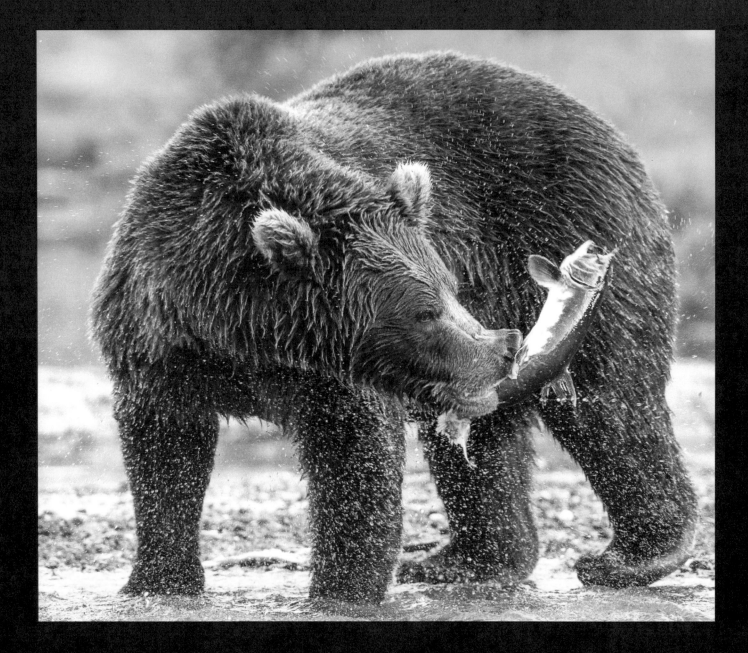

"I used to think the top environmental problems were biodiversity loss, ecosystem collapse, and climate change. . . But I was wrong. The top environmental problems are selfishness, greed and apathy"

— Gus Speth, American environmental lawyer

Bear Paradise in Alaska

We took a float plane into the bear paradise in the Katmai National Preserve, Alaska. Cameras with big lenses dangling from our necks, tripods under arms, we waded thigh-deep into the frothing current and sometimes held hands to keep from being swept away.
On all sides, bears lunged into water, emerging with salmon. Giant paws held the fish down, while mouths chopped off pieces. The fish were so plentiful, they chowed down prime parts and discarded the rest. Excited gulls swooped in for the leftovers.

Our group of wildlife photographers, under the direction of Roy Toft, set up tripods on an island in the middle of the fishing bears. Oblivious to us, two males wrestled in play. Nostrils flared, grunting, swiping, and hugging, they went at each other with fury and affection. Gigantic spruces and cedars created shade to cool them.

"Stay with the group," our guide said. "As long as you respect them, bears are not dangerous. Never give them a chance to single you out. Stand tall and never run from them." Our guide had some bear or pepper spray, which would sting their eyes enough to stop an attack.
One of the men left a red jacket on the edge of the little island we claimed. One of the adolescent bears lumbered up to investigate. Our guide, a burly guy with a Hemingway-like beard, stepped out of our group and spoke to him in a stern tone. "No, no, no," he said sharply. "We don't want bears here. Go. Go away." He had the red can of bear spray ready in his hand. The bear heard the warning and returned to the water. "I've never had to use the spray on a bear."

I watched two cubs on the water's edge, as their mother lunged with long claws, dunked her head with a splash, and emerged with a fish. Dripping water, she climbed to shore, placed the meal at her feet, and shook her head. Drops of water formed a sparkling halo.
As she ate, pulling salmon between claws and clenched teeth, one cub cried and leaned up for the morsel in her mouth. She leaned down and shared it with him. When she was back in the river, sounds flowed back and forth between the family as she peered into the frothy water and caught two small fish for them. Sparking silver in the sun, the fish dangled in their mouths as they darted along the shore while their mother fished. The love between them was palpable.

As they wrestled, one dropped his fish in the water. His twin jumped in to retrieve it, but it was lost. While he struggled to get out of the water, Mom clicked the roof of her mouth, a sign of danger. They stood tall and stared at an approaching male, then galloped after their mother. She turned back to make sure the twins were following before trotting toward the rocky exit.

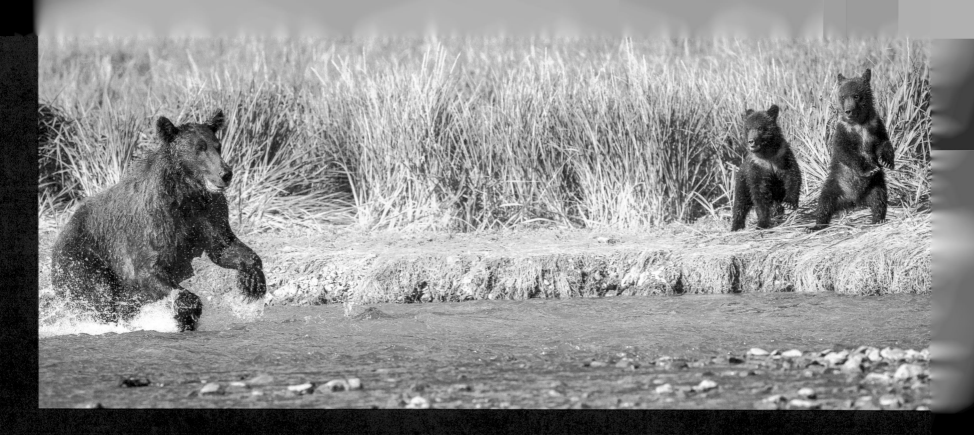

Playing God

We play God, but we are not competent to be God. We lost contact with our wider intelligence. Pope Francis, who saw all creatures as his brothers and sisters, says violence is a symptom of our sickness. He believes the desolation we are creating—unprecedented destruction of ecosystems—stems from a spiritual, ethical, and moral crisis.

With heartbreaking sadness, I remembered the bear massacre in New Jersey when over 539 bears were piled up like trash. In death, all dignity was gone. Strung upside down by their feet in the back of a truck, sticky fluids matted their muzzles.

Even more tragic was trophy hunters posting pictures of their bloodied victims on the internet. Among the selfies was a trophy hunter in front of a bear crumpled in a field. An arrow went sideways through the bear's nose, but it did not hit a vital organ. The bear's suffering was horrific. Behind him, in a camouflage suit, sat the killer, grinning. What does his beaming smile teach kids? Turning magnificent life into suffering and smell death is fun? Happiness is crushing the life out of another living being? Images like this brainwash children into our cult of superiority.

When trophy hunters in Minnesota taught children the thrill of killing, they set up the shot and told kids to pull the trigger. The kids said, "I pretended the bear was going to bite me, that's why I shot him." Or "I imagined the bear running toward me and about to leap on me." All of the children pretended they killed in self-defense. Children have a moral compass that killing for fun is wrong. But exposure to our delusion that we are more important than animals stunts children's empathy as they watch parents feel power by disempowering others.

As one keyboard protester said, "Nature does not need the help of maniacs and psychopaths with power rifles to balance the population of species. Mother Nature employs wonderful mechanisms for this. It is the human population that should be regulated." Rescuing those who can't defend themselves is a healthier way to feel power rather than killing, maiming, and destroying.

The Living System

Nature was vibrant and healthy in the wilderness of Alaska, without people, houses, and cars. All parts of the living system worked together. On the way to the Katmai Preserve, the salmon already fed gulls, seals, sea lions, wolves, and porpoises. The bears carried the fish into the forest to feed mice, mink, and crows. Insects moved in to lay eggs. Birds came to eat the insects. Shade, fallen branches, and logs protected the fish and warmed the water. Salmon fertilized the roots of plants with nutrients and created lush trees.

During the 1940s, fish companies wanted to cull bears because they feared economic damage from them eating salmon. The opposite was true. The bears help the fish become forest, because flesh they carry into the brush hatches insects, which feed salmon. There are many salmon because there are many bears.

In the 1800s, Native Americans created rock corrals to make catching fish easier. Once they got their winter's supply, they opened the barricades so fish could ascend the stream to spawn. Canneries, who had no concept of enough, used mile-long nets as permanent corrals so the area became fishless for many years. The chiefs of the Tlingit and Haida Indians could not understand how canneries would take all the fish, because they knew starvation would soon follow. By1924, Congress passed a law requiring that half of the salmon be allowed to spawn, but commercial fish companies ignored it. In 1957, President Eisenhower declared Alaska's salmon situation a federal disaster.

Alaska, through regulations, managed their valuable wildlife resources. By 1991, we stopped high sea drift-netting and banned the traps. Commercial and recreational fishermen now have a stable number of salmon. The earth is a self-regulating system. Once we step back into

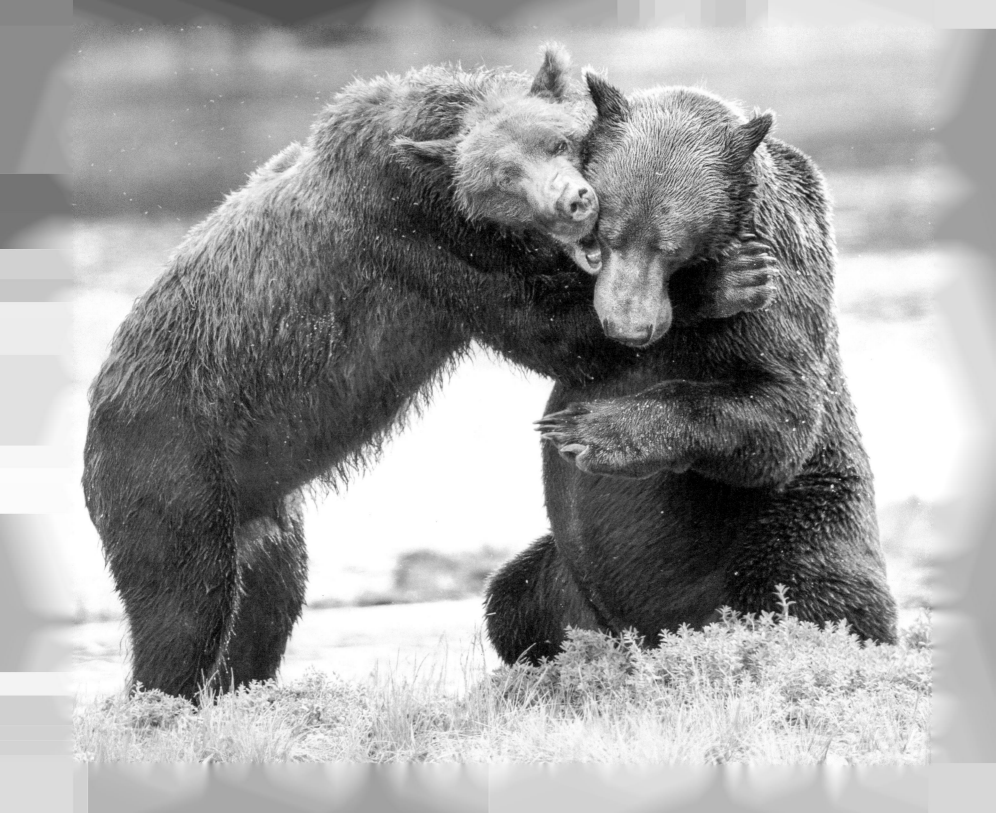

"In a changed world, we are in need of an ancient way of being. It is, perhaps, the darkest pain of the contemporary human that we are losing everything of true worth from this world. In all four directions, the animals are leaving. Through our failed humanity, they are vanishing, and along with them we are losing something of utmost importance: the human traits of love, empathy, and compassion.

For eight years, working with animals became the center of my life, the pivot point at which I learned to think. . . . It was hard work, dirty work, but in exchange, they offered me peace and healing, a kind of knowledge that is still finding its way into words. I knew I was in the process of intelligence, and I had to learn new kinds of behavior to be with them, a slowness, a stillness, and inner silence that is no longer common in our fast-paced lives. . . . But mostly, what I wanted to learn was the traditions of my ancestors and those of other tribal people to help me define the possibilities for future relationship between animals and ourselves."

— Linda Hogan, Chickasaw writer,
author of D*wellings: A Spiritual History of the Living World*

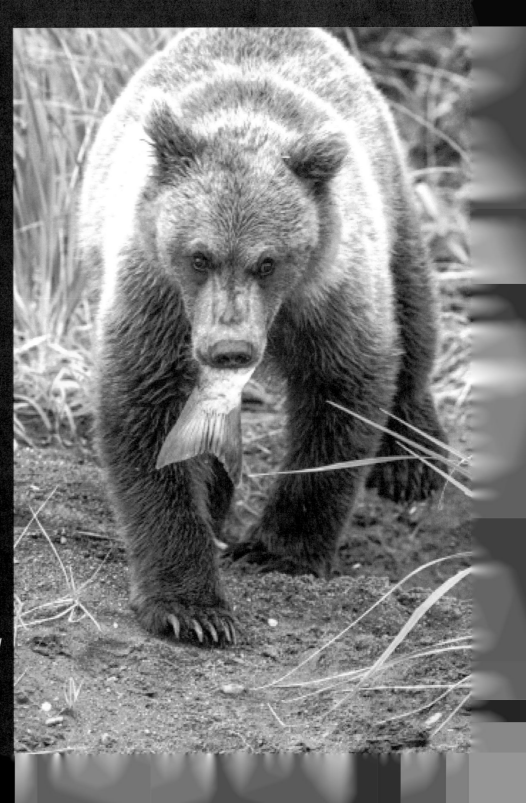

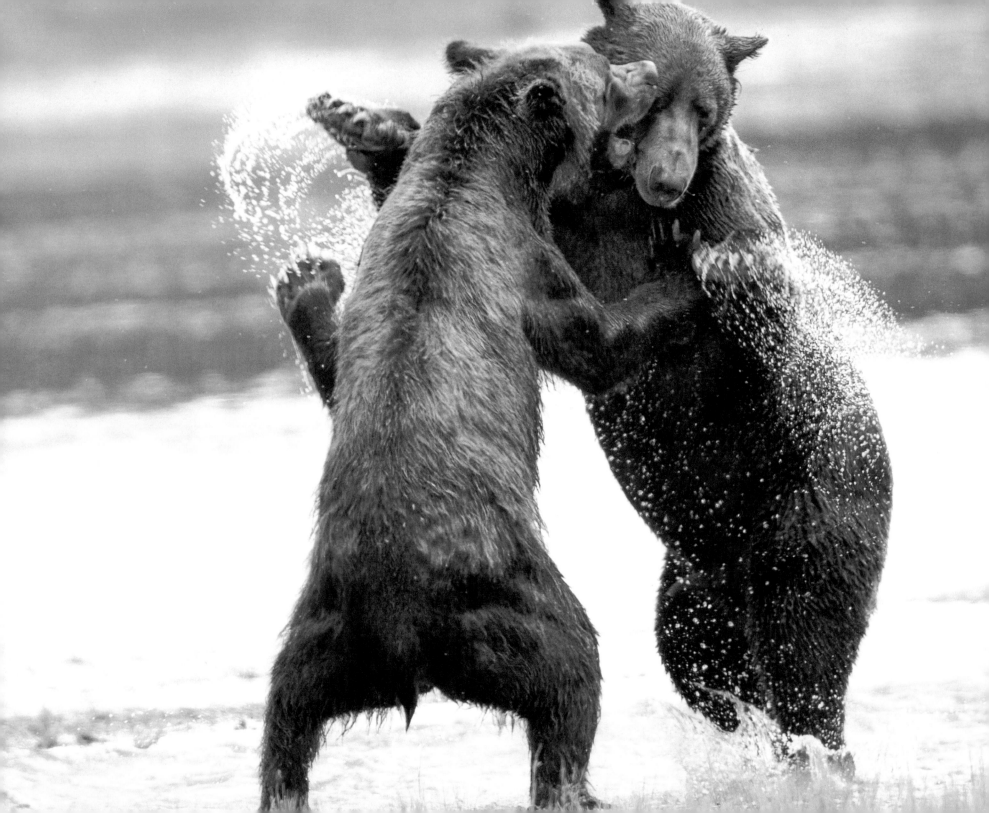

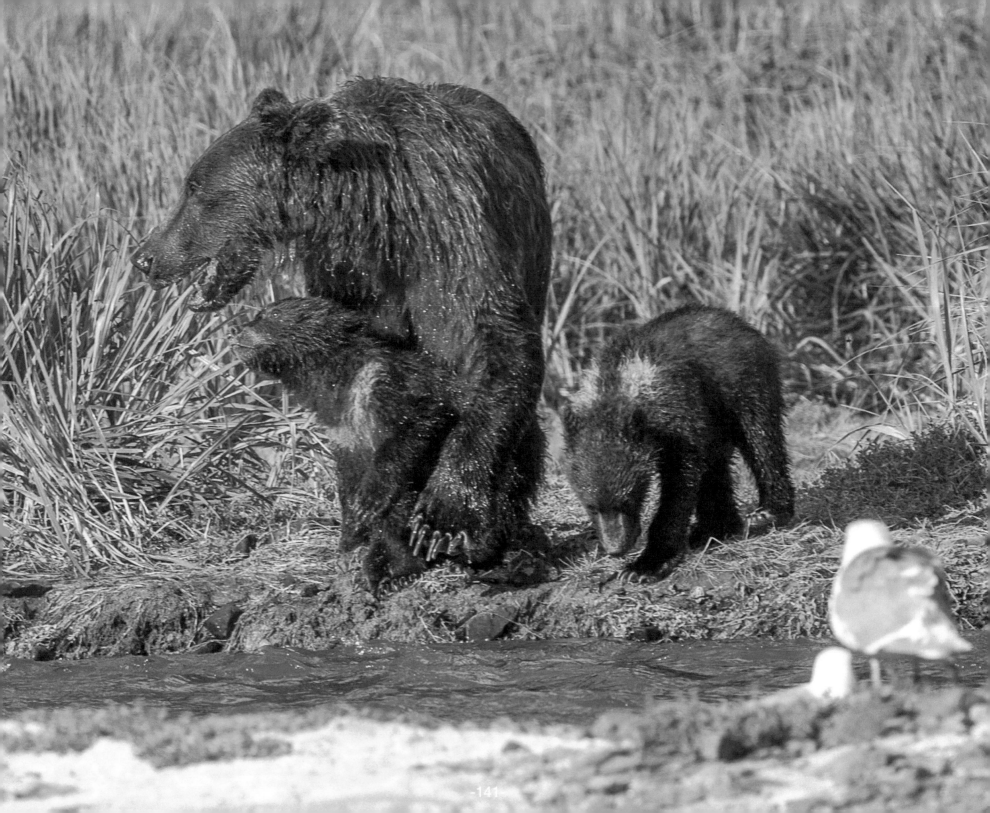

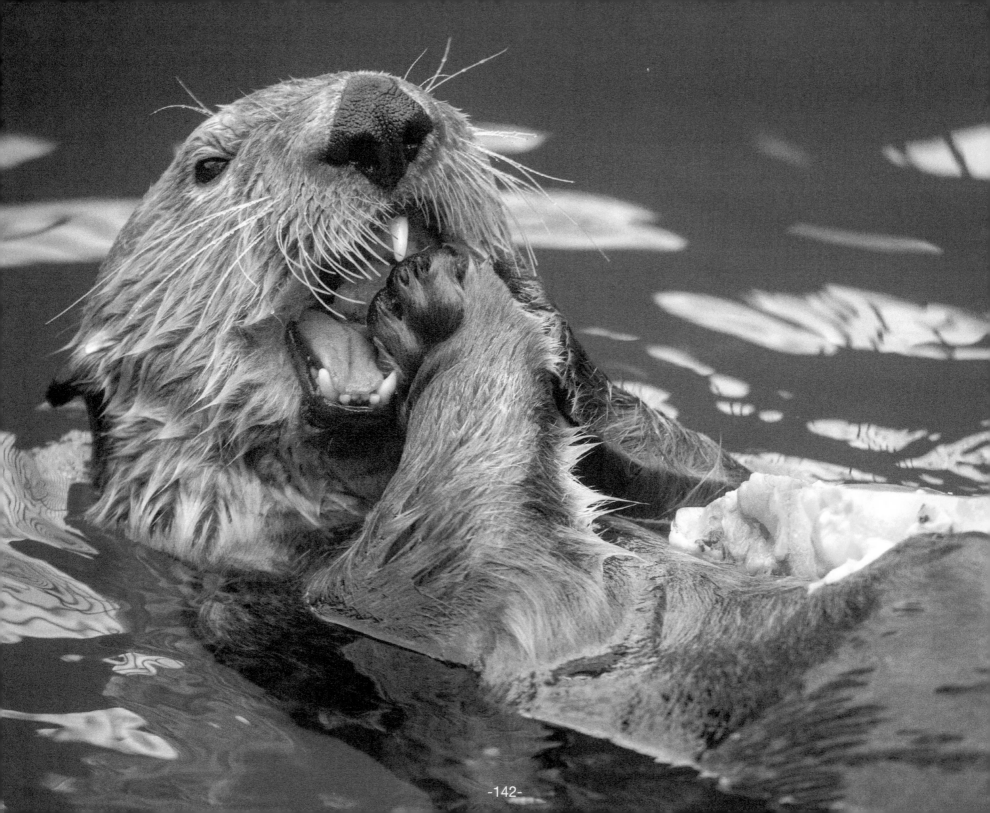

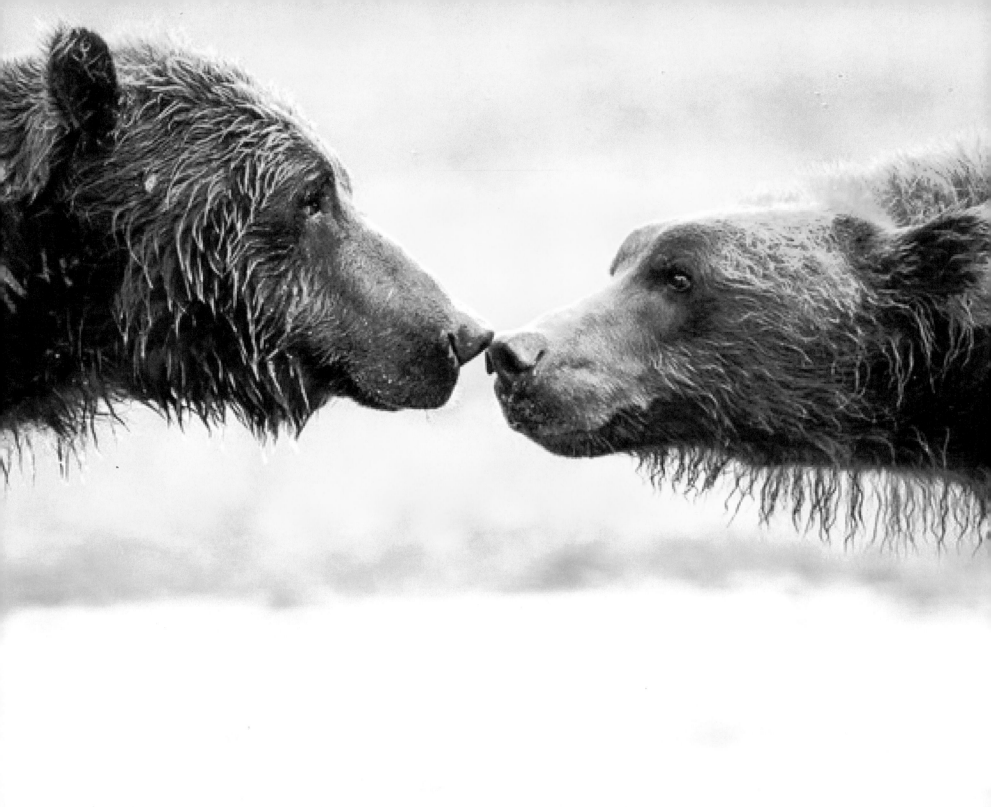

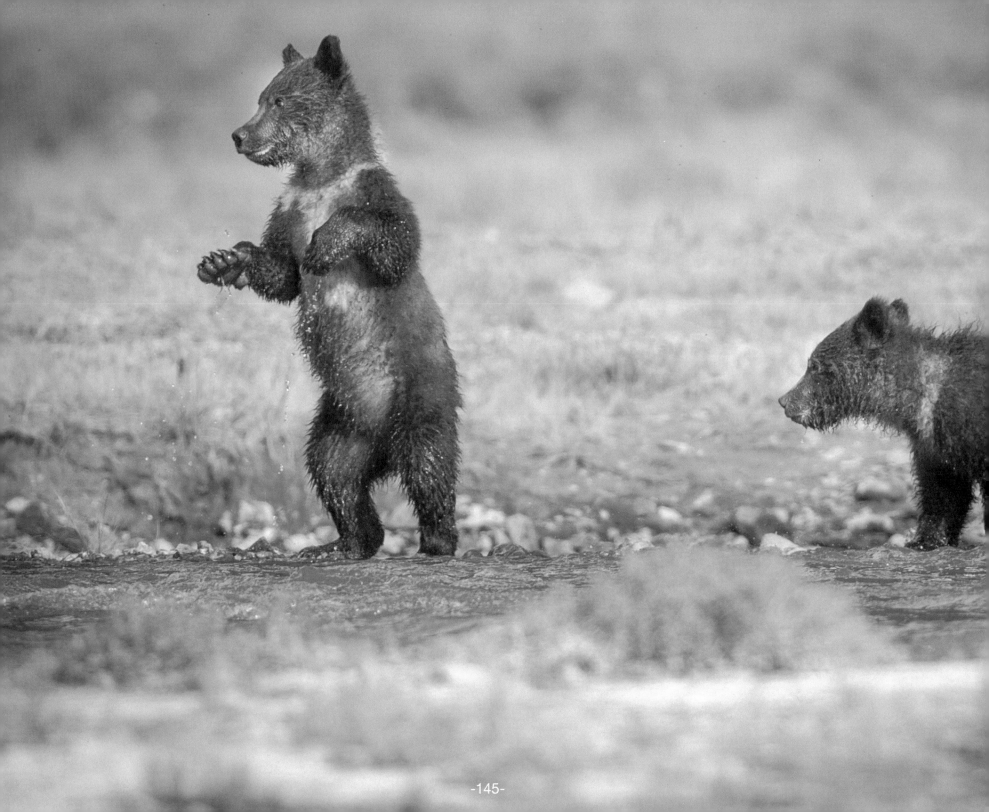

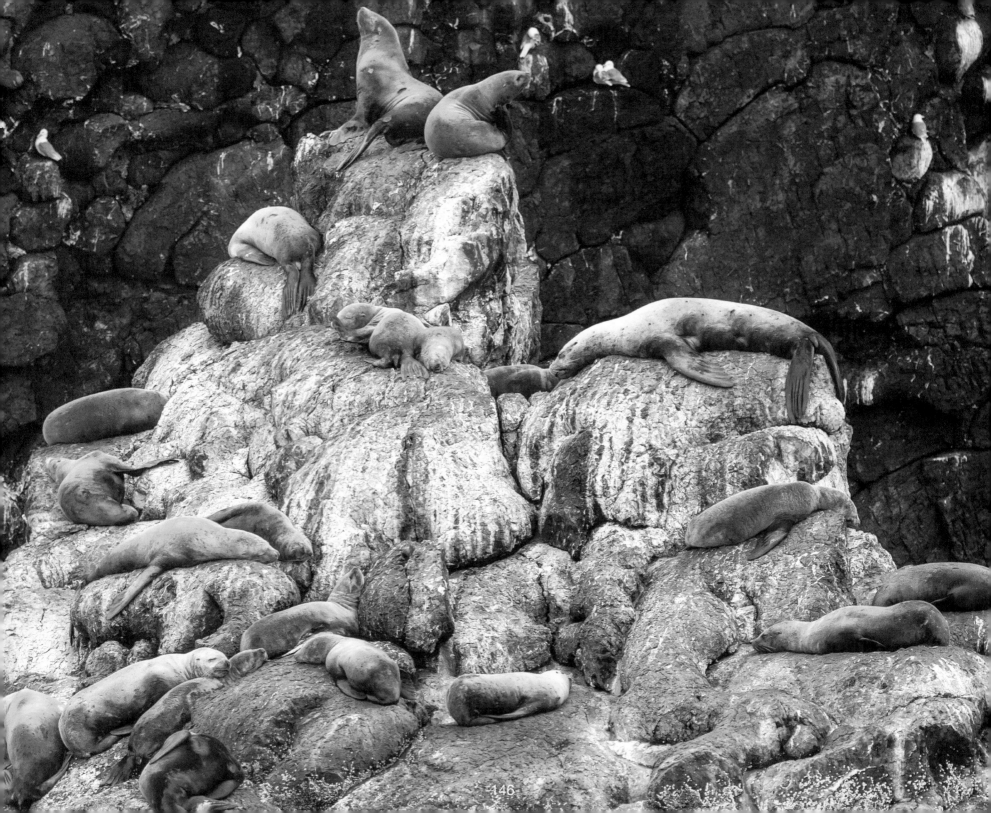

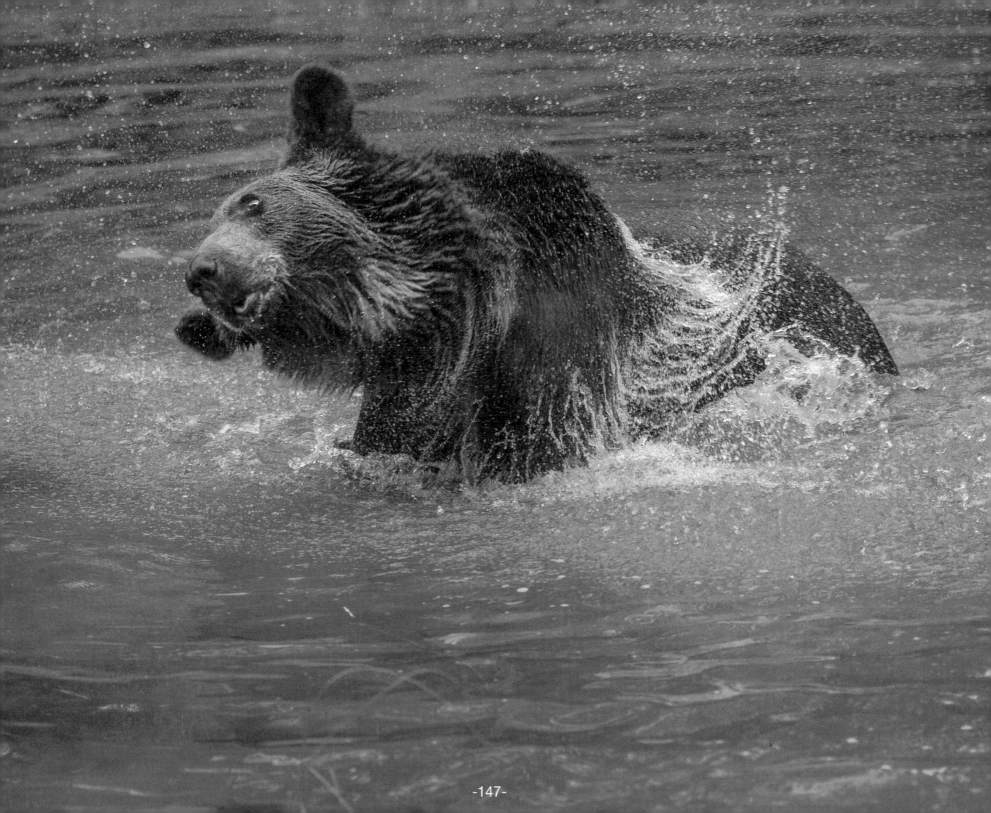

Don't Shoot

"If a man aspires toward a righteous life, his first act of abstinence is from injury to animals."

– Albert Einstein

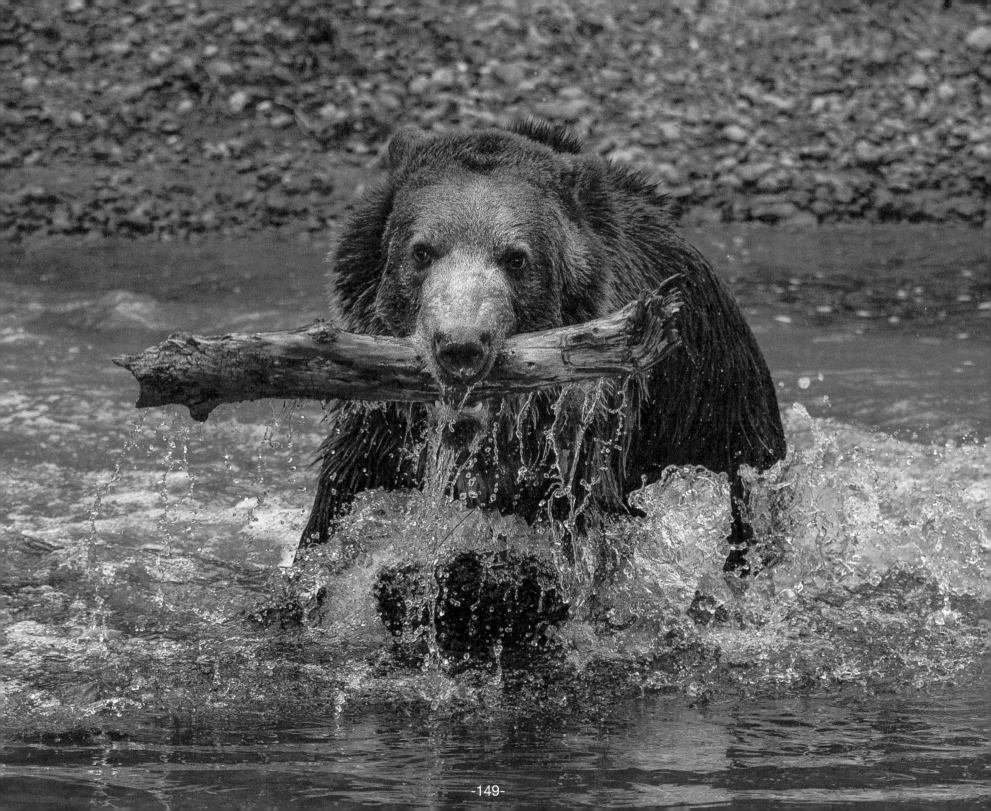

Agashya the Alpha Silverback

We hiked uphill past farms covered in the purple flowers accompanying potatoes. Other land had lush green tea leaves. Along the dirt path, three boys herded goats. Bells on the goats' collars tinkled. They kicked up orange dust as they made their way down the jungle-draped volcanoes and waved happily at us. Another boy guided a bicycle down a hill. From seat to handlebars, it was loaded with bananas.
Our guide used a machete to slice open the wall of vegetation with bamboo thickets as we made our way to visit the Agashya family of gorillas in Volcanoes National Park, Rwanda.

Agashya (which means The News) got attention when the alpha male took off with the family of the previous silverback, Nyakarima. He expanded his family from thirteen to twenty-five by wooing lone females to procreate. Since he took females of other males, he feared threats and frequently took his family uphill.

The females had been habituated to humans by rangers who spent time with them, so they were comfortable with people. Agashya had been wild when he took control of the group, so the rangers thought they would have to start the habituation process over again. However, the females showed him humans meant no harm, so he didn't try to flee or fight.

Before we started out, we met with a guide who explained what to do if a silverback approached: squat submissively and avoid eye contact. We practiced the deep guttural hum that is a calming vocalization. He also illustrated the high-pitched one that was the opposite. Gorillas use hums, melodies, and barks because they can't see each other in the dense rainforest. Our guide explained that once we got close to the gorillas, we would leave the porters and take just our cameras. After spending one hour with them, our guide would announce it was time to leave.

We piled into cars that drove us close to where trackers located the Agashya family that morning. When we got out of the vehicles, we met porters to carry camera gear and water, leaving our hands free to grab trees and branches to balance ourselves as we tripped on vines and trekked over rocks and thick branches.

After cutting through brush and going up and down hills of tangled vegetation, we came to a clearing where a silverback rested, face up. In the background was a smaller female, who sat calmly near a toddler.

Between ourselves and other species is a space of respect. On another trek, our leader leaned too close to a silverback to lift branches for someone's photo and was charged. Our leader squatted down and showed respect, so the silverback backed off but continued to watch him suspiciously.

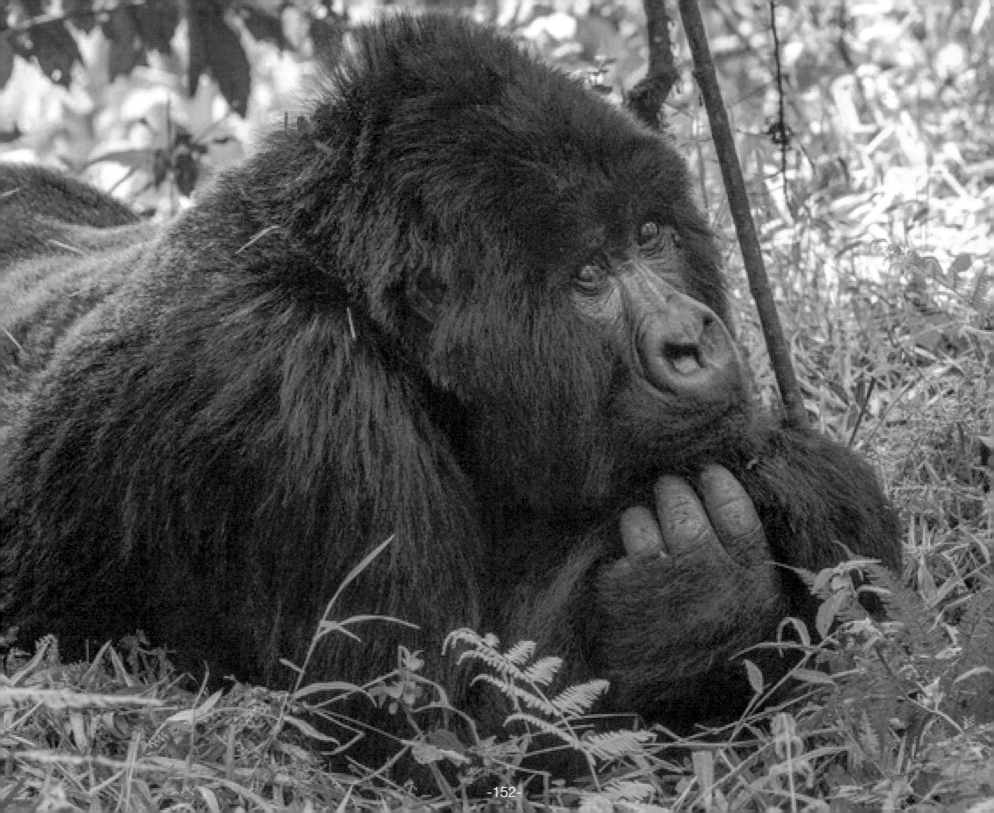

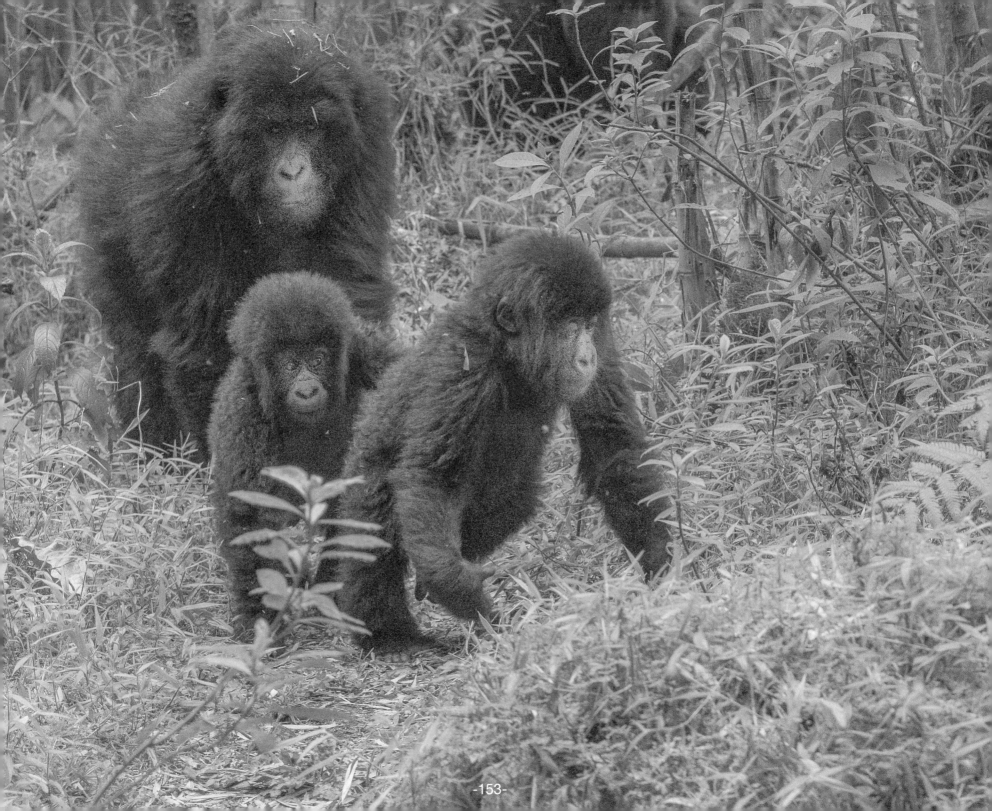

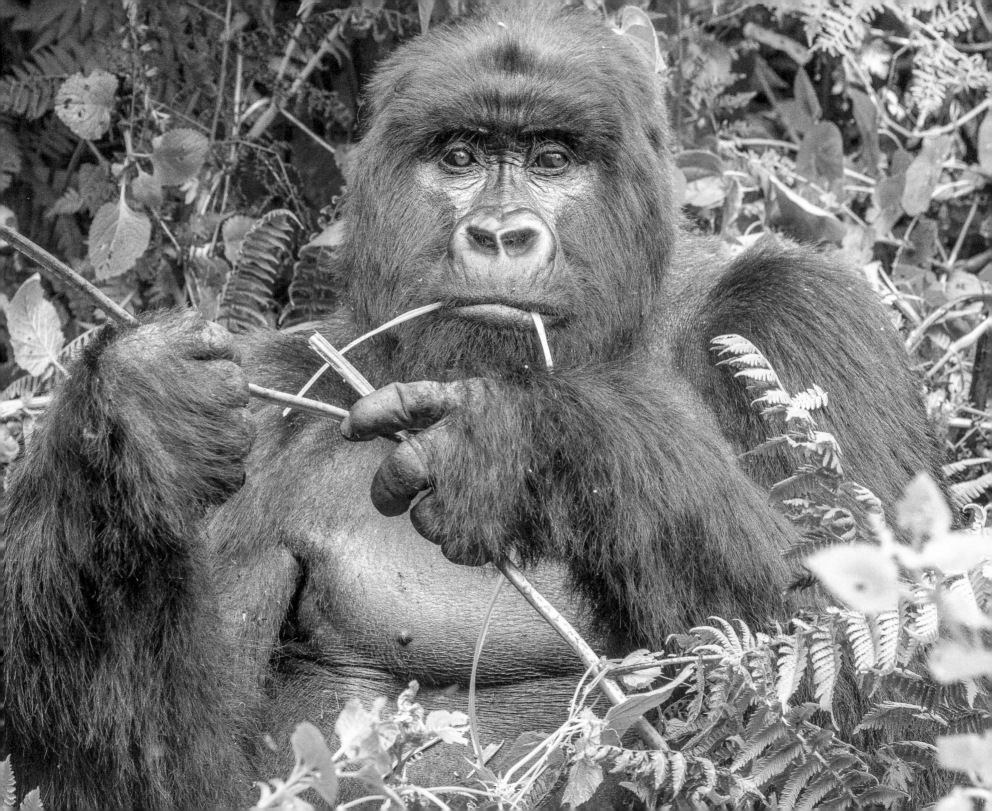

The men in our group stayed with the silverback, watching as he shoved leaves in his mouth and hummed with a soft-graveled voice. There was something sly in his eyes as he posed for pictures, something he did for an hour every day.

Previously, I had learned how peaceful and empathic gorillas were when I read *Songs of the Gorilla Nation* by Dawn Prince-Hughes. She explained how a family of captive gorillas at the Seattle Zoo brought her out of her shell of autism. Because gorillas were sensitive, subtle, and nonthreatening, she was able to get close to them the way she hadn't with humans.

Living in a zoo, their confinement reminded her of the autistic wall between herself and others. When a gorilla called Congo touched her, she connected in a way she never had with a human person. He was in a corner when she shook the tin bowl of strawberries. He rose up massively and hoisted himself below the ledge of the window, where she fed him. It began a long relationship with another being who brought her out of isolation and helped her learn to love.

One day when she had had a terrible week, he furrowed his brows and rushed over to put his shoulder down so she could place her head on it. She had her head on his shoulder for over thirty minutes. She learned you can't worry about looking like a fool or getting hurt. It all boils down to wanting to connect at all costs. Congo's love opened her heart.

There is a mysterious third world, the shared habitat of the
heart. There is the deep connection between a person
and another animal. It is the permeability of empathy. It is
the connection that extends from within us, across the mysterious
between, and into another being. If we're lucky, we feel
something almost indescribable in return."

— Richard Louv, *Our Wild Calling*

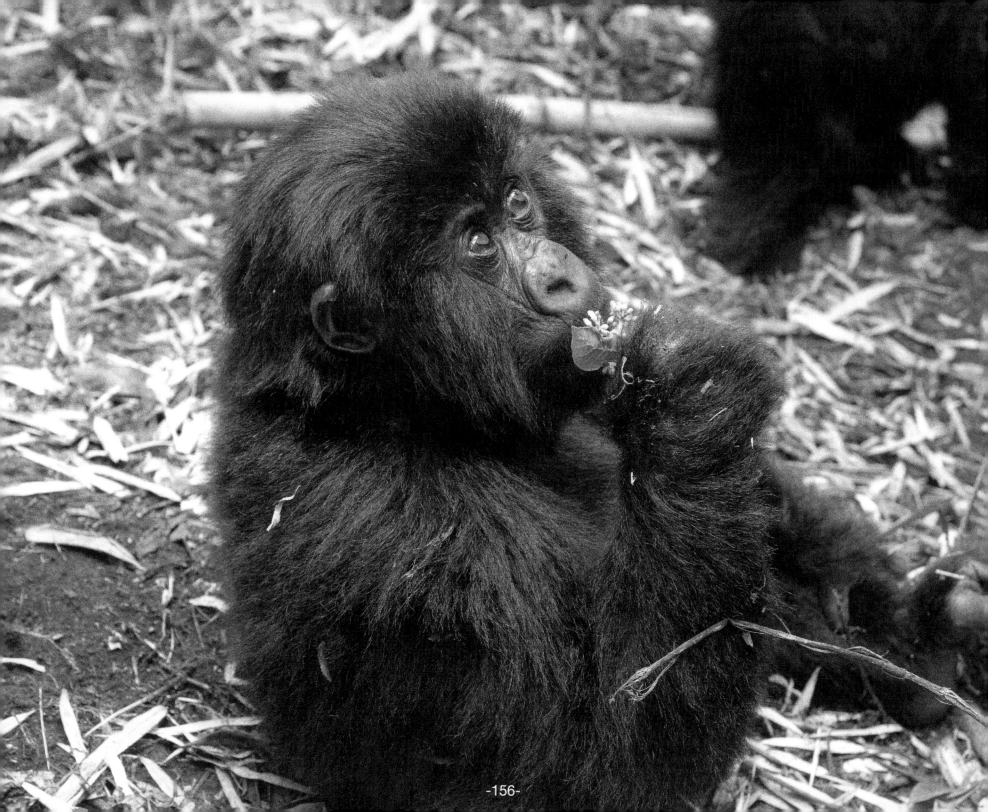

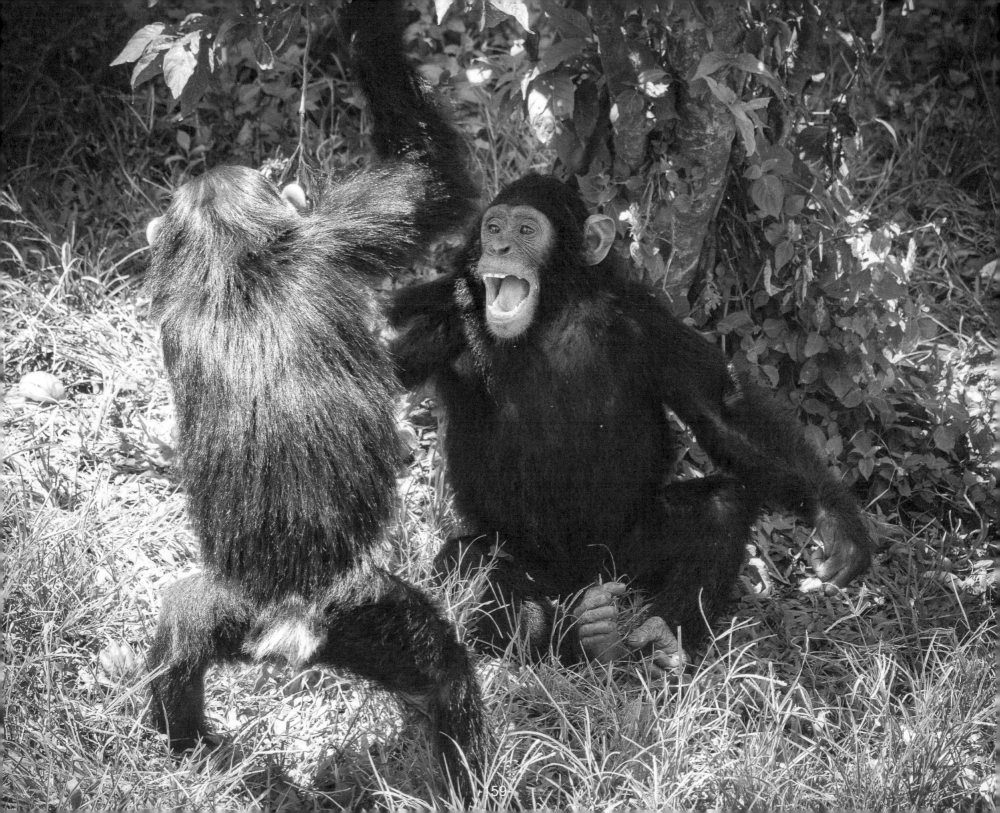

What Dogs Teach Us

Emerging from a morning dream, I heard a whine. Two paws, near my nose, framed dancing eyes, and a juicy black nose. I kissed Gabby's nose and leaped from the bed. A Dandie Dinmont terrier, Gabby has the face of a sheepdog and the body of a snake. Drumstick legs spread out behind her on the mattress, as her eyes followed me. As I struggled into clothes, I realized it was Easter and we were sheltering in place to stop the coronavirus pandemic.

With a Clorox wipe, I disinfected the doorknob of my condo building before I let Gabby out. She bounced down the stairs, greedy to greet the day. At a bush, she inhaled scents, driving her snout in, then her whole head, smelling skunks and raccoons who came by during the night. Re-sniffing from different angles, she threw her whole body in, inhaling while wiggling her butt. She absorbed vast knowledge about which I was clueless.

I tugged on the leash. Her nose, stuck with dirt and leaves, emerged. Our eyes connected. We made a wild dash for the beach, where the red-and-orange sun spread fire onto the water. She scurried around, inhaling fumes from a dead fish, seaweed, and shells. She was a hunter, a stalker, and an explorer.

She rushed a flock of seagulls. After watching them flap into the sky, she sniffed the scent of a brown dog coming down the beach. The other dog was twice Gabby's size. They rubbed noses. They raced and lunged. Feet in the air, tongue lolled out the side of their mouths, ears flew in the wind. They embraced mid-air, then thudded into a sand dune.

Gabby raced in circles with the taller dog behind, then somersaulted to evade a nip. As her paw prints wrote her joy in the sand, Gabby helped me live in a more innocent world. She probably missed standing up and waving her paws in the air to greet Inna, who was usually at the beach. She didn't know that Inna, a pulmonologist, was in the Intensive Care Unit, on the front lines of a new war with a virus. I was so glad Gabby did not know about the torture of dogs in Chinese wildlife markets and the plague of human cruelty that had started the pandemic, and which has killed 135,000 people so far.

At home, I listened to Pope Francis, who said the smallest element of nature had created a viral genocide, a clear message we are not all powerful. The pontiff hoped the pandemic would unmask the false superfluous priorities of modern life and help us find our way back to health by small acts of kindness, tenderness, and communion with nature.

The quarantine had canceled family dinners, so I celebrated the holiday by feeding rabbits who had moved to a wooded area when their forest was destroyed. (Easter was named after Eastre or Ostara, the Goddess of Springtime who saved a frozen bird by changing him into a rabbit who could lay eggs.) In the car on the way to the rabbit's den, Gabby stuck her head out the window. Nostrils opening, closing, ears flapping, eyes blinking, she said, "Arf, arf, arf," "I am here. I love life."

Like the Pope advised, Gabby delighted in our natural world and taught me what was true. In the deepest part of her being, she just wanted to belong. After an absence, she was a frenzy of squirming, butt–wiggling, and licking. Contact with who she loved became ecstasy.
When I get engrossed in a book, Gabby nudges my elbow up with her nose so I will pat her. When I watch a movie, she rests her head in my lap. She perks up and looks at the screen when a dog barks. She likes to watch leopards jumping into trees, hear lions growling at each other, and any program by *The Dog Whisperer*. She falls asleep with eyes flickering, legs moving slightly to the trot in her dream. When she yelps, I cradle her head to soothe her.

Dogs and other animals know what's important. They teach us how to love unconditionally. Anyone who has shared their life with a dog knows animals are more than a commodity.

Part 5
We Can Solve This

Tanks Meet Sacred Buffalo

Trying to live in alignment with Mother Nature's wisdom led me to stand with Native Americans at Standing Rock, North Dakota, trying to protect their water from Big Oil. In the fall of 2016, when ordered to leave the land Native Americans say was theirs by the 1868 Treaty of Fort Laramie, they refused and were tasered, clubbed, thrown to the ground, hooded, cuffed, arrested, and shoved into dog kennels.

Native Americans believe our mother created deep pockets of oil in the earth for a shock absorber. Their mission was to unite global communities to stop the continued contamination of our food, land, and water. Mother Earth, they believe, cannot sustain more chemicals and warfare.

The oil company held different assumptions about land and nature. Corporations didn't question their belief that whatever could most efficiently convert forests, rivers, lakes, water, minerals, and live animals into money was worth the collateral damage. On the side of the oil company was a massive army of tanks, Humvees, trucks, and National Guard soldiers and police in riot gear.

The space between the two sides vibrated with tension and fear. The Native Americans remembered broken treaties, slaughtered buffalo, robbed lands, and the killings at Wounded Knee. Behind a barrier of tires, wood, and hay, water protectors prayed and burned sage and sweet grass trying to incinerate hate.

A young Native American with a long black braid and a lone feather flowing behind sat on a white horse. The horse's thigh was stained with blood. Beside him, a chief in full feather regalia held a bottle of water to the sky. He danced and chanted to drumbeats.

The conflict was from vastly different world views. As Chief Luther Standing Bear said of white men, "The love of possessions is a disease with them. They claim this mother of ours, the earth, for their own and fence their neighbors away." Native Americans believe ownership by humans does not give nature, wildlife, or the unborn a right to life. They believe our use of toxic chemicals and our lust for endless gadgets and cheap cooking oil are eating the earth alive. They believe it is a "disease of mind" to believe more killing will bring peace.

"How does one own one's mother, the source of life?" one of the water protectors at Standing Rock asked. As our Western culture stakes a claim on the earth and refuses the rights of other species to share it, we lose connection with love, compassion, and empathy. Only a failed humanity loses what gives life meaning.

A fundamental contest of our age was being played out. Powerful industrial forces are turning natural resources into profits for a few. The damage to air, water, and soil erodes our health. Although the physical camp of Standing Rock is gone, the spark that began there, with the belief

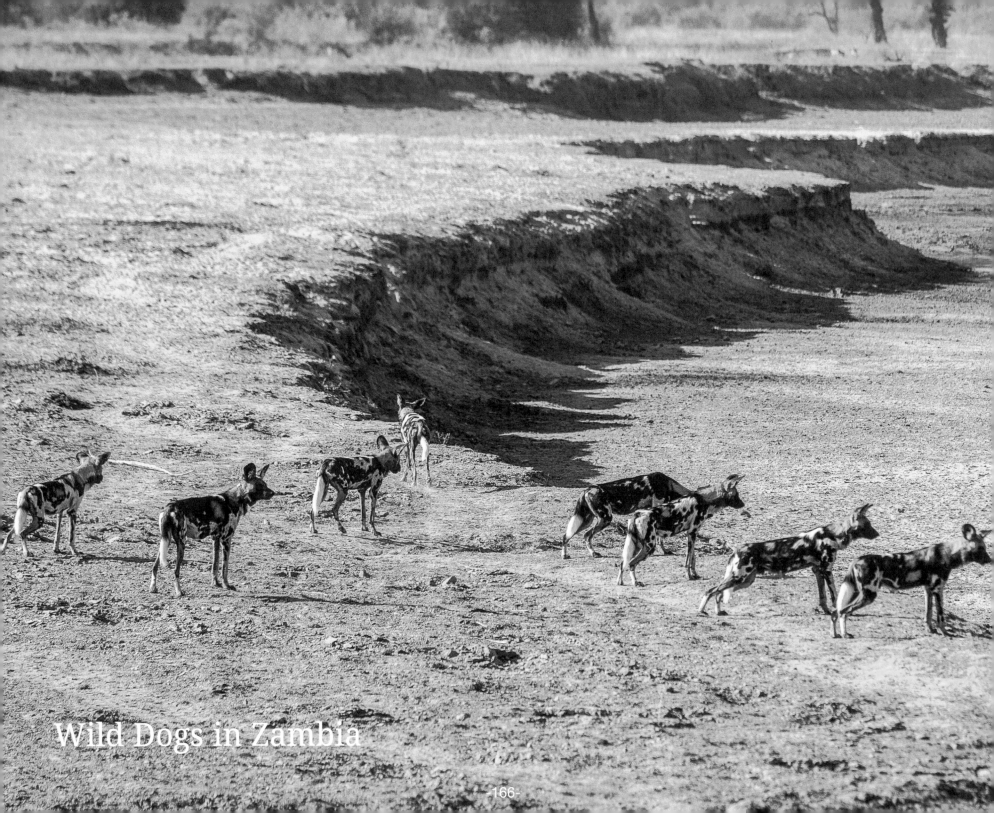

Wild Dogs in Zambia

Healing Our Disease of Possession

In *Owning the Earth*, historian Andro Linklater said that until two centuries ago, land was communally held, sometimes with a monarch or the church. The assumption was that land belonged to our maker. He showed how private property cultures were insidious because of the selfish way they shaped one's outlook and promoted greed. One person profited regardless of the consequences to the community.

The Industrial Revolution began a large-scale destruction of resources and habitats. Factories dumped chemicals into water and human homes took over the habitats of wolves, bears, coyotes, and mountain lions. Fearful when carnivores wandered into yards, many people slaughtered them. The killings came from our assumptions that we own the earth.

The earth is 4.6 billion years old. If we translate that to a scale of forty-six years,

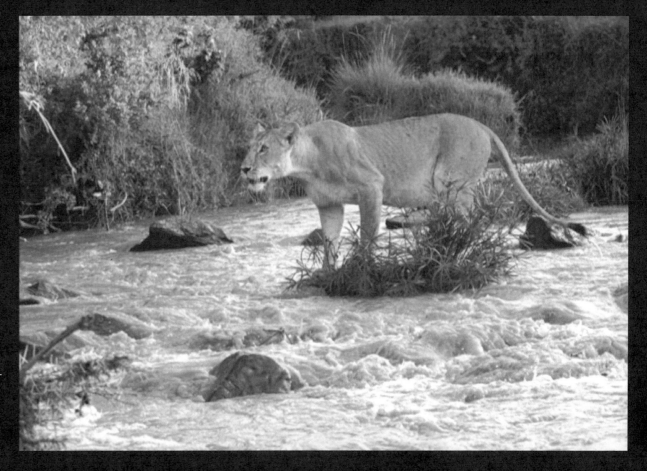

we humans have been here four hours. A 2014 study by Greenpeace showed that since the Industrial Revolution, one minute ago, we have destroyed 50 percent of forests—oak, elm, cottonwood, cedar, spruce, and birch trees—upon which life depends. A report by the World Wildlife Fund shows that two-thirds of wildlife are gone.

The colonial era belittled the culture of semi-nomadic cultures attuned to nature and the seasons but given the damage industrial societies have done to the natural world, we need to welcome their wisdom.

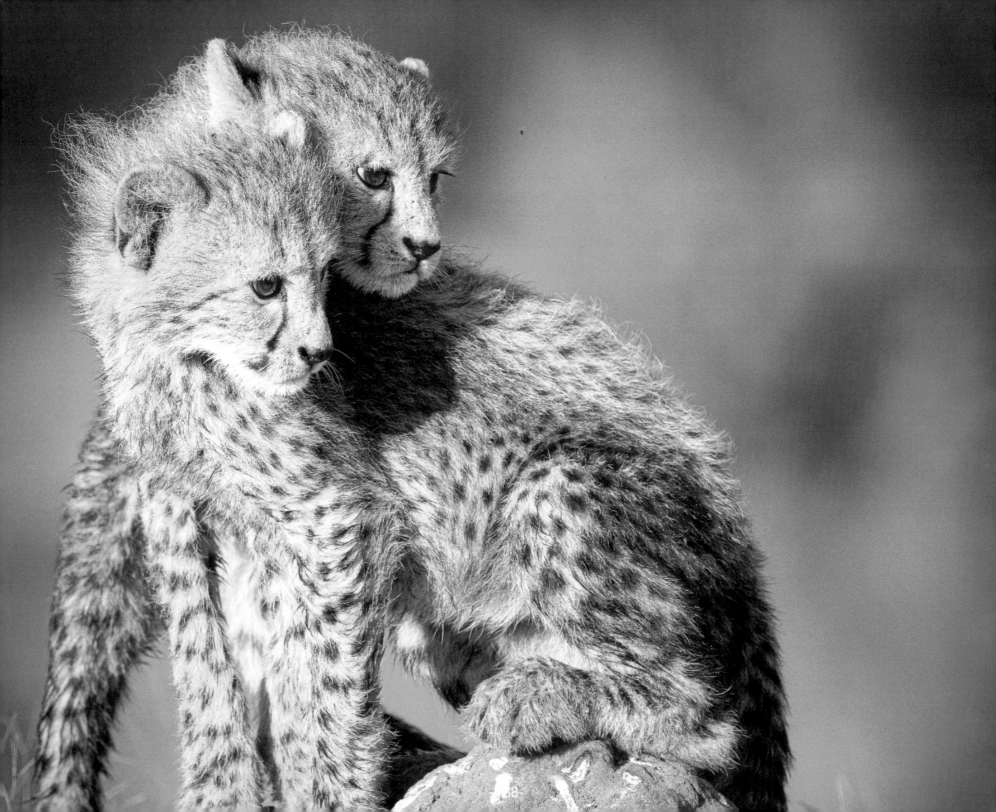

The Blanket over the Porcupine

"It's a mouse," my patient said. She pushed a strand of blond hair from her face and raised her eyebrows to get a better look at me. There was a smirk on her face that let me know she thought I'd lost my marbles.

She was taken aback by the elaborate nest with tunnels, baskets, logs, and branches I'd built to relocate a mouse from the underground cities of my kitchen. "Yes, lots of animals eat mice," I explained. "I had to give him hidey-holes to escape predators." I didn't tell her his name, Gabriel.

"It's a mouse," she repeated, meaning he was *just* a mouse. My patient, a biology teacher, taught her students to dissect frogs. To acknowledge that little creatures mattered was not a place she would go.

I didn't tell her about my tender feelings as Gabe trembled when I loomed over him in the translucent green cylinder where he spent much of the night. The humane mousetrap had caught his tail, like a snake slung over a door. He hadn't even gotten to the cheese. I pressed the door to release his tail and he scampered back and forth, looking for a way out.

One end was snapped shut. The other end was a gate that slid up to release him, which I wouldn't do for two days because of rain. So, I filled a bottle cap with water and slid it under the gate. Gabe dipped his hands in and rotated his paws back and forth around his cheeks and snout to wash his face. Then he stood like a small brown angel, his tiny pink palms together, as if in prayer.

Then, Gabe channeled his inner lion. When I raised and closed the gate again to toss in bits of cheese, carrots, and apples, it came off its track. In the space between the gate and cylinder, a pink nose with whiskers stuck out. His neck strained with the effort to wiggle the gate open, but I held my thumb on it. Next, ten tiny pink fingers with delicate nails rounded into soup spoons as Gabe pressed with all his might to free himself. His shiny eyes were fierce as he struggled. I felt sad as his hope of escape turned to a primal fear of capture. He didn't know about the mansion I had built for him.

My patient's superiority over this magical little fellow is how our culture is breaking the web of life. To envision how we might value our interconnectedness, I remembered an exercise in moral reasoning we did at the Harvard Graduate School of Education, where I studied human development.

My professor, Carol Gilligan, was the author of the transformative book *In a Different Voice*, which shook up psychology by showing how making decisions from care, sensitivity, and connectedness (typically female reasoning) were not less developed than decisions based on a hierarchical order (typically masculine reasoning). We did research by asking people to solve a problem of a family of moles. The moles had offered shelter to a homeless porcupine during a blizzard but were being stuck by his sharp quills. Living in their home hurt, but the porcupine

interviewed a female economics major at MIT and a young man attempting to become a writer. The young woman, who was entering a profession with hierarchical rules, said, "It's simple. It's property rights. The porcupine has to leave." This form of reasoning, central to many of our institutions, is described as hierarchical rights and an ethic of justice. One person, frequently the one with more power, wins, and the other loses. Sometimes, the one who loses dies. The young man, who watched his parents warring over property in their recent divorce, found a solution that honored the needs of both parties. His solution was to drape a blanket over the porcupine's sharp quills. Just because he didn't have a home didn't mean the porcupine had to die. In the young man's solution, the needs of all were taken into account.

Gilligan believed that these two methods of making moral decisions, one from hierarchical rules or rights and another from connectedness, are both needed. They are complementary. Gilligan challenged her mentor, Lawrence Kohlberg, who believed hierarchical rights were more morally advanced than making decisions based on connectedness and care. With the exception of indigenous communities, these hierarchies have led to many horrors of violence and warfare.

Two psychologists questioning the sustainability of hierarchical and mechanical models, Cheryl Charles and Bob Samples, in their book In *Coming Home,* show how natural systems encourage us to see we are part of a larger whole. In healthy systems, all lives contribute in a synergistic way. Kathleen Allen in *Leading from the Roots: Nature-Inspired Leadership Lessons for Today's World* applied lessons from the genius of nature to revision change. She points out that machines and closed mechanical systems emphasize uniformity while living systems flourish with interconnections, diversity, and the ability to adapt.

When we dump plastic in the already clogged ocean, we can see how industrial systems are inferior to the genius of nature where the waste of one species is food for another. Not only has our hierarchical dynamic broken the web of life, but it is fundamental to our laws. Property law is founded on the delusion that we own land, trees, soil, and rivers. It is a human construct. We give human beings the earth and take it away from other species in violation of Mother Nature's design.

During my lifetime, women have moved into traditionally male careers. Like the young woman I asked about the mole and porcupine dilemma, sometimes they used their profession's dominant way of reasoning. Other times they changed their profession. Scientists who studied primates such as Jane Goodall, Biruté Galdikas, and Dian Fossey, brought empathy to science and have been outspoken against the suffering of animals. "The man who kills animals today is the man who kills people who get in his way tomorrow," said gorilla researcher Dian Fossey.

Jane Goodall said, "We need our clever brain and our human heart to work in harmony to achieve our full potential." Goodall was criticized for naming the chimpanzees she studied. Other researchers told her scientists do not get involved with their subjects. She felt that their coldness and lack of empathy enabled them to do unethical things to animals. She said that as we kill off the wild, we are killing part of our own soul.

Science and cold detachment are clearly not the apex of moral reasoning. Our feelings are our richest, most valuable source of guidance and motivation, yet we are encouraged to wall them off with logic. Our habits and institutions began when civilizations carved out comfort from wilderness, but now we are violating Charles Darwin's basic law of survival to adapt to change.

Love and Power – Harmonizing Dominance with Compassion

For mental health, we need both love and power. We have gone too far in the direction of power. Our reckless domination and a business model of life has unbalanced nature's harmony. We cannot destroy the fundamental fabric of life and still survive.

We can learn from theologian Paul Tillich's idea of power, which he says is "the drive of everything living to realize itself." This power is generative, not destructive like the dominating kind. He defines love as the drive "toward the unity of the separated" which builds toward interdependence and wholeness. Tillich's most famous student, Martin Luther King Jr., said, "Power without love is reckless and abusive."

Marc Ching, who rescues dogs from the Yulin Dog Meat Festival in China, questions how human evolution did not develop enough to stop cruelty. Words can't capture the suffering he sees in slaughterhouses where live dogs are lit on fire. Yulin's atrocities are similar to those in the wildlife market that created the coronavirus pandemic. They illustrate how power not tempered by compassion is apocalyptic.

Human cultures are sick with dominance not harmonized with empathy, as illustrated by the decision to cage immigrant children at the United States' border with Mexico. On social media the photograph of a little Jewish boy who was imprisoned and assigned a number in August of 1939, was compared with a similar photo of little Mexican boy who was assigned a number at our Southern border in June of 2018. These decisions made from hierarchical laws are similar to the one in the porcupine parable. The little Mexican boy, the porcupine, and dogs and cats in shelters could die from hierarchical rules which views their lives as not valuable, in violation of the laws of nature which sees all life as precious.

According to University of California, Berkeley psychologist Dacher Keltner in his decades-long research, idolizing power encourages people to act like sociopaths and those with damage to the frontal lobes. Laws that reflect our delusion that only human life counts make it legal for these damaged people to hack the head off a moose for a wall ornament and deprive a bear of his one precious life

In a photo circulating the internet, Matador Torrero Munera is collapsed in remorse. He sits with his head in his hand. The other hand holds a red cape flowing over his ornate gold suit and the ground toward a bull. The animal's shoulder, where three steel spikes impale flesh, oozes with blood. Colorful, the daggers pretend there is something to celebrate in a festival of gore, agony, and human cruelty. The bull refuses to fight and gazes at Munera.

"I looked at the bull. He had this innocence that all animals have in their eyes and he looked at me with this pleading. It was like a cry for justice way down inside of me," said the Colombian about his last day as a bullfighter. "I describe it as being like a prayer…I felt like the biggest shit on the earth." His macho charade over, Matador Torrero Munera, ceased his sadistic torture of innocents and stopped playing God. He became

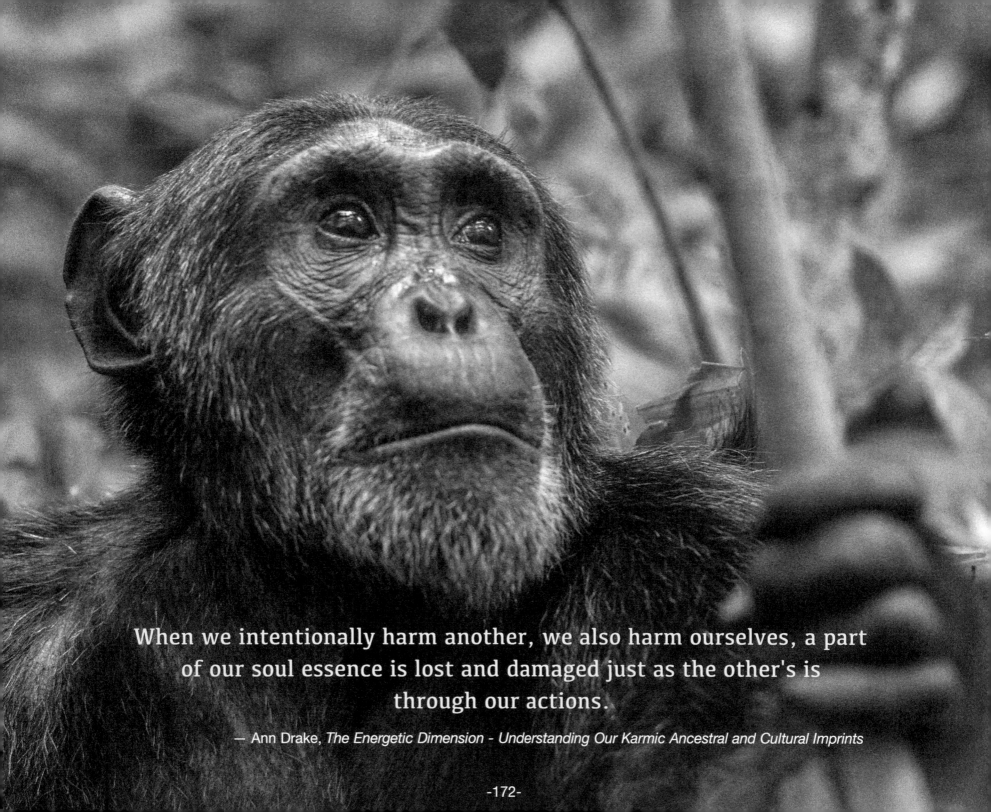

When we intentionally harm another, we also harm ourselves, a part of our soul essence is lost and damaged just as the other's is through our actions.

— Ann Drake, *The Energetic Dimension - Understanding Our Karmic Ancestral and Cultural Imprints*

The Wisdom of Listening to Nature

Female leaders like Jacinda Ardern of New Zealand, Angela Merkel of Germany, Sanna Marin of Finland, and Erna Solberg of Norway led their countries successfully through the coronavirus pandemic because they empathized with their populace, listened with humility to scientists and made decisions to save lives. The United States and England closed off scientific voices while the virus spread.

According to former President Barack Obama, our leader's chaotic response to the coronavirus pandemic has "torn back the curtain on the idea that so many of the folks charge know what they are doing." He asked young high school graduates to "seize the initiative to build a community where we are alive to one another's struggles. The old ways of doing things just don't work."

Basic to the laws of nature is the interdependence of all life. In November of 2019, when the White House was alerted to the pandemic in Wuhan, China, leaders could have told doctors to look for infections, blocked some flights from Europe and China, and stockpiled protective equipment for doctors and nurses. Instead, our leader focused on an ineffectual border wall and instilled hate toward immigrants by his delusion that asylum seekers would bring in disease. Meanwhile, a real pandemic was brought in and spreading. It is believed that the first infected man in his 30's came back from Wuhan, China into the Seattle, Washington airport on January 15, 2020.

Since COVID-19 is a starter plague giving us a hint of the effects of environmental degradation, the solution is to ban together with other countries to heal Mother Earth. Instead, our leader, unable to grasp how everything is connected, began pulling us out of the Paris Agreement. His focus, human wealth, will not survive our holocaust of nature.

Community Versus the Individual

It wasn't just our wisdom-challenged leadership that enabled the coronavirus to bring America to its knees. Our cult of the individual from the days of wagon trains turned lethal when we needed to work together. Some people attended political rallies and bars to exercise their rights of not wearing a mask. Stacey Nagy of Texas wrote a scathing obituary about her husband's "needless" death. "The blame for his death and the death of all the other innocent people falls on Trump, Abbott (the governor) and all the other politicians who did not take this pandemic seriously...Also to blame are the many ignorant, self-centered and selfish people who refused to follow the advice of medical professionals, believing their right not to wear a mask was more important than killing innocent people."

Allowing some individuals to spread a lethal virus violated the concept of a community where we look out for each other. This was similar to how innocent people are killed in mass shootings. When our founding fathers gave us the right to bear arms, they were not referring to an AR-15, an automatic weapon designed to kill many enemy soldiers at once. Useless for hunting, sharpshooting, or protecting your home, there is no need for civilians to own weapons of war. But if you want to release rage onto little kids, our congress, paid heavily by the NRA, allows you to buy an assault rifle. This right violates the rights of children to life and jeopardizes the safety of the public. The lives of 346 students and faculty have been sacrificed to gun violence. Before the virus lockdown, we had a mass shooting on five out of every six days. From 2011 to 2014, violence in America tripled, according to research by the Harvard School of Public Health. There have been more multi-fatal shootings in American schools than in China, England, France, Germany, Ireland, Russia, Italy, Kenya, Spain, Syria, Yemen, Israel, South Africa and all the other countries **combined**.

Other countries poke fun at us. A tongue-in-cheek program in Denmark, *Sunday with Luback*, described the NRA as the Nonsensical Rifle Addiction, a dysfunction in America which causes people to shoot each other. It is contagious and is passed from parents to kids and happens automatically and semi-automatically.

A teenager who doesn't find a weapon when he wants to unleash rage into kindergarteners will not do so. It is not accurate to blame mental illness, because, while the number of shootings has skyrocketed, mental illness has not increased. What has increased is the detachment of viewing the world on a screen. It is urgent that we heal this alienation by harvesting compassion and reconnecting with our roots in nature.

The Sandy Hook massacre taught us the downside of detaching from nature. Adam Lanza accelerated toward the shooting with an orgy of violent video games. Bird songs, the aroma of pine needles, and fresh air could not get through his windows sealed with garbage bags. Predictably, on December 14, 2012, he unleashed his fantasy of gore into twenty students and six teachers. We are especially horrified by the Sandy Hook shooting because of the innocence of the victims who still believed in Santa Claus and slept with teddy bears. Their sweetness and delicacy was not yet of this world. Dylan Hockey drew big purple dots with magic markers and flapped his arms like a butterfly. Daniel Barton had a gap-tooted smile because he just lost two front baby teeth. Dylan's mother, Nicole Hockey, and Daniel's dad, Mark Barton, founded the Sandy Hook Promise to train 1,484,296 members the signs of gun violence.

"It is time for us to evolve as a society," said Mark Barton. Implicit in the Sandy Hook Promise are values about community, "Whatever I do unto others, I do into myself." Nicole Hockey remembers her son's flapping his arms and says a butterfly can cause a hurricane half way around the world. She is training kids to reach out with kindness to anyone who feels sad and to see himself or herself as "wingmen," having the back of

anyone in trouble. She says gun violence is preventable by intervening in the steps leading up to a rampage.

Frequently, future school shooters hurt animals. Nikolas Cruz, who slaughtered classmates in Parkland, Florida, used chickens and frogs for target practice. Stephen Paddington, the Las Vegas shooter, shot animals for fun in Alaska before he slaughtered people. According to *Psychology Today*, "Animal abuse is often the first manifestation of serious emotional turmoil that may escalate into extreme violence such as a mass killing." Jeffrey Dahmer, Albert DeSalvo, David Berkowitz and almost all serial killers describe an animal as their "first kill." A study in Australia showed that 100% of murderers who raped their victims before they killed them were cruel to animals first. Hurting animals is one of the diagnostic signs of a developing psychopath.

If we had learned from Sandy Hook, Jesse Osborn would have gotten help after he brought a machete and a hatchet to class. Instead, on September 28, 2016, he shot tiny Jacob Hall and others at Townville Elementary in South Carolina. Jacob was set to rest as Batman with a flowing cape to help him fly with the angels. "Jacob is in heaven," his mother said, "asking his mommy to be strong enough to forgive" and to show people "to love instead of hate." At the Oakville Baptist Church, about a thousand people dressed as Avengers, Spiderman, and Teenage Mutant Ninja Turtles gave Jacob Hall a Superhero sendoff.

Jacob was the only boy Ava Olsen ever kissed. She could not bear to see the dead Jacob in a miniature casket covered by yellow chrysanthemums, but mostly, she felt bad she'd never given Jacob the note she scribbled. "Come play with me …We could get married. My mom will make us lunch." At the bottom, she drew herself in a pink dress standing next to the smaller bespectacled Jacob. Beside a red heart, she wrote, "I love you."

"Darkness cannot drive out darkness, " said Martin Luther King. "Only light can do that." We cannot depend on our leaders. We have to be the change the world needs. Only a few are creating bloodshed. The rest of us can band together to create a kinder world. "The masculine force now dominating the world is heartless and abusive; it is war oriented, out of balance, and sick," writes Arkan Lushwala, in *The Time of the Black Jaguar.*

Healthy power is when our vitality joins with the life-force to nourish others. Empathy for other creatures curbs violence. In Gujarat, India students get daily lessons in compassions for animals. Coordinator Puja Mahajan says, "Teach a child to be kind to a mouse and you do as much for the child as for the mouse." An underdeveloped sense of empathy leads to viewing others as objects of our purposes.

We become individuals through interactions with our community, by the flow of love and support from our parents, teachers, and friends. As Lushwala says, "Human strengths such as willpower and compassion are kept alive when people are inspired by love and there is a blending of feminine and masculine qualities…This type of intelligence –intuitive and wise – is rooted in the Earth…"

We need to listen to nature. The flooding, hurricanes, and fires of climate change will not go away with denial or intimidation. As Pope Francis says, when we do not approach nature with "awe and wonder" we become "consumers, ruthless exploiters who place no limits on ourselves." He said it was our responsibility to help what is imbued with His radiance.

To survive, we need poet Mary Oliver's attitude to "hold what is mortal against our bones." In her poem Bird she described how love and power worked together when she took home an injured seagull she found on the beach. She placed the gull on an island of towels, near a glass door overlooking the harbor. A shattered elegance, one of his wings was broken. The other was hurt and both feet were withered. But he was alert,

To survive, we need poet Mary Oliver's attitude to "hold what is mortal against our bones." In her poem Bird she described how love and power worked together when she took home an injured seagull she found on the beach. She placed the gull on an island of towels, near a glass door overlooking the harbor. A shattered elegance, one of his wings was broken. The other was hurt and both feet were withered. But he was alert, enjoyed his bath in the tub, and was responsive as she smoothed his feathers. Mary became fond of the amusement in his eyes as they played. After one of his atrophied legs fell off, she nurtured him through the rough and tumble work of dying. Mary celebrates the preciousness of life, even when it is broken.

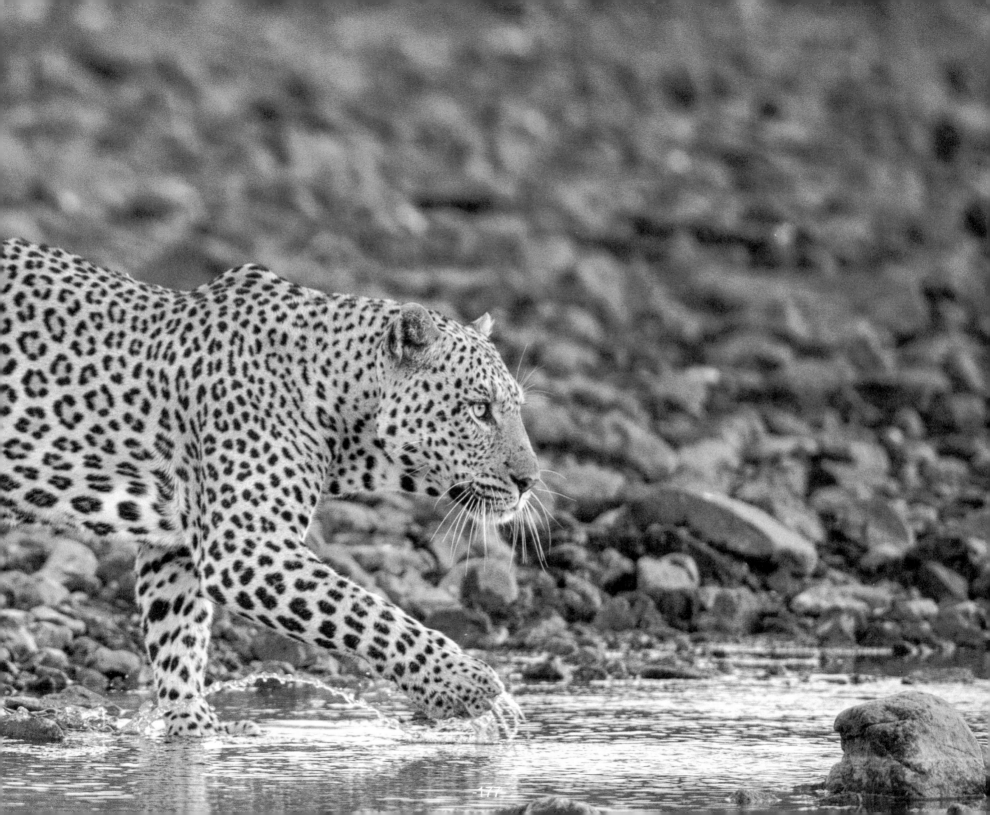

> *we cannot solve our problems with the same consciousness that created them.*
>
> — Albert Einstein

As we barricaded ourselves inside fighting the coronavirus pandemic, an enemy of our own making, a pause in the industrial revolution cleaned lung-choking pollution in China and showed people in India the Himalayas for the first time in thirty years. On hold was our delusion we can kill for fun, so 120 bulls were saved in Spain when bullfights were canceled. Numerous elephants were not shot by trophy hunters in Botswana. On hold was our belief that other species are for our use. Seventy-eight enslaved elephants who carried tourists were set free in Thailand. On hold was our assumed ownership of waterways, so swans glided through the canals in Venice and dolphins wiggled between the docks of Cagliari in Sardinia.

The coronavirus showed us how nature thrives without us. During the lockdown, patients with whom I talked in video sessions raved about kangaroos hopping down the road in Adelaide, Australia, penguins waddling on sidewalks in Cape Town, South Africa, and lions sleeping on roads in the Maasai Mara, Kenya. On Earth Day, April 22, I heard excitement in my patients' voices about a coyote who ambled over the Golden Gate Bridge in San Francisco and a mountain lion who meandered into downtown Boulder, Colorado. Additionally, bears used empty roads for traveling in Yosemite National Park in California, and sea turtles in Brevard County, Florida, thrived without plastic, beach chairs, and people.

As the virus cut through our denial of a shared fate with our environment, the correlation between the health of wildlife and the health of humans gave us hope. Many people joked that nature had sent us to our rooms to think about what we had done. Social media was filled with posts about how we couldn't return to normal because it normalized the killing of wildlife for farming, asphalted the homes of brother and sister species, depleted and extracted limited resources, and poisoned rivers, clogged oceans, and polluted air.

The cascading consequences of our exploitation, fueled by our cult of superiority, has destroyed ecosystems supporting life. Our deepest knowing is wiser than the hierarchical rules of our culture. A patient came to me after his wife killed herself and left a note, "I'm a monster." Her guilt from killing healthy animals at her job at an animal shelter was too much to bear. Her heart knew the cats and dogs were precious even if they did not have a home, but she felt powerless to change the shelter's assumptions based on hierarchical thinking. Although most people know the treatment of animals in factory farms is horrific, we feel powerless to stop it. Perhaps when the filthy conditions become a time bomb, it will become a priority.

For my doctoral dissertation, *Positive Transformations Following Extreme Trauma*, which was published in popular form by Charles Press, *Undaunted Spirits - Portraits of Recovery from Trauma*, I examined how loss forces us to reexamine our priorities. I interviewed Elie Wiesel, a concentration camp survivor who became a novelist and Noble Peace Prize winner, Max Cleland, a Vietnam Veteran and triple amputee, who become a United States senator, and Rabbi Harold Kushner, who wrote *When Bad Things Happen to Good People*. After a life-shattering loss, they connected to some fundamental essence. New priorities emerged and, with them, the turning of their very existence.

The Chinese sign for crisis means both danger and opportunity. The danger is that we do not pay attention to nature's warning shot fired into the air. The danger is that we drift back into our delusion of human omnipotence. This crisis clarified an essential truth—nature does not need us.

Opportunity

Healing occurs from a profound shift in the way we see ourselves and the world. Acting from our deepest fears, the viral epidemic taught us to override differences to conquer a common enemy. In a spirit of unity, Italians hit hard by the virus celebrated life by singing from balconies. At 7 p.m. on March 27, 2020, thousands of quarantined New Yorkers went to their windows to applaud health care workers in blue scrubs and masks as they walked along the sidewalks below. The virus could turn all our lives to dust, so we forgot to be republicans or democrats, rich or poor. The virus taught us humility. So much death helped us focus on life.

Media airtime for celebrity fashions, makeup do-overs and lavish homes of the rich made way for the faces of nurses with red suction marks from N95 masks. Gone were fake eyelashes, lipstick, and high heels. What was for show gave way to what mattered. Collective acts of self-preservation put consumerism on hold. Perfume makers turned to creating hand sanitizers, and fashion companies switched to producing masks and surgery gowns.

After disaster, nature teaches us to rise again. Green shoots break through the charred earth. After the coronavirus quarantine, people sprawled on colorful blankets in parks. Instead of looking at their phones, they watched birds and squirrels. One loves by constant encounter and touch. While we were focused on computer and television screens, we forgot the earth is a living presence to which we belong.

One of the basic principles of nature played out: the interdependence of all life. A bat infected a pangolin in a Chinese wet market, which led to hundreds of thousands of human deaths across the globe. Because we violated the laws of nature, nature gave us a swift sample of her justice. The invasion of tiny unseen organisms infected doorknobs, light switches, faucets, handshakes, and even hugs. The air itself was not safe. We were trapped in homes like being stuck in a Stephen King horror story. The novel virus could make us its host, then, similar to how it leaped from a bat to pangolin in a wildlife market, it could kill our friends, family, and anyone we met face-to-face.

By May, over 100,000 people who caught the virus struggled to breathe until they couldn't anymore. None of our technology could wake them up from the nightmare we created. Disney was out of magic. Hollywood was out of happy endings. And we no longer believed we were all-powerful.

As the coronavirus raged out of control, work, music, theatre, and sports events were canceled. Since we didn't have much of a life, people joked we wouldn't have to count 2020 as part of our age. But 2020 could be our best year – when we were stunned into hearing nature's screams.

We took the wrong path when we replaced the indigenous view of the earth as sacred with a view that nature was a warehouse for humanity. Turning life into trash violates every spiritual, moral, and ethical tradition, yet we kill raccoons, foxes, bears, prairie dogs, porcupines, skunks, wild horses, beavers, mountain lions, coyotes, ducks, and geese for ranchers or when they wandered onto land we claimed as ours. If we don't coexist with the natural world, our delusion of superiority will destroy us.

In March, in a display of lethal dominance, police officer Derek Chauvin suffocated a handcuffed black man, George Floyd. There was a superior pleasure on Derek Chauvin's face as he pressed the life out of the helpless Floyd. That Floyd was huge and strong seemed to make the murder reminiscent of trophy hunters who kill the biggest, most powerful lions.

The unification we felt at the common enemy of the virus seemed to ignite a collective rejection of dominance. As protests over the abuse of power erupted, our leader had our military use rubber bullets, tear gas, and pepper spray on peaceful American citizens. A symphony of backlash condemned his show of "dominance" and his characterization of those peacefully assembled as "terrorists." The former secretary of defense, James Mattis, understood that seeing another as alien enabled violence. Mattis was appalled by the use of our military against American citizens because it "erodes the moral ground that they themselves are part of the society they are sworn to protect."

Trauma survivors are hypervigilant to avoid what previously harmed them. Perhaps now, we can stop destroying forests because protecting nature protects us. Perhaps now we can respond collectively when scientists explain that rising temperatures will unleash bacteria that becomes deadly in heat. Perhaps we can become alarmed about the numerous saiga who dropped dead in May 2015 in the grasslands of Asia. A saiga is an antelope with a bulbous nose who looks like a cartoon character. Two-thirds of them died when a bacteria that's usually harmless became deadly because of warming temperatures.

Since contaminating water is out of sync with our continuity, perhaps now we will care when thousands of snow geese die from burns when they land in water, like they did in March of 2018. The water was toxic with arsenic, cadmium, cobalt, copper, iron, and zinc from a mining company

Abuse of Power Protests

"Our country was founded on protests," said former President Barack Obama, after the marches against the lethal dominance of a police officer. "Every step of progress . . . every expression of our deepest ideals has been won through efforts that made the status quo uncomfortable."

Joining together for change strengthens the bonds of community. As the deaths from the virus merged into marches, the bottom of what was familiar fell out. A cultural shift had been brewing for years, as Paul Hawken showed in *Blessed Unrest – How the Largest Social Movement in History is Restoring Grace, Justice, and Beauty to the World*. He described two million organizations trying to save our planet. Held together by information technologies, they tried to reverse climate change, replant rain forests, clean our oceans, and save coral reefs. Others were helping elephants, rhinos, lions, orangutans, bears, and whales.
'

"I think we are at a crossroads," said one activist. "Either we make a commitment to a world built on values of sacredness, nature, and inter-connected systems of life or we say, 'Oh well, we're doomed to a world of selfishness, greed, and violence.'"

Millions marched in Washington, DC, during the Women's March on January 21, 2017, on Earth Day, April 22, 2017, to Make America Think Again, and for the March for Our Lives on March 24, 2018, organized by survivors of the Stoneman Douglas School shooting. As actress and singer Janelle Monae said at the Washington, DC, Women's March: "This is a march against the abuse of power." As America Ferrera said, "The president is not America. The cabinet is not America. Congress is not America. We are America...As long as we commit to what aligns us, we have a chance to save the soul of our country."

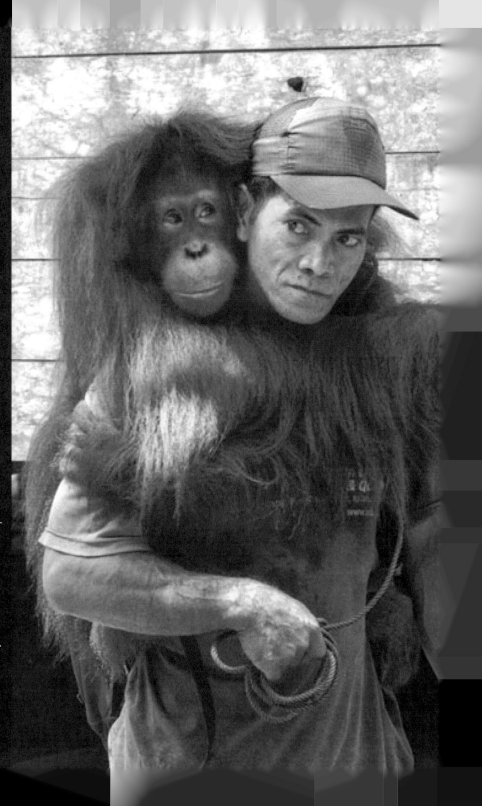

As science highlighted suicidal governmental policies, we swelled with power coming from the ground up. Hopefully, the mainstream culture will see how pillaging and plundering mindlessly tinkers with the earth's self-regulating system. We are waking up from perversions of power destroying the earth and distributing suffering and death to those who can't defend themselves. Most people do not want bear hunts or wolves exterminated. Most people do not want animals slaughtered by Wildlife Services or trophy hunters, but feel resigned to the horrific and disgraceful acts, because they have no voice. Most people do not want our natural resources sold to corporations. In 2008 and 2009, the American Psychological Association did a study that found that powerlessness creates a paralyzing feeling of resignation.

At the Stoneham Douglas School, classmates who watched Anthony Borges get shot five times through a door while protecting others became mobilized to change laws so children are not sacrificed for gun profits. Disgusted by adults, the children asked for new values, priorities, and paths to the future. Survivor Cameron Kasky asked Senator Marco Rubio if he was going to continue to take money from the gun lobby. Rubio stammered, shifted his feet, looked down, and tried to change the topic. "It's scary to think," said Cameron Kasky, "these are the people making our laws." As Matt Post said, "Our nation's politics are sick with soullessness." Children know the mass shootings stem from profits being valued more than the lives of children.

Even kids know it is unwise to sacrifice the health of the living planet, upon which all life depends, for the riches for a few. Pig-tailed climate activist Greta Thunberg says adults failed them so they must make the earth great again. We are in an upside-down world, when children sound like adults and adults sound like children.

Former President Jimmy Carter said unlimited political bribery "violates the essence of what made America a great country." He said the corruption of government by money "has been the worst damage to our basic moral and ethical standards I've seen in my life."

Perhaps now we will look up from our gismos, Netflix, and shopping to stop the corruption in government reminiscent of the decadence, opulence, and collapse in reason that led to the fall of the Roman empire. The Women's March, the March for Our Lives, and the Earth Day marches did not get our attention the way the coronavirus did. Faulty reasoning in government led to us dying instead of elephants, wolves, bears, orangutans, and coral reefs. I hope now we can perfect the knack of resurrection. Awe for the magic of nature can inspire us to stop waging war on our planet and use our own gifts to make the earth green again. When a critical mass hears the wisdom of those who see the earth as a gift, we will tip toward lasting change.

"How, in our modern world, can we find our way to understand the earth as a gift again, to make our relations with the world sacred again?" asks Robin Wall Kimmerer in *Braiding Sweetgrass*. "The market economy story has spread like wildfire, with uneven results for human well-beings and devastation for the natural world. But it is just a story we have told ourselves, and we are free to tell another, to reclaim the old one. One of these stories sustains the living systems on which we depend. One of these stories opens the way to living in gratitude and amazement at the richness and generosity of the world . . . and asks us to bestow our own gifts in kind, to celebrate our kinship with the world. We can choose. If all the world is a commodity, how poor we grow. When all the world is a gift in motion, how wealthy we become."

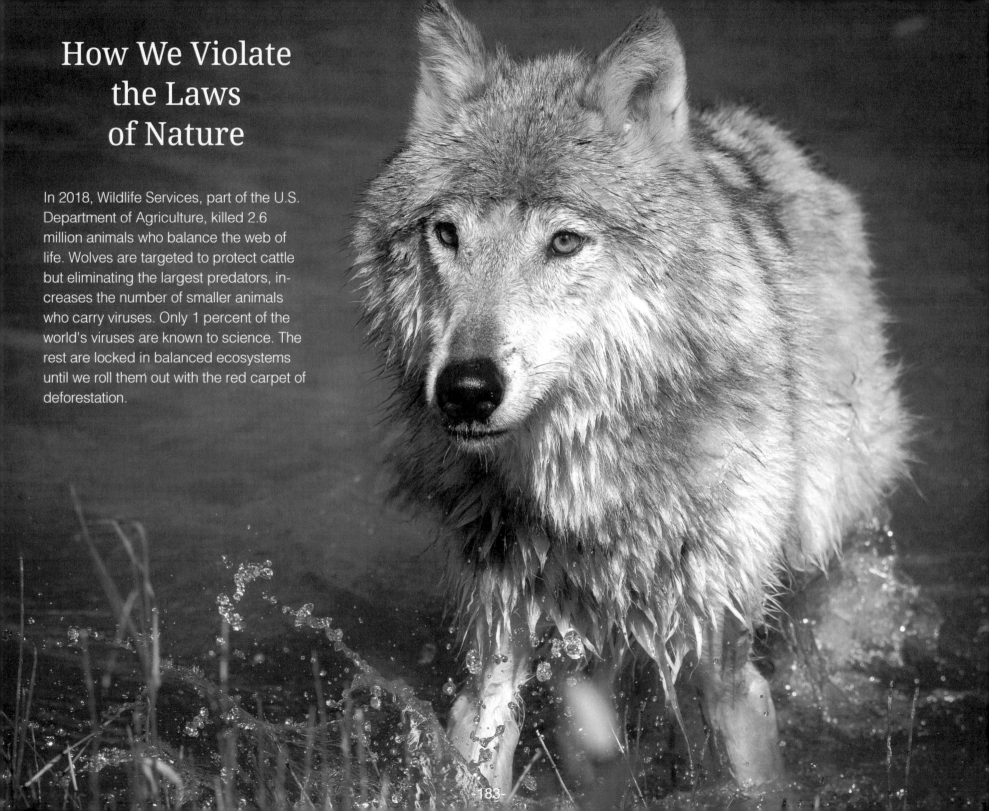

How We Violate the Laws of Nature

In 2018, Wildlife Services, part of the U.S. Department of Agriculture, killed 2.6 million animals who balance the web of life. Wolves are targeted to protect cattle but eliminating the largest predators, increases the number of smaller animals who carry viruses. Only 1 percent of the world's viruses are known to science. The rest are locked in balanced ecosystems until we roll them out with the red carpet of deforestation.

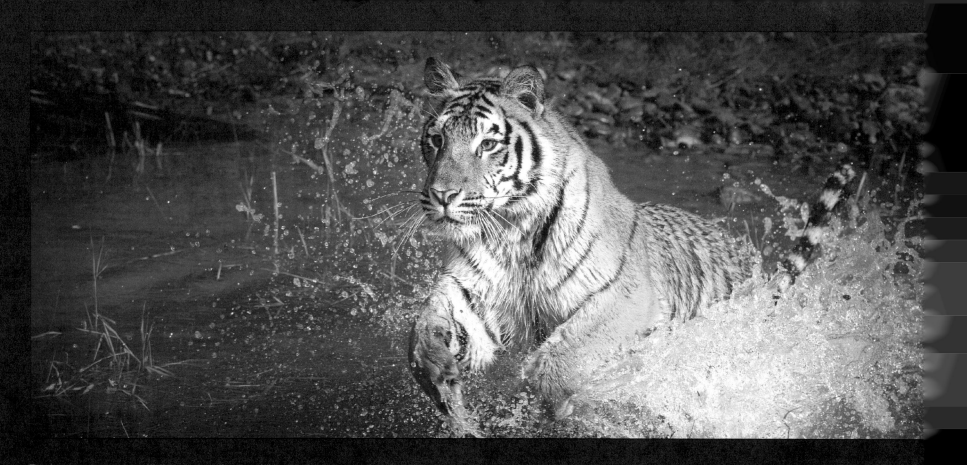

Perhaps now we will listen to what spiritual experts and scientists have been saying. Pope Francis says the plundering of nature "lays bare the depth of man's moral crisis." Cosmologist Stephen Hawking says greed and stupidity are "devouring us," destroying all of our accomplishments since the Stone Age. He says massive pollution has 80 percent of inhabitants of urban areas exposed to unsafe levels of toxic air that contributes to many diseases.

As machines burn the earth's body and pollute our air, poet Wendell Berry says, "The machine economy has set fire the human soul and all creatures are burning within it." Astrophysicist Neil deGrasse Tyson says America rose up from a backwoods country on industries pioneered by science. Science is an entire exercise in finding truth by decades of experiments. He says the denial of science by those in power is a recipe for disaster because people have lost the ability to judge what is true from what is not." Quantum physics and quantum biology recognize the interconnectivity of all life.

Poet Mary Oliver described the process of embracing the living world. "One day you finally knew what you had to do and began, although the voices around you kept shouting their bad advice." When the passion to save our planet moves from environmental groups to a heart of us all, it will become what ecologist Joanna Macy calls the Great Turning. As we save lives and the damage done to our habitat, I know, as William Butler Yeats wrote, we "must lie down where all the ladders start—in the foul rag and bone shop of the heart."

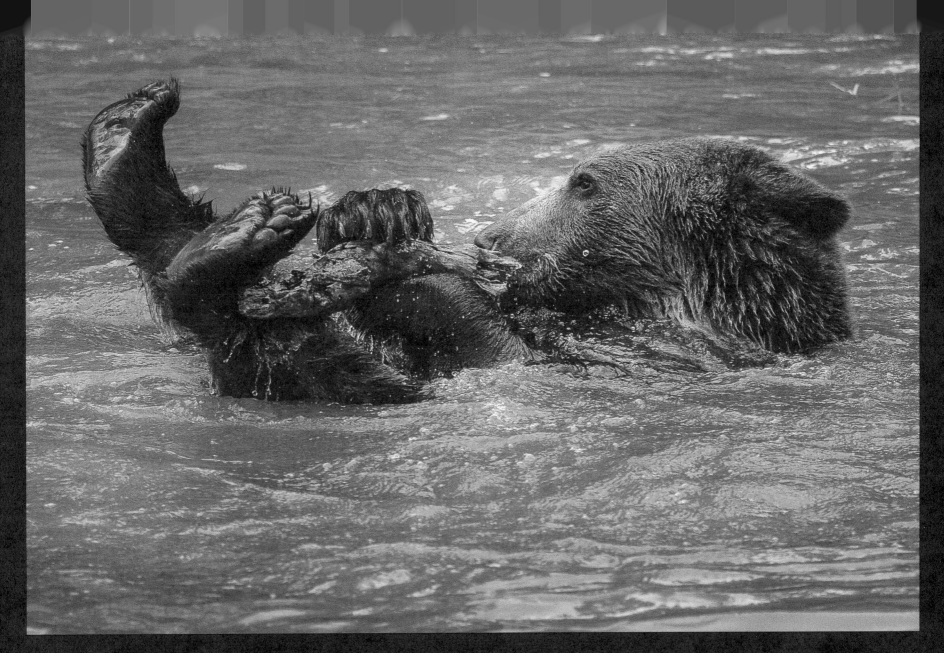

As L. R. Knost said, "Do not be dismayed by the brokenness of the world. All things break. And all things can be mended. Not with time, but with intention. So go. Love intentionally, extravagantly and unconditionally. The broken world waits in darkness for the light that is you."

As Chief Arvol Looking Horse said at the Standing Rock protests, we are at a turning point and must choose between a scorched or green path to the future. "Each of us is put here at this time and place to personally decide the future of mankind. Did you think the Creator would create unnecessary people in a time of such terrible danger?"

Love Heals Baby Elephants – Rebirthing Ivory Orphans

"The message is clear—whether we are elephants or humans—love heals. Through heart-opening photos and wise, touching insights, we see how baby elephants learn to trust again after seeing their families killed. Mary shares her vital message from the perspective of a brilliant psychologist as well as a deeply committed animal lover. Read this book. Share it with others. Be an active participant in helping elephants, endangered species, ourselves, and the world.

—Dr. Allen Schoen, author of *Kindred Spirits*

This wonderfully written and magnificently photographed book about orphan elephants makes us understand the powerful similarities and connections between human and animals. When we understand this, the slaughter of elephants for ivory becomes a crime against all we aspire to as human beings"

—Margaret Lazarus, Academy Award–winning filmmaker
of *Defending Our Lives*

Undaunted Spirits -
Portraits of Recovery from Trauma

"This book is a pleasure to read, not only because of the lessons learned from the survivors, but from the feeling that one is sitting with them, as Baures did. Passion and feeling are in this book. All of the people interviewed have learned how to use their passion to heal themselves and others."

— Bernie Siegel, MD

"Baures successfully applies her skill as an investigative reporter and her knowledge as wise psychotherapist to produce a winning book about hope and determination."

— Charles Figley, Ph.D. Founding Editor, *Journal of Traumatic Stress*

"Mary Baures shares these remarkably uplifting portraits with sensitivity, insight, compassion and genuine understanding."

About Mary Baures

A passion for wildlife photography drew Mary Baures out of the boxy rooms where she was a practicing psychologist. Through enchanting encounters with our brother and sister species, she came back to the earth and learned from an intelligence wiser than our culture.

As we accompany her into the wild, she introduces us to orangutan and elephant babies, leopard cubs, mating lions, lion guardians, and indigenous leaders who taught her to view Mother Earth as sacred.

In *Love Heals Baby Elephants - Rebirthing Ivory Orphans*, she documented how turning kindred spirits into things violates rules wiser than man's law. In the orphanage, elephant babies who watched the massacre of their families found resilience and learned to love and trust again. While working with Cambridge Documentary Films as a co-producer of *Strong at the Broken Places: Turning Trauma into Recovery*, she learned how loss mobilizes us to transform in magical ways.

In *Undaunted Spirits: Portraits of Recovery from Trauma*, she documented how a horrific loss can lead us to discover wisdom and a fuller sense of self. Rebuilding forces us to find new priorities and values.

Mary Baures has a doctorate in psychology from Antioch New England, a Certificate of Advanced Graduate Studies in human development from Harvard University, and three master's degrees, in counseling, creative writing, and psychopharmacology. Before she became a psychologist, she wrote magazine articles and taught writing in the Master of Fine Arts program at Emerson College.

Visit MaryBauresBooks.com
to order framed prints
or to inquire about
speaking engagments.

Portions of this book were published in *The Compassion Anthology*.
The photographs in *Awakening Awe* were taken by Mary Baures.

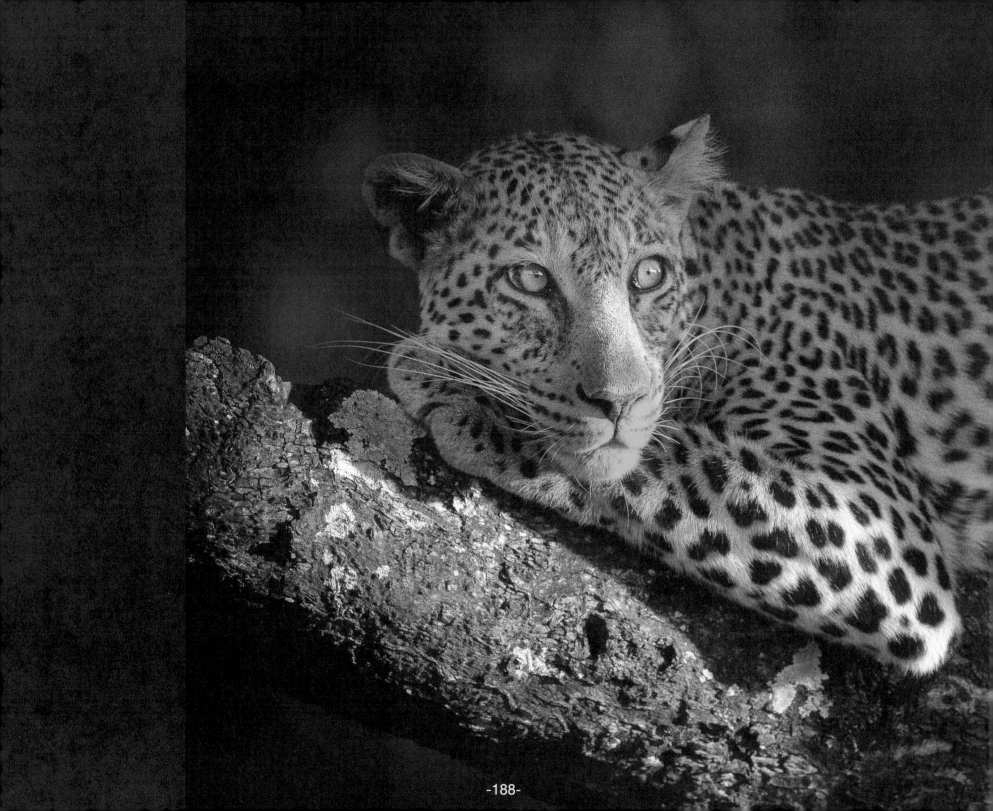

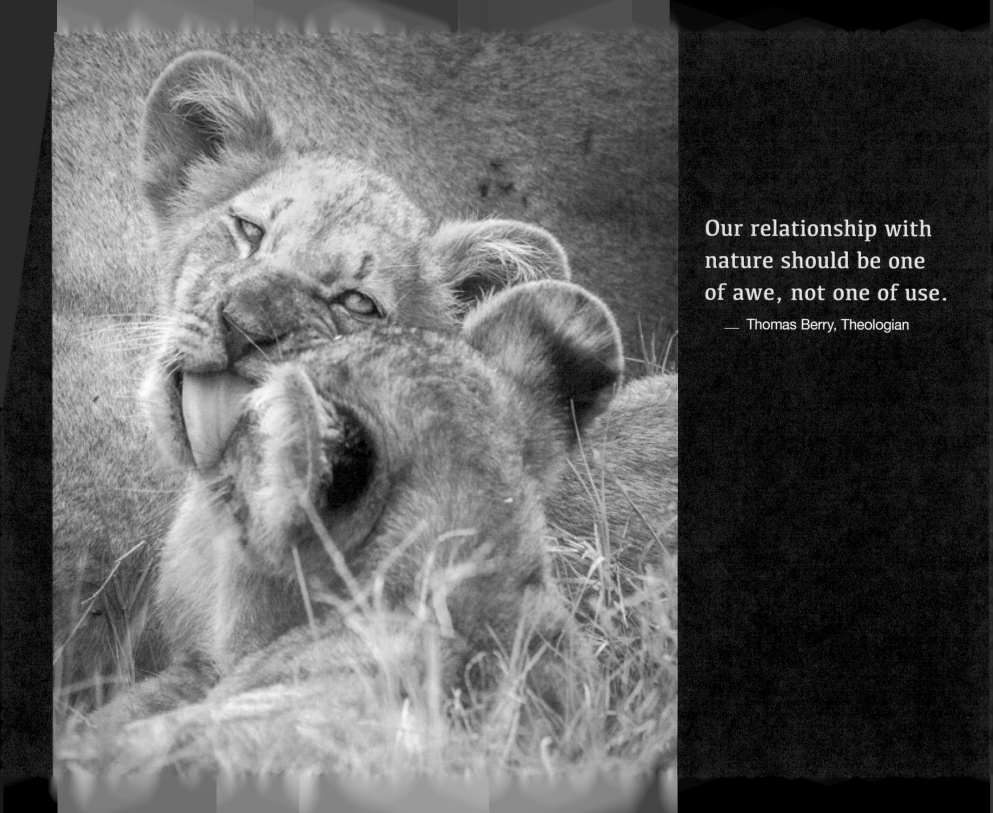

Our relationship with nature should be one of awe, not one of use.

— Thomas Berry, Theologian

CPSIA information can be obtained
at www.ICGtesting.com
Printed in the USA
BVRC102247241022
650135BV00022B/272